THE ART AND MAKING OF

THE LION KING

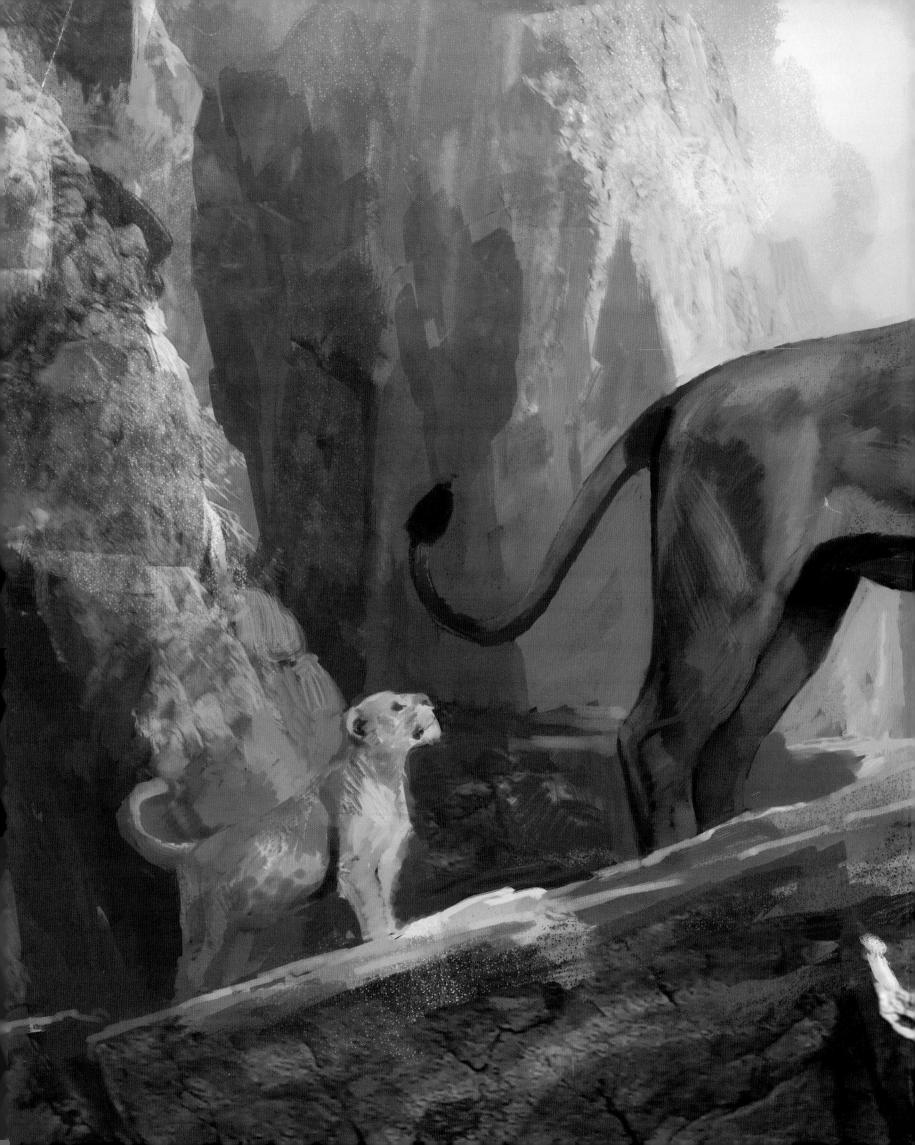

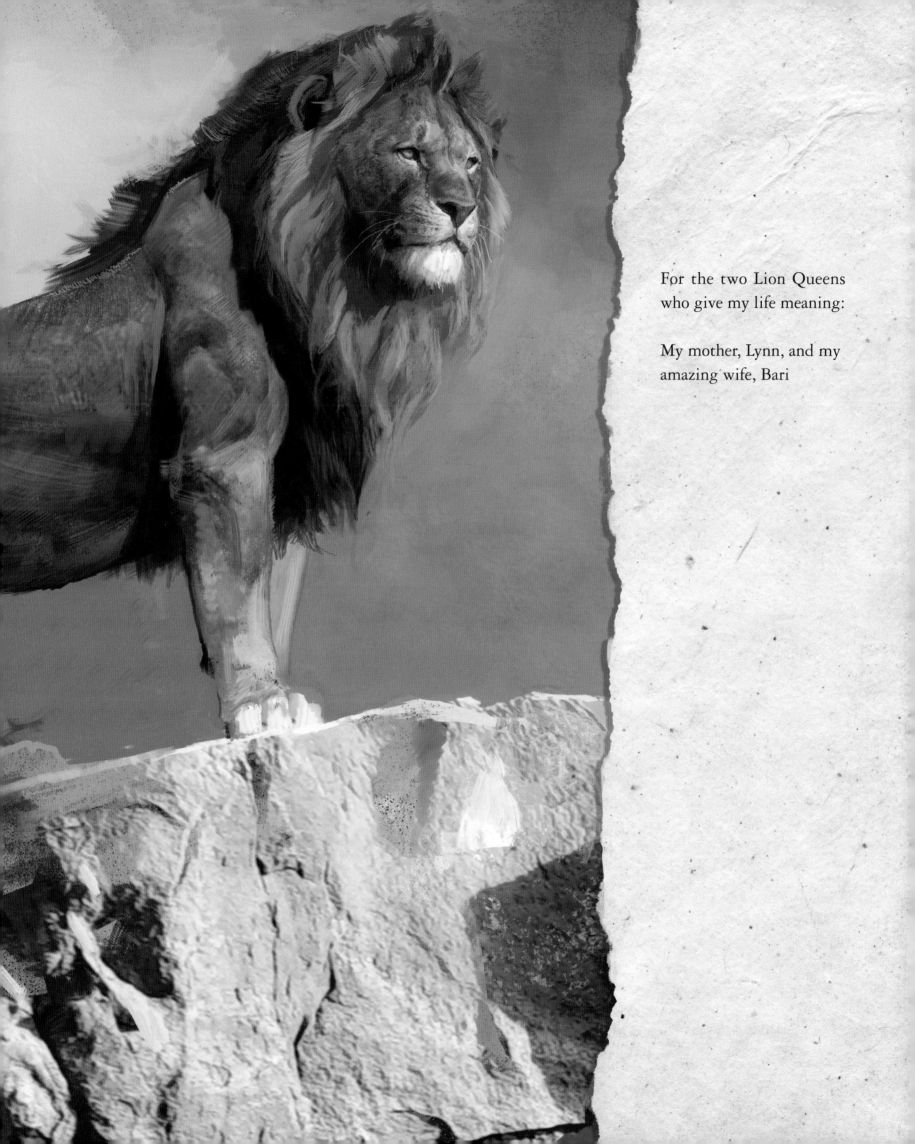

For the two Lion Queens
who give my life meaning:

My mother, Lynn, and my
amazing wife, Bari

THE ART AND MAKING OF

THE LION KING

Michael Goldman

FOREWORD BY THOMAS SCHUMACHER
AFTERWORD BY JON FAVREAU

BOOK DESIGN BY TAMARA KHALAF

EDITIONS

Los Angeles • New York

CONTENTS

FOREWORD

For almost thirty years, every single day, *The Lion King* has been a part of my life in one way or another. Beginning as a sort of "orphaned" animated feature, through a groundbreaking stage musical, and now as a whole new realization in what director Jon Favreau calls "a third medium" that combines techniques and vernaculars of animation, cinema, and human performance, *The Lion King* not only endures, it has evolved and become a part of global culture.

Yet after all that time, and with the intimacy I have gained with this property, I continue to wonder—why does it still delight and excite audiences in all languages and cultures? Why does it work when I sit with a movie audience in Hollywood or Holland? Why does it work when I see our stage production in Johannesburg, South Africa; or Paris; or London; or Hamburg, Germany; or Tokyo—or anyplace that *The Lion King* plays or has played?

What is it?

As *The Lion King* permeates and distills through the myths of the ages and the study of our common culture of storytelling, it fundamentally reveals that it is, surprisingly and simply, a story of *us*! And therein lies its greatest meaning and deepest resonance.

What's fascinating is that, no matter where you are, who you are, or what your circumstances are, *The Lion King* can be an elegant and powerful allegory that allows each culture to bring its own perspective. Everyone has a family, one they are born into, or one they have created around them. Everyone has community. Everyone has to face the question of precisely what their responsibility is, for their family and their community.

When do you take responsibility for who you are? And what do you do to set things right when you have made them wrong?

Ours is a very simple tale, but it has significant resonance because it has borrowed liberally from global history and great works of religion and literature, plus celebrates our ongoing human struggle with the very meaning of our shared experience.

It's also interesting—at least from my perspective—to note that for a story with no people in it, what I tend to remember most are the people: the countless artists and creators in so many crafts who have contributed to its many powerful elements and incarnations. I've often spoken of the power of the community that created this work, but never do they get enough credit.

When I think about the animated feature, the list of essential players is far too long to include in a brief foreword. But chief among them of course are the directors, Rob Minkoff and Roger Allers, who infused the film with much more than we could have originally imagined; Don Hahn and Peter Schneider, who were invaluable shepherds; and brilliant songwriters Elton John and Tim Rice—joined by Hans Zimmer, Mark Mancina, and the extraordinary Lebo M.—who provided the film its indomitable musical landscape. (Much of the expanded stage score was given birth in the songs and themes buried in the process of making the films.) Animated films have complex story and writing structures: *The Lion King*'s screenplay is by Irene Mecchi and Jonathan Roberts and Linda Woolverton. Still Brenda Chapman, as head of Story, along with the screenwriters can be heard and felt throughout the film's dialogue and plot.

By the time *The Lion King* came to the stage, every element of the film had influenced Julie Taymor's extraordinary creation. Her genius in seeing a live theatrical creation within the inherently cinematic telling is testimony to her breathtaking gifts. When Peter Schneider, Stuart Oken, and I approached her to explore the

Thomas Schumacher, photographed by Pramod Thakur

theatrical potential from the blockbuster—but impossible to stage—animated film, she immediately exploded with ideas, visions, and dreams before leading us to what now plays all over the world today.

Reinterpreting the film's iconic images and story points, her team of choreographer Garth Fagan, lighting designer Donald Holder, scenic designer Richard Hudson, and book writers Mecchi and Allers were part of an entirely new fleet of artists and creators who were tasked with bringing the story literally to *life*.

The music team stayed together and expanded what was already a triumph on-screen.

Now an altogether new team of creators (whom you'll meet in the pages of this book) has taken on a completely new interpretation of this beloved story, with a vision and under the creative leadership of Jon Favreau.

The first time I met with Jon Favreau in New York, I quickly learned of his passion for the source material and deep commitment to taking it "one step further," rather than in an altogether different direction. But it wasn't until I began to visit his studio and see his process firsthand that I realized his ability to see the material in a way that is altogether new was actually possible.

The lasting power of *The Lion King* is that its story and characters are so global, and yet so personal. It is like so many of the enduring and epic legends handed down through time, to be told again and again, by different means and media, and by varied shamans and storytellers.

It's a tale that has been told before. It is being retold today. It will be told again in time to come. Well beyond our time.

—Thomas Schumacher
Producer & President, Disney Theatrical Productions
Executive Producer, *The Lion King* (1994)
Producer, *The Lion King* (Broadway, 1997)
Executive Producer, *The Lion King* (2019)

ORIGINS AND PRECURSORS

CHAPTER ONE

Exploring, Experimenting, and Moving Forward

". . . There's really no secret about our approach," Walt Disney said. "We keep moving forward—opening up new doors and doing new things—because we're curious. And curiosity keeps leading us down new paths. We're always exploring and experimenting."

Walt Disney is typically (and somewhat romantically) referred to as a showman or a storyteller, both of which are accurate descriptions. But just as significant an identity in his history and legacy is the role of innovator. The list of technical advances in entertainment that Walt Disney pioneered includes cartoons with synchronized sound, three-strip Technicolor for animated films, cinematic stereophonic sound, wide-screen animation, and even stereo simulcast television—not to mention the innovations in place making, transportation systems, computers, and robotics that his work on Disneyland and the 1964–1965 New York World's Fair brought into everyday use.

"Progress, you know, is slow up to a point," Walt once said. "You know what I mean? And then some little thing'll happen . . . Boom! A breakthrough! That's the way with motion pictures, too."

But Walt did not pursue technological innovation for its own sake. Every breakthrough had a purpose, a storytelling engine for which the technology used was always primary in his thinking. He was masterful at reaching into a lexicon of narratives and achieving a seemingly all-new success based on established and beloved cultural memories.

Visual developmental art of Mufasa and his son, Simba, from *The Lion King* (2019)

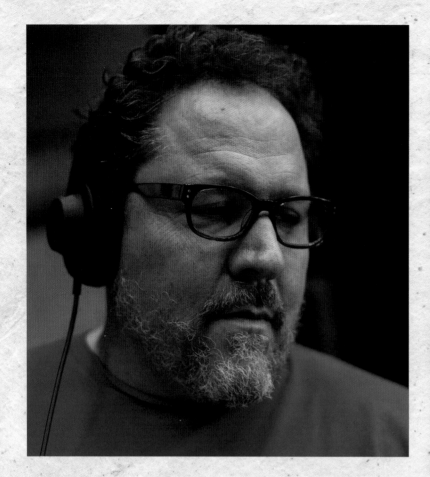

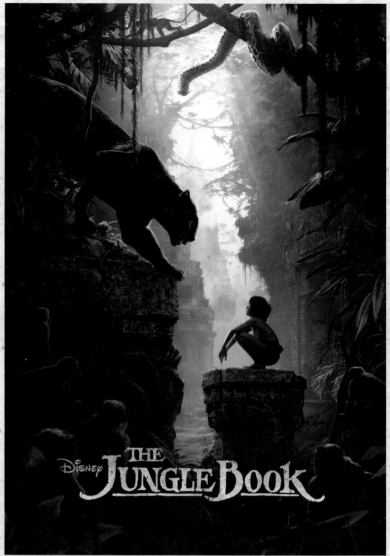

A Legacy of Innovation

It's no surprise, then, that new generations of filmmakers and storytellers look to the enduring culture of the Disney legacy—both in content and in technique—to inspire their new creations. "Disney stories are rich in storytelling, and familiar in character," writer and Disney historian Craig D. Barton says. "Actually, they were *so* rich and familiar that when filmmakers began to envision new ways to tell these tales, they realized the necessity of telling them in a way that will honor both the origins and the Disney versions that so many have grown up knowing."

Director Jon Favreau addressed this necessity in reimagining a classic Disney animated feature with his version of *The Jungle Book* in 2016. The treasured memory of childhood brought forward, the "talking stick" being passed around the communal campfire of popular culture.

Favreau wanted his take on *The Jungle Book* to *remind* people how and what they loved about the Walt Disney original, not to *replace* anything. It was not only a time-tested tale and a new storytelling method, but the very real action of cultural inheritance, a defining of self through the collected narrative of a life and its experiences.

"That's why we spend our adult lives seeking out the food we ate, and the music we heard, and the movies we saw when we were younger," the director says. "When you access those memories, you get back to your deepest self."

Favreau wanted *his* film version of *The Jungle Book* to capture not just the beloved and iconic characters and unforgettable musical environments of the 1967 Disney animated feature, but the way in which childhood, through a child's eyes, can take on a mythic vibrancy and scale.

Favreau says, "Certainly, what [Kenneth] Branagh did [with his live-action *Cinderella*], and what was done with *Maleficent*, gave the studio and myself confidence that there is an underlying curiosity, for retellings of these stories using new technology. Disney was comfortable enough to say, 'Hey, let's really go for it,' in the style of *Life of Pi* and *Avatar*, and go photo-real and see what technology has to offer. To have those tools available for something other than a superhero movie was a big treat for me."

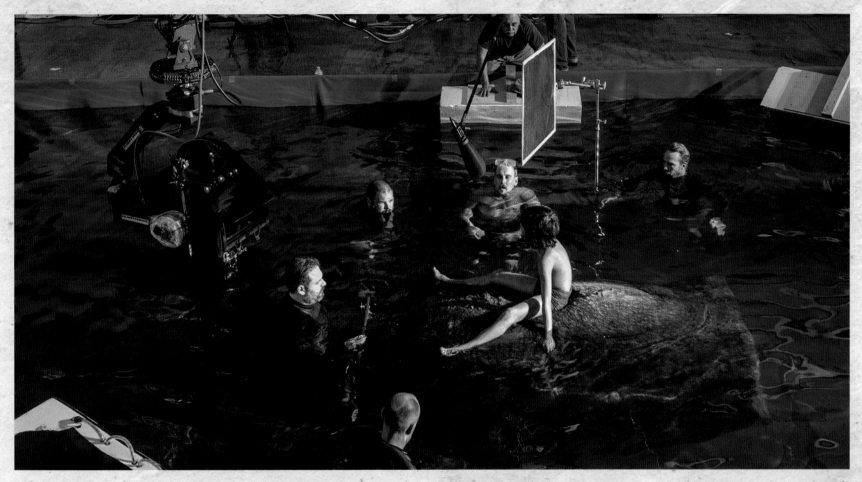

Opposite page, left: Director Jon Favreau listens to playback during filming on *The Jungle Book* (2016)

Opposite page, right: *The Jungle Book* film poster

This page, clockwise from top left: Pencil sketch for the iconic "Bare Necessities" scene from Favreau's *The Jungle Book*; early visual development art for same story moment; Neel Sethi (as Mowgli) filming the scene in a huge water tank; and a final frame from the "Bare Necessities" scene

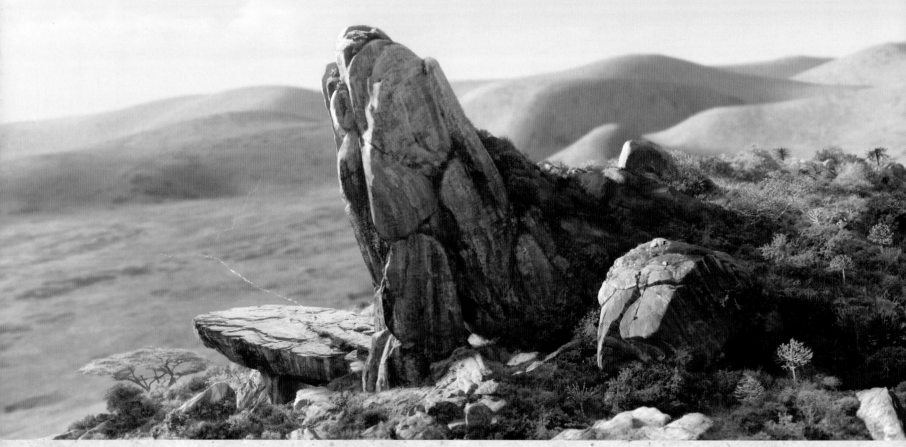

Top: Visual developmental art from *The Lion King* (2019) showing Mufasa from his Pride Rock perch

Bottom: Visual development painting of the film's iconic Pride Rock

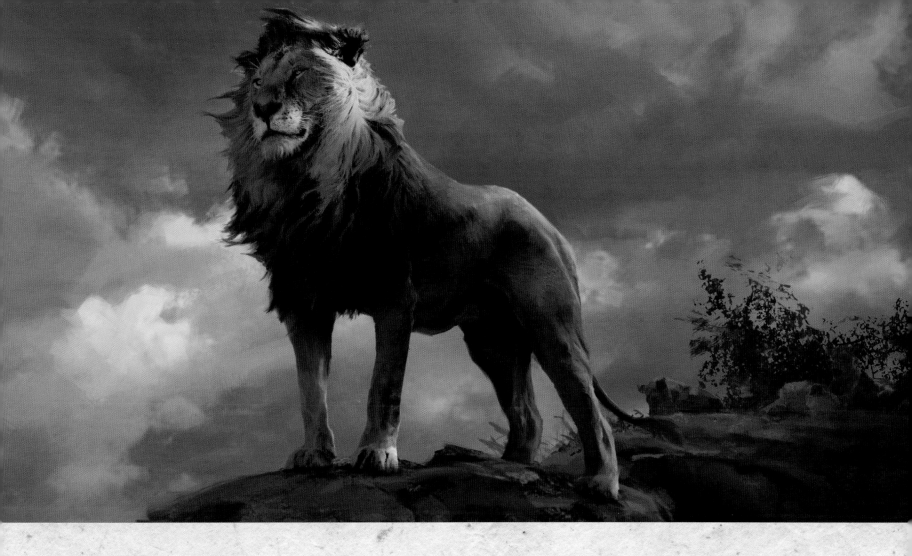

Tools to Tell the Tale

"Part of the fun of filmmaking is the innovation and pushing things technically and figuring out how to use new tools—and also creating tools that didn't exist—to help tell a story," Jon Favreau explains.

"I came in as somebody who understood visual effects from films like *Iron Man*. During the two, two and a half years [of production on *The Jungle Book*], I was learning more about how to use the technology effectively for not just a metal suit, but for organic characters, and elements like fur. Simultaneously, the technology was getting better, so I was getting a synergistic confluence of circumstances that led to the ability to show things on the screen that you hadn't been able to before. What that did was open up doors of being able to tell stories that otherwise would not have been possible."

The resulting feature was cutting-edge animation on a grand scale. Indeed, 98 percent of *The Jungle Book* was CGI—the only visible human actor was young Neel Sethi as the "man-cub" Mowgli. But Favreau wasn't so dazzled by his technological toolbox that he forgot to be a filmmaker in charge of a *Disney* film.

Astute viewers of *The Jungle Book* will see imagery recalling *Snow White and the Seven Dwarfs*, *Pinocchio*, *Fantasia*, *Dumbo*, and *Bambi*. Each of those are films whose audience reaction is reliant on technological innovation that serves as sort of invisible "actor," components for increasingly sophisticated filmmaking.

"And that is the dance that has been going on for the last century with movies," Favreau observes. "How do I tell the story? Let me create this tool. Now that this new tool is available, what stories can I tell with that tool? Whether it is a Steadicam, or any new device that is built, pre-digital . . . you are always trying to figure out, you are trying to build a tool to solve a specific set of problems. And then, those new tools inspire new ideas. And it is that dance that continues now.

"We are honestly trying to preserve that cinematic tradition here by not disrupting the entire filmmaking process," the director points out, "but instead, building upon what came before us, and using the skill set of the people who came up in a pre-digital world and trying to incorporate that culture into the filmmaking process."

Another Story to Tell

The huge critical and financial success of *The Jungle Book* immediately brought The Walt Disney Studios back to Jon Favreau, to see if the director had any further such projects in mind. Favreau recalls, "I wondered, just what else could this technology do? And what type of stories can you tell with it?

"My favorite kind of film-making is when I am subjectively drawn into something to the point where I suspend judgment, and just get drawn into this emotional journey and get to experience it through this piece. I think it really comes down to storytelling," the director says.

"The one property I identified with—the one I felt I could really do something special with—was *The Lion King*. I felt I understood the importance of that 'inherited relationship' the audience had with the material and the characters, and certainly with the music. Underlying that, it has such powerful and timeless themes—archetypes of struggle, betrayal, coming of age, death, and rebirth that are the foundation of all the myths around the world—an emotional resonance that pre-dates the film itself.

"You look at documentaries like [those made by] Disneynature and *Planet Earth*," the director adds. "You see how lyrical and fantastic nature can be when it's photographed and edited and scored skillfully, painstakingly creating compelling stories out of documentary footage. Now we have technology and tools and proven talent that could actually present the story in that way—showing these characters as if they were real, living animals. We could make it something that felt completely naturalistic, and real, and beautiful."

From the beginning, Favreau tasked his creative and production teams to craft a realistic-looking virtual-production film using underlying principles of traditional live-action filmmaking. He also started to examine the story and characters of *The Lion King* in its previous incarnations. As he researched the original feature's production, Favreau was told about a November 1991 trip that a group of Disney artists took to East Africa. There, the team not only observed animals in their natural environments, but also African art and culture, which manifested itself in the film in subtle ways.

Director Roger Allers recalls, "The whole experience helped bring everything into focus and allowed us to visualize the enchanted yet realistic Africa that we wanted as our setting. The movie wouldn't have been the same without that trip."

The group's tour guide also introduced them to an interesting local phrase: "Hakuna matata."

The filmmaking team decided that a research visit to Africa could be vital to the look and feel of his new production—and to the group culture of his filmmaking team.

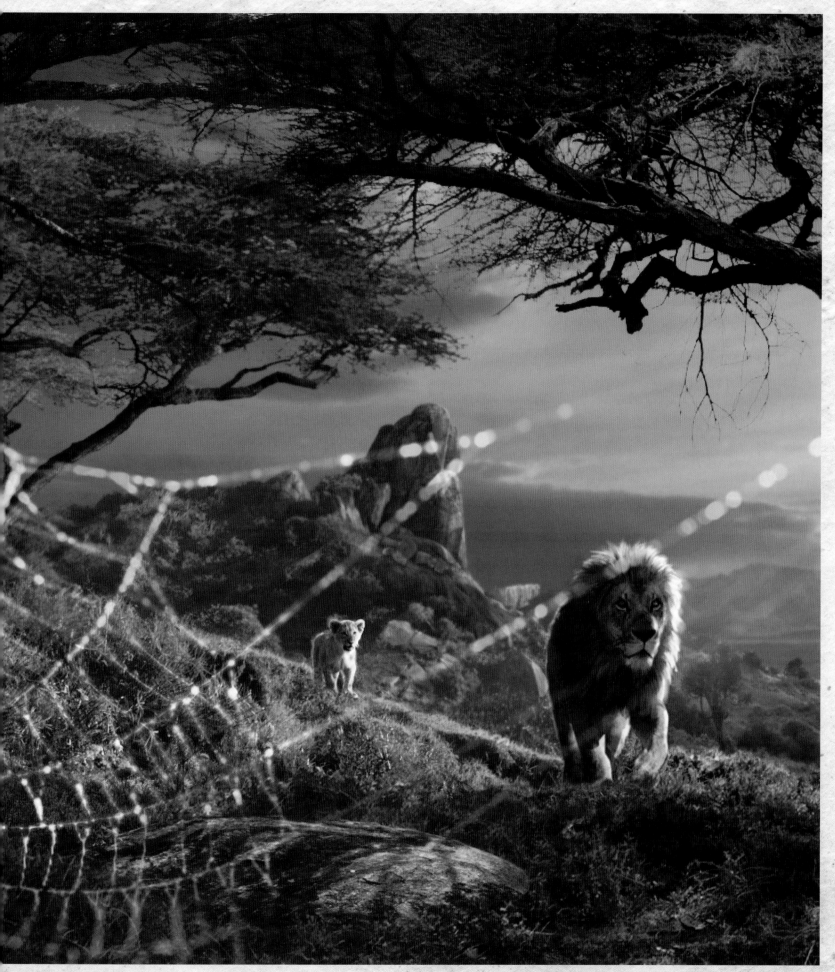

Father and son explore the African landscape. These designs were predicated on material and research about the terrain captured by filmmakers during their visit to Kenya.

Understanding and Creating a Place

The first thing the filmmaking team did was take an adventure of a lifetime in March of 2017—a journey across the southern portion of Kenya. The purpose of the trip was to gather reference footage, still photographs, scans, and other materials to apply to the digital moviemaking process. But there was an added benefit from this as well: the ability to immerse filmmakers in the visual and visceral nuances of the real environment at the movie's foundation.

Among those who went on the trip to, through, and around the famed Maasai Mara National Reserve, Mount Kenya, and other regions in or adjacent to Kenya and other parts of East Africa were cinematographer Caleb Deschanel, visual effects supervisors Robert Legato and Adam Valdez, production designer James Chinlund, animation supervisor Andy Jones, and several producers. In Kenya, Deschanel used an extremely high-resolution 4K Arri Alexa 65mm digital cinema camera to photograph the environment, skies, and animals to produce often stunning reference material, including some shots filmmakers later replicated

digitally. They also were able to scan rocks, mountains, trees, and flowers and capture data on sunlight, shadows, and other environmental elements to be able to precisely emulate them during various stages of production.

The experience was so influential on filmmakers that Deschanel insists the entire film "is essentially a tribute to what we discovered when we went to Kenya."

Above, clockwise from top left: Producer Jeffrey Silver travels Kenya's Masai Mara in search of reference material; executive producer Tom Peitzman with Silver and visual effects supervisor Robert Legato enjoying the filmmaking crew's detailed examination of Kenya via ground transport; Silver and Peitzman survey the land from helicopter; and Audrey Ferrara, the film's set supervisor from the London-based visual effects house MPC, recalls of the trip: "It was a lot of scouting to find the right species of plants but also the right environments. . . . It also helped us plan for the future. We scheduled another session with just MPC crew to go back to Kenya and have a more-extended shoot of all those references."

Opposite page, clockwise from top left: Cinematographer Caleb Deschanel photographs stormy skies on the research trip; visual effects supervisor Adam Valdez from MPC and animation supervisor Andy Jones research a forest terrain; Silver photographs at pale light; and Valdez photographs a desert topography.

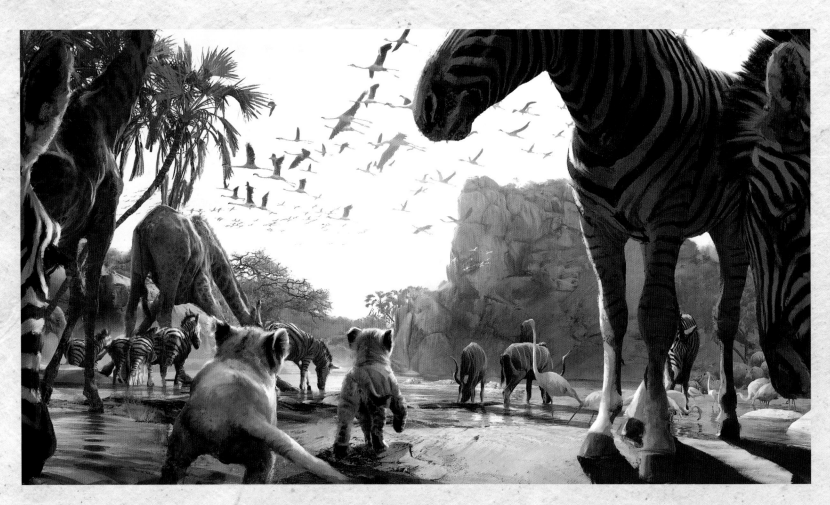

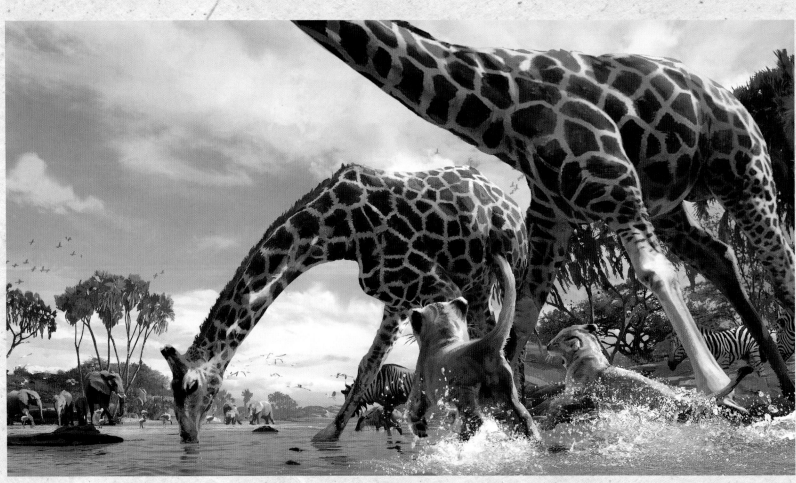

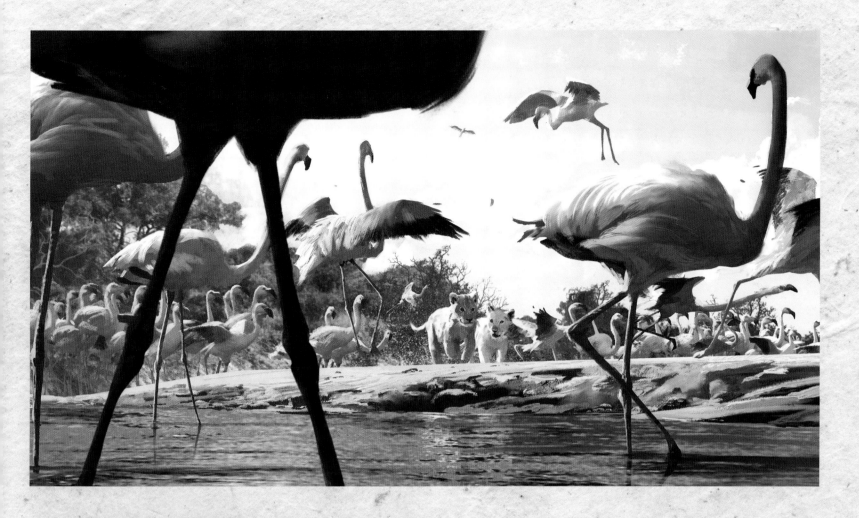

The Sweet Spot

James Chinlund was responsible for overseeing the design of entirely believable environments for each scene, all largely based to one degree or another on what filmmakers saw, experienced, and recorded during their Kenya/East Africa trip. He spent much of his time there in a helicopter, studying topography, mountains, and rock formations. Chinlund says that given the requirement to make audiences feel everything in *The Lion King* was real, the Kenya excursion was crucial to finding what he calls "that sweet spot" between the emotionally compelling, but artificial, world of the original *Lion King* story and the reality and beauty of the actual portion of Africa where the action takes place.

"The primary challenge was creating a world that delivered the familiarity of the world of the original [film] and the truth of the real Africa intersecting—that sweet spot in there that gives people the feeling this is a real place in the real world and still the world they know and love," Chinlund explains. "Therefore, the realities of what we found on the ground in Kenya were absolutely critical and integral to the design of the movie. It was very important to deliver a true feeling of Africa, and you could only do that by being familiar with the real thing."

Animal Instincts

For Andy Jones, the man responsible for supervising the animation team's painstaking efforts to make every animal movement believable, the trip was "all about the animals I encountered on safari.

"We just took as much footage and still pictures of the animals in their natural habitat as we could, and based on that, tried to get interesting behaviors recorded so that we could pull those from the library of material we acquired during our time there," Jones relates. "A lot of it was directly used for reference, and it was incredibly useful in animating these characters."

Producer Jeffrey Silver sums up the journey as "crucial to the visual DNA of the movie," emphasizing that the experience launched a photographic and emotional thread for filmmakers to follow throughout production of the movie in the virtual world.

Look to the Skies

Adam Valdez emphasizes that among the elements filmmakers experienced in Kenya that knocked his socks off were the panoramic African skies that are illustrated so realistically in the movie.

"Kenya is 'Big Sky Country,'" Valdez says. "The sky is wild and colorful and always changing. We visited savanna, mountain, deserts, and they were amazing, but what is common to all those areas is the sky presence. That aspect is present in all [real photography] we captured in Kenya and put into the film. That is something that would be hard to do on a soundstage with artificial light or CGI."

Pages 24–25: Animation supervisor Andy Jones captured tons of research photos on safari of Kenya's wildlife, which served as the basis of the concept art seen here, as well as final imagery of the film's wildlife.

Above and opposite page: The Kenyan skies, topography, and vegetation were meticulously photographed and examined by the film's production design and visual effects teams in an effort to ensure realism in every manufactured shot.

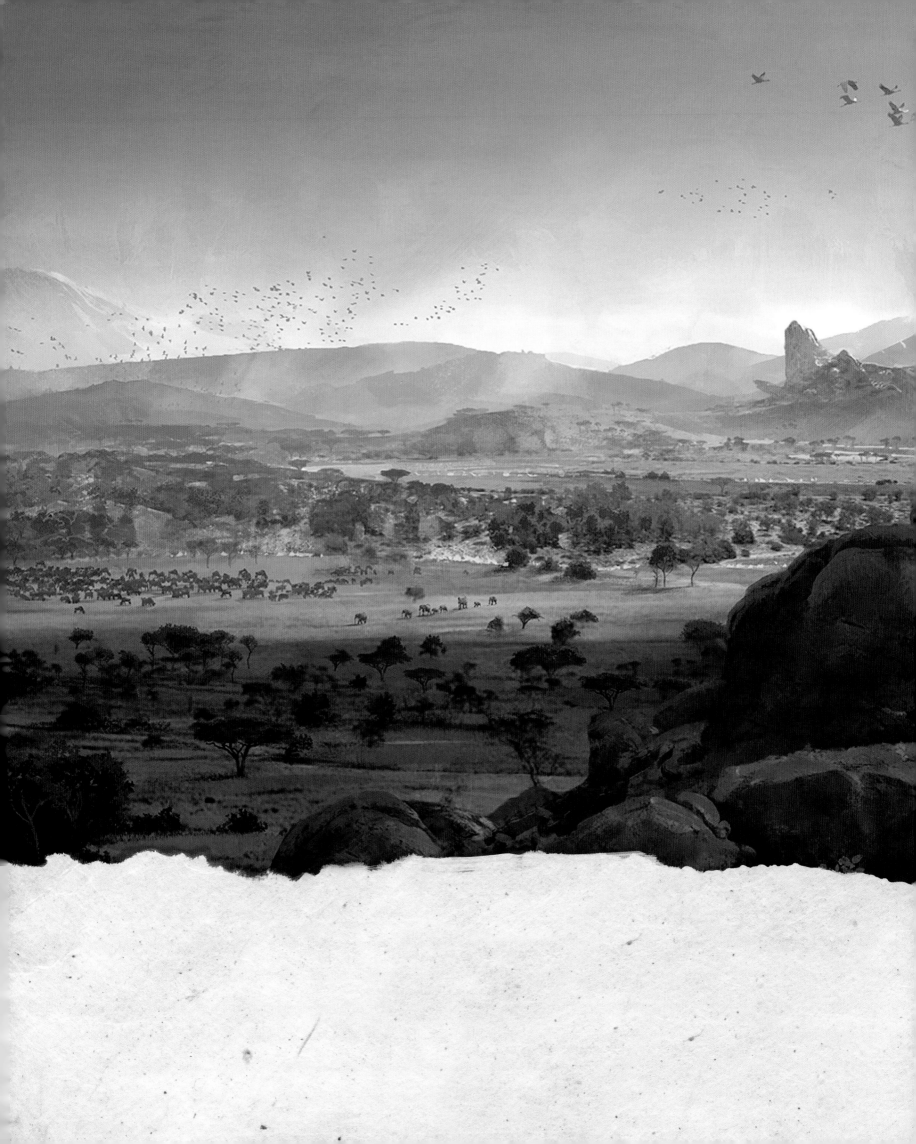

MUSIC IN
THE MYTH

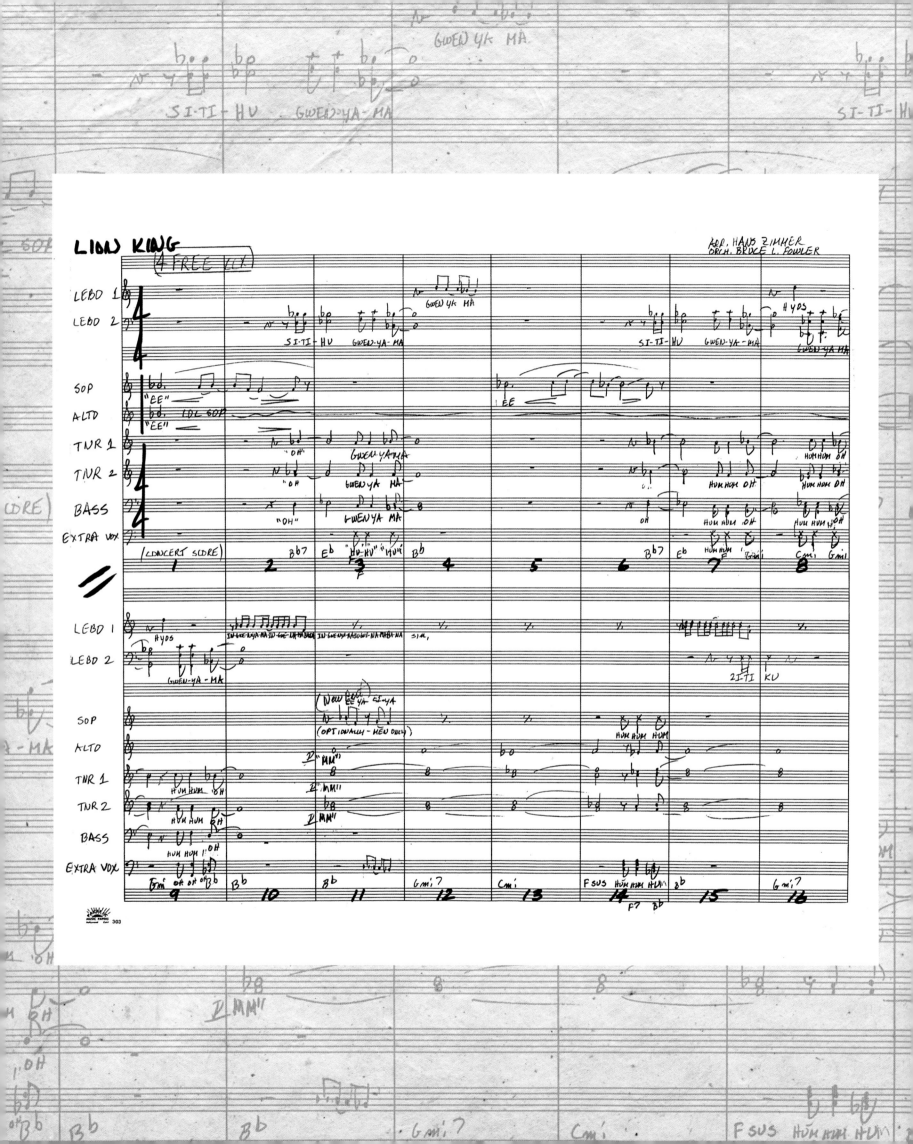

CHAPTER TWO

An Auditory Authenticity

Perhaps the most iconic and memorable component of *The Lion King* is not a visual, story, or character element.

It is a sound.

Specifically, a cry, a musical summons to the unfolding tale—sung-spoken in Zulu at the beginning of the film:

Nants ingonyama bagithi Baba!
Sithi uhm ingonyama

Nants ingonyama bagithi Baba!
Sithi uhhmm ingonyama
Ingonyama

Siyo Nqoba
Ingonyama
Ingonyama nengw' enamabala

The hand-written sheet music to the chant, known as "Nants' Ingonyama," that opens *The Lion King* (1994) immediately before the "Circle of Life" song was arranged by Hans Zimmer and orchestrated by Bruce L. Fowler.

Lebo M. Don Hahn

The opening to the chant, known as "Nants' Ingonyama," was was composed and performed by Lebohang Morake (aka Lebo M.), a producer and composer who arranged and performed music for *The Lion King* movies and stage productions, as well as the one who formed and conducted the original film's choir. "It was just something Lebo M. did, and it immediately took you to Africa," past president of Walt Disney Music Chris Montan recalls. "It is so deeply authentic. At that moment, *The Lion King* wasn't a bunch of Hollywood people trying to do what we thought Africa should be. It was someone with a deep-rooted knowledge and understanding of a culture voicing an almost timeless emotional expression about a place."

"That's the powerful, creative voice of Lebo M.," says Thomas Schumacher, producer and president of Disney Theatrical Productions and also executive producer on both the 1994 and 2019 *The Lion King* films. "That distinctive beckoning 'call to gather' symbolizes the elemental strength of the musical component of *The Lion King*. It's the moment when all of the music coalesced and made utter sense and elevated the entire enterprise. Much of the appeal of *The Lion King*, the core of its communicative potency, is its music. In many ways, music is the universal hook of the piece."

Lebo M. provided this coming together of the musical identity of the film. His experiences during the 1990s, as South Africa destroyed its inhumane apartheid practice of racial segregation and witnessed a new dawning of equality, are ingrained in his work. "Most of the music I wrote," he says, "and the lyrics and arrangements, are very much inspired by my life story and my background as a South African artist."

The unique blending of music from many different sources is one of the distinctive and unique components of *The Lion King*—a surprising result given the origins of the animated feature.

Musical Origins

"One of the things people don't usually know is that *The Lion King* was initially *not* a musical," Thomas Schumacher says. "It was going to be a nonmusical called *King of the Beasts*. It was, in a sense, a *National Geographic* special that would be animated. The story was a conflict between lions and baboons."

"Originally, it was thought of as a *Bambi* in Africa," co-director Rob Minkoff says. "More True-Life Adventure than mythical

Irene Mecchi

Roger Allers

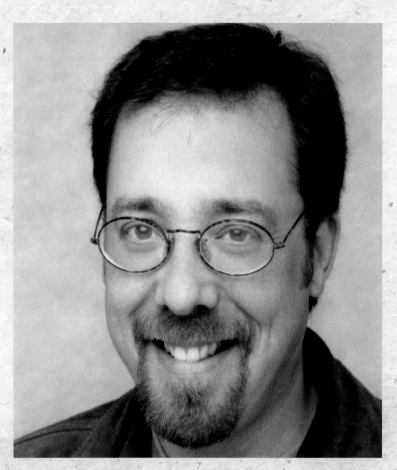

Rob Minkoff

epic. But when [fellow co-director] Roger Allers and I finally got together on it, we imbued it with the more spiritual elements that are a hallmark of the film."

"We wanted to do an animal picture based in a natural setting, but also a story that dealt with the issue of taking on the responsibility of adulthood and the larger issues of life and death," Allers says.

Screenwriter Irene Mecchi recalls, "You think you have a theme, and as the movie pulls together, it becomes more apparent in each scene—we were talking about responsibility a lot . . . in every scene, you can see characters being responsible or not responsible, and what the repercussions of those choices are."

Somewhere in the midst of all of this, Schumacher recalls a transforming idea. "It struck me that this story could be a musical.

"Tim Rice had come to work at the studio—he and Andrew Lloyd Webber had sold the film rights of their musical *Evita* to Disney, and in addition, he had been hired to consult on a number of other things; he was sort of 'at large' around Disney. I asked, 'Could this thing be a musical?' Tim said, 'Dear boy, anything can be a musical. Look at *Evita*.' He had a point."

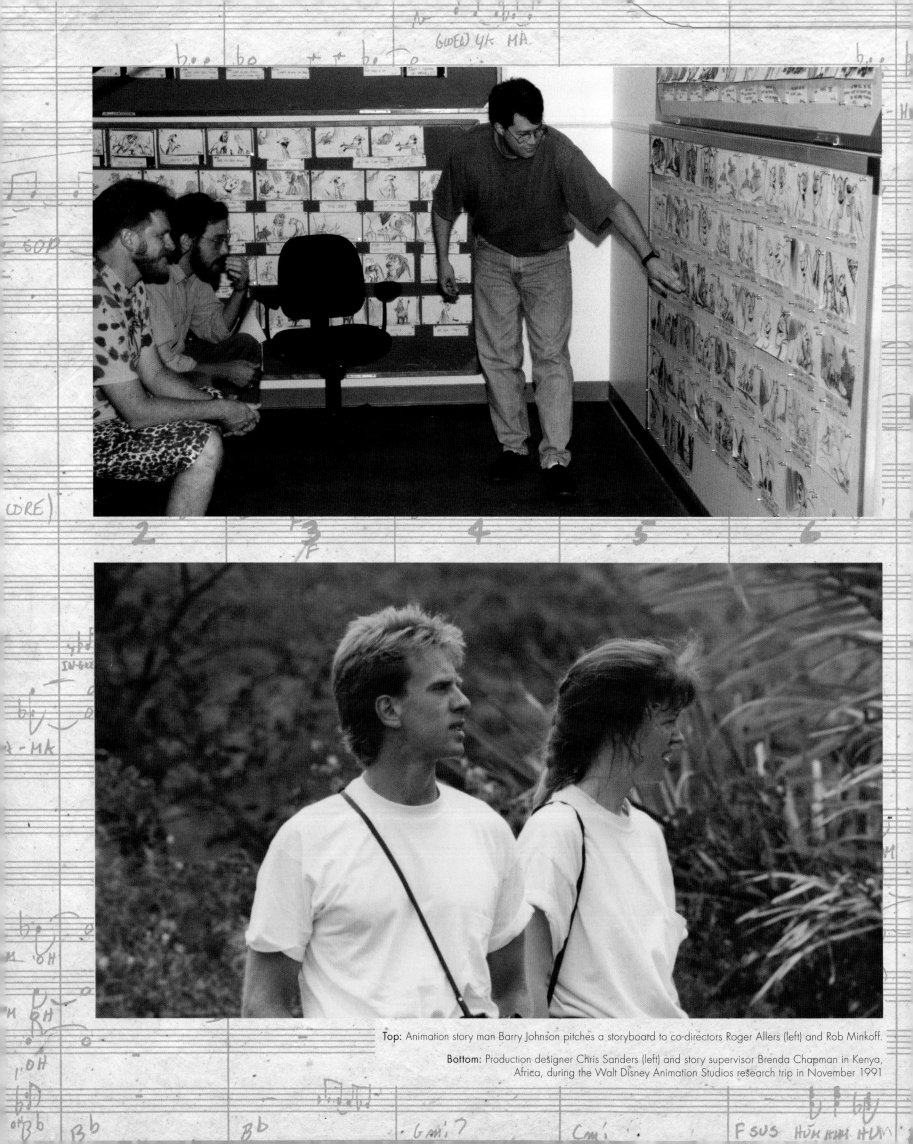

Top: Animation story man Barry Johnson pitches a storyboard to co-directors Roger Allers (left) and Rob Minkoff.

Bottom: Production designer Chris Sanders (left) and story supervisor Brenda Chapman in Kenya, Africa, during the Walt Disney Animation Studios research trip in November 1991

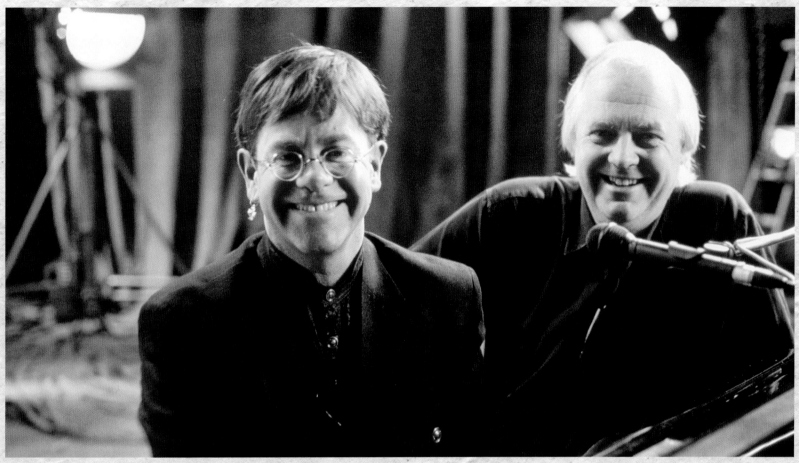

Enter Elton

"It was Tim [Rice] who suggested Elton [John] for the job," Rob Minkoff recalls. "Tim right away said, 'Elton John. If you could have anybody in the world, go for Elton John,'" Thomas Schumacher concurs.

"Elton, to me, seemed the obvious answer," Rice says. "I'm not sure that Disney would have necessarily thought of Elton, but I think that was perhaps my biggest contribution to the project. What Elton has—and it really doesn't matter if you regard Elton as a great 'rock artist,' which he is—[is] he's actually a great 'tunesmith.' He writes wonderful melodies that work whether you treat them as standards, with a 'theatrical' treatment, or whether you look on them as just great rock numbers. A song such as 'Sorry Seems to Be the Hardest Word' or 'Your Song' or 'Sacrifice' will work in almost any context. They are such great melodies . . . I wasn't deliberately trying to break through with rock in Disney movies. I just thought, 'This is a great *composer*.'"

John remembers, "Tim Rice rang me up and said, 'Listen, would you be interested in doing an animation film for Disney, writing the music if I write the lyrics?' You know, they really didn't have to sell it to me. I mean, I was in from the word 'go.' It came at a time in my career where I thought it would be a challenge to do something different. The animated movies were legendary, and classic, and so *good*, it was a challenge for me to rise to the occasion."

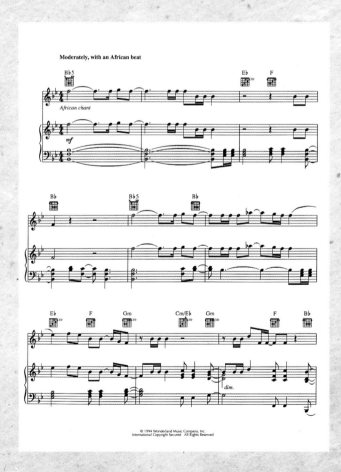

Story and Style

Rob Minkoff recalls, "After working on the story together, we divided up the sequences so that each one had either Roger [Allers] or me leading the way. For example, Roger did 'I Just Can't Wait To Be King' and I did 'Circle of Life.'"

Allers adds with a knowing smile, "Actually, we did 'Circle of Life' together, then we split up the film by sequences, being particularly careful that we each had scenes that really spoke to each of us. We worked side by side on story, music, and editing, while such things as animation, backgrounds, et cetera, we gave to separate domains according to the sequence."

Irene Mecchi says, "Collaboration is an extraordinary way to make a movie, and it's not the way most Hollywood pictures are made. And I think by nature of the personalities that came together, and the fact that we had leadership that was inspiring us every day, we formed an evolving consciousness about the movie so that when you see it, you don't really remember who was responsible for what, because everyone built on the other ideas. As a screenwriter who's usually greeted with 'Thanks for the script, goodbye now,' I was blessedly involved with aspects of the film that normally a writer wouldn't be."

Through the development of the screen story, the musical storytelling evolved in parallel. Tim Rice became a sort of musical "point person" as the production went on, shifting lyrics, changing musical elements, and collaborating directly with Elton John.

John focused on music that supported the story, but with a unique viewpoint. "A little less Broadway, much more 'pop.' But things like 'I Just Can't Wait to Be King' and 'Hakuna Matata' were just fun things—they owed a lot to *The Jungle Book*," recalls John.

The lengthy story and production process was not without its collateral damage. "At one point, I think I was going stark raving mad because I was writing about warthogs and things like that," John says. "And I was thinking, 'Oh my God, at this stage of my career I'm writing about warthogs?' But really. I was laughing about that."

This page: Visual development artwork for the 1994 animated feature.

Opposite page: Visual development artwork by Hans Bacher.

Page 38: Color keys by Chris Sanders.

Page 39: Top six storyboard drawings by Barry Johnson, bottom two drawings by Brenda Chapman for "I Just Can't Wait to be King."

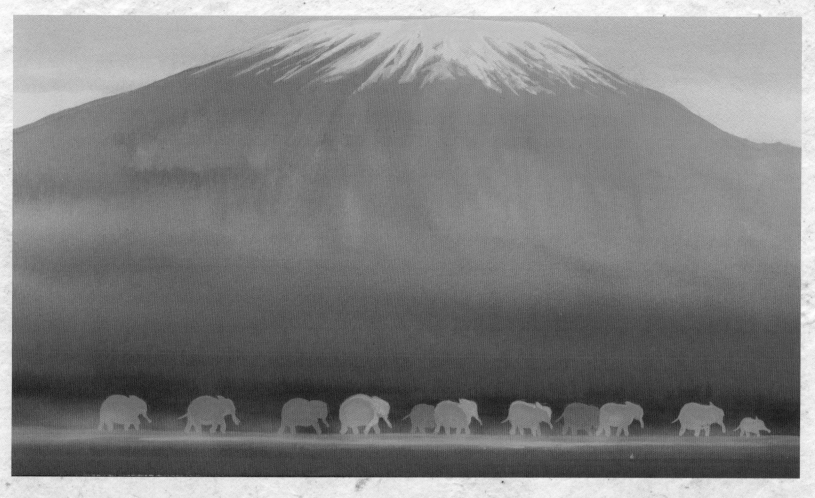

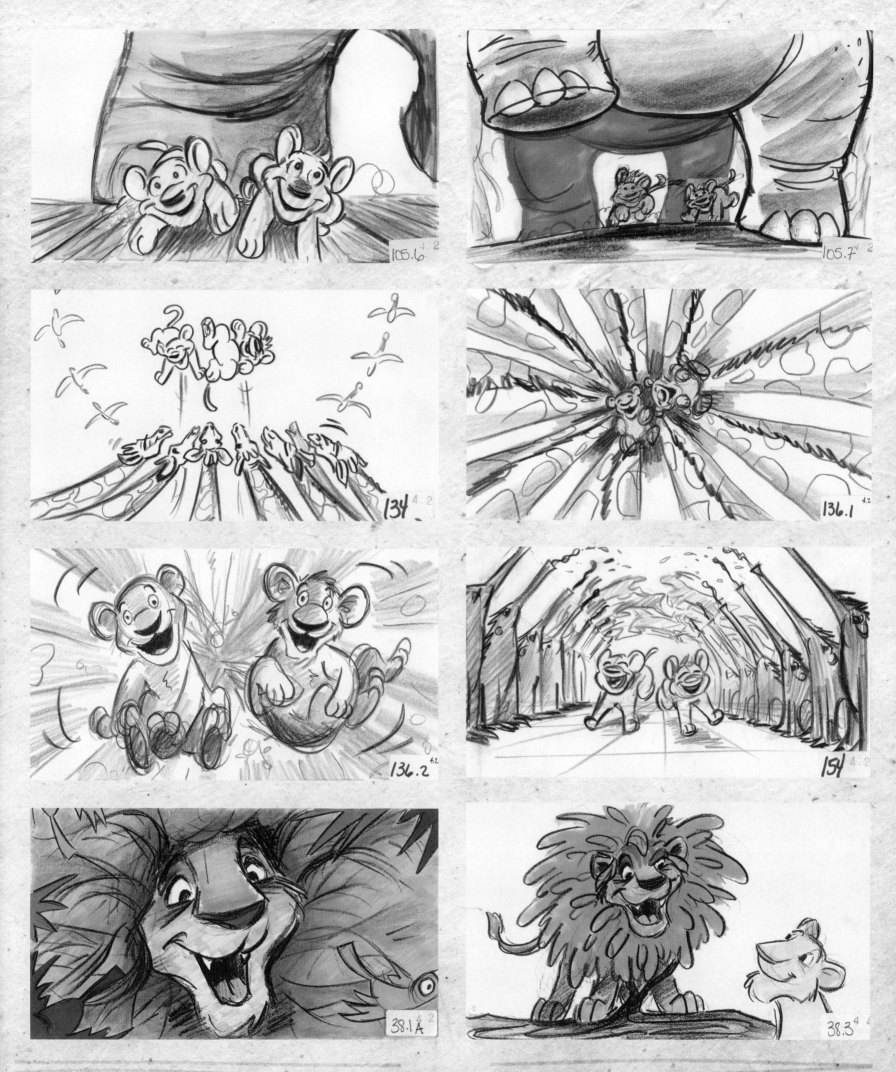

A Musical Pulse

"One of the things that was clear to us early on was that the great songs from Elton [John] and Tim [Rice] were only part of the larger musical voice of this," Roger Allers says. "We knew we wanted a *pulse* to go through it. An organic underlying heartbeat, a *feeling* that would live inside it. We didn't want to be utterly authentic as much as accurate—almost a fairy tale of African sound."

"Me, [producer] Don Hahn, and Roger wanted Hans [Zimmer] based on his work in *The Power of One*," Minkoff says. Zimmer had deeply invested in a musical culture for that film, utilizing vocal and musical talents and styles from South Africa to give depth and integrity to the storytelling of his score. "That score also featured [producer and composer] Lebo M. Their collaboration on the score and musical elements really brought the story to life and gave it its enduring power."

"We asked Hans to bring together the songs and score in an utterly distinctive way," Hahn says. "We felt he could seamlessly bring every seemingly disparate musical element and need into something completely fresh. It was Hans that introduced us to the amazing Mark Mancina and the remarkable Lebo M."

"Hans really brought the movie to life via the music," Minkoff says. "It was his ability to [provide an] authentic flavor that really made the film come to life musically. Mark Mancina was working for Hans at the time and also contributed greatly to the *feeling* of the movie. He also was musical director and composer for the stage production. As for his experience as a live-action composer, I think there is very little difference in how a composer works on animation and live-action, although typically an animated score is more closely married to the images. It was a terrific collaboration."

Zimmer and Nick Glennie-Smith focused on the orchestral score elements while composer and arranger Mancina faced the challenge of creating unique arrangements and components for the songs, bringing a stylistic unity to a disparate song list. "If you look at the range of music in *The Lion King*, we have everything from British pop songs to musical comedy to traditional African elements—it goes all over the place," Mancina says.

The addition of Lebo M. to the team proved to be a creative catalyst. He had worked with Zimmer, infusing authenticity into the score for *The Power of One*, and his is the first voice heard in the beginning of *The Lion King*, singing that call to gather which is now synonymous with the identity of *The Lion King* in popular culture.

"That element is never dubbed or translated," Thomas Schumacher says. "No matter what language the film is in, that's Lebo calling at the top, as the sun rises. Lebo became a through-line for that musical and emotional quality inside the film."

"Elton and Tim's songs help tell the story with humor and heart while Hans's brilliant score and arrangements (along with Lebo M.'s choral work) gave it its scale, drama, and *placed* it in Africa," Allers says. "Mark Mancina's arrangements of 'I Just Can't Wait to Be King' and 'Hakuna Matata' gave the film its moments of playfulness."

"That collaboration created a very specific and unique environment," Chris Montan says. "Music can do that, if it's real. If it's phony, it will knock you right out of the movie. That's why Lebo, and his influence, and the collaboration between [him] and Hans and Mark was so important. The music really established our own sense of place."

A Musical Phenomenon

The music of *The Lion King* was a complete phenomenon in popular culture. Much like the source film, which had smashed every

record in its path, the soundtrack recording shipped more than ten million copies in the United States alone, and eventually achieved Recording Industry Association of America (RIAA) "10× Platinum in 1995" (Platinum signifies sales of a million units), becoming the biggest-selling soundtrack ever from an animated film. When the RIAA instituted its "Diamond" certification in 1999, the recording was promoted to that status.

The music of *The Lion King* won the Golden Globe for Best Original Score and two Academy Awards, for Best Original Score (Hans Zimmer) and Best Original Song, "Can You Feel the Love Tonight" (by Elton John and Tim Rice). "Circle of Life" and "Hakuna Matata" were also nominated. "Can You Feel the Love Tonight" also won the Grammy Award for Best Male Vocal Performance.

In addition to its awards, it's safe to say that the music of *The Lion King* was also transformative to every notion about the scoring for animated films—and for musicals, and even for the accepted archetypes for film scoring overall.

MUSIC INSPIRED BY

Disney
THE
LION KING

RHYTHM
of the
PRIDE LANDS

Album artwork for the 1995 Walt Disney
Records release, *Rhythm of the Pride Lands*

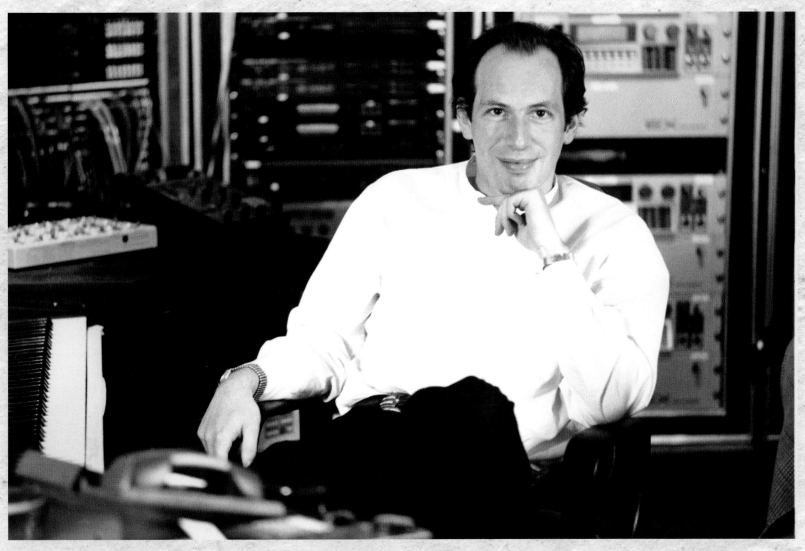

Hans Zimmer

Musical Momentum

With the release of the film, the public responded enthu-siastically to the music and its unusual hybrid musical style. "Elton [John] and Tim [Rice]'s pop songs were, as we expected, gigantic successes," Thomas Schumacher says. "'Can You Feel the Love Tonight' and 'Circle of Life' shot up the charts and got a great deal of attention, but at the same time, the work of Hans [Zimmer] and Mark [Mancina]—somewhat unexpectedly, from a consumer music viewpoint—got enormous reaction."

In fact, the hunger for more of the unusual music mixes of *The Lion King* led to the creation of a spin-off "soundtrack," a concept album called *Rhythm of the Pride Lands*. It had additional music from the film soundtrack, as well as new music inspired by—and from—the same music creators as the soundtrack. Schumacher says, "It hit a chord that was already in the culture at the time. The great sound of South African male choral group Ladysmith Black Mambazo came to prominence with Paul Simon on his 1986 album *Graceland*, and wide audiences were hearing the vocal styles of *isicathamiya* and *mbube*.

"The musical environment of the late 1980s had set the stage for an amazing confluence of acceptance and appetite for what we were creating," Schumacher contends. "In many ways, it was that continued musical exploration that led to the distinctive creative approach and sound of the Broadway stage musical of *The Lion King*."

Mark Mancina agrees. "We all contributed to that album, but it's really Lebo's record, though. He's all over it, all of the African lyrics—he came up with such beautiful music. I think that [director] Julie Taymor—hearing that is what made her want to do *The Lion King* as a stage play, probably more than just having seen the film."

The Pride Lands Onstage

"To go back into that world again was about the last thing I wanted to do," Mark Mancina says of joining the stage musical development. "I had a very successful film career happening, and I didn't want to leave that—but I went to one meeting with Julie [Taymor], and the first thing she said was, 'I don't want to revisit the film.'"

Taymor instead was interested in pulling apart the entire thing and examining how it could be reassembled and reimagined for the stage, with a more deeply authentic flavor of Africa. Mancina recalls Taymor saying, "'I want to really explore Lebo's role and Lebo's part, and I want to bring an organic nature to the music.' At the time we did the film, technology wasn't where it is now, and we weren't able to do quite as 'organic' as we wanted to.

"I felt that when we did the film, what Lebo brought to the score was so great, I wished there'd been a lot more," Mancina adds. "So, when I had my initial meeting with Julie, that's the first thing she conveyed . . . she wanted to do a new score with new songs and new pieces, and that's what got me really excited about it. After talking to her for about fifteen minutes, I was just completely on board, because I knew that we were going to open up the boundaries in a lot of new ways, and not just visually."

Lebo M. emphasizes, "I knew that this thing shouldn't be anything like what is normally done on Broadway. From my perspective, the feel and vibe of this whole show had to be organic, to be as realistic and true to African music and the African creative experience as possible. And that's why I enjoyed working so closely with Julie on the choreography and design of the show, including the visual and musical aspects of the drums, because it was not a strange concept to me. So I was able to arrange the rest of the music, and especially the vocal ensembles, around that."

The varied styles of the music created even more complexities in adapting and expanding the music for the stage. "It's not just a marriage between African and Western, but between so many cultures," Mancina points out. Pop sensibilities had to merge and blend with everything from reggae and country to surf music and zydeco, tango, hard rock, and Chinese opera.

And this had to be done in front of an audience, eight performances a week.

"It was an interesting problem, but it was exciting and organic," Mancina says, "because it was all played, live, every night."

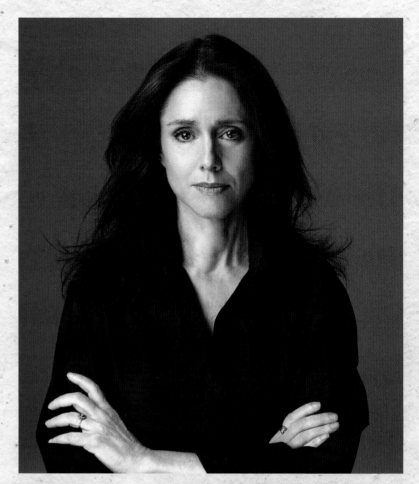

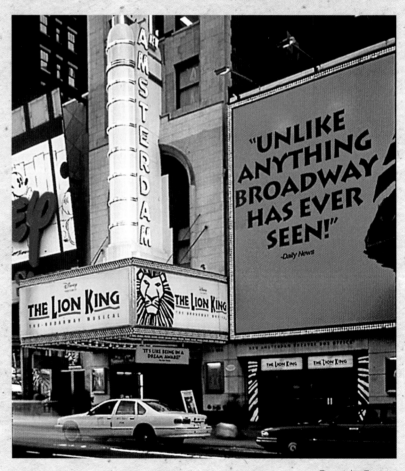

Top: Julie Taymor

Bottom: The New Amsterdam Theater, original Broadway home of *The Lion King*

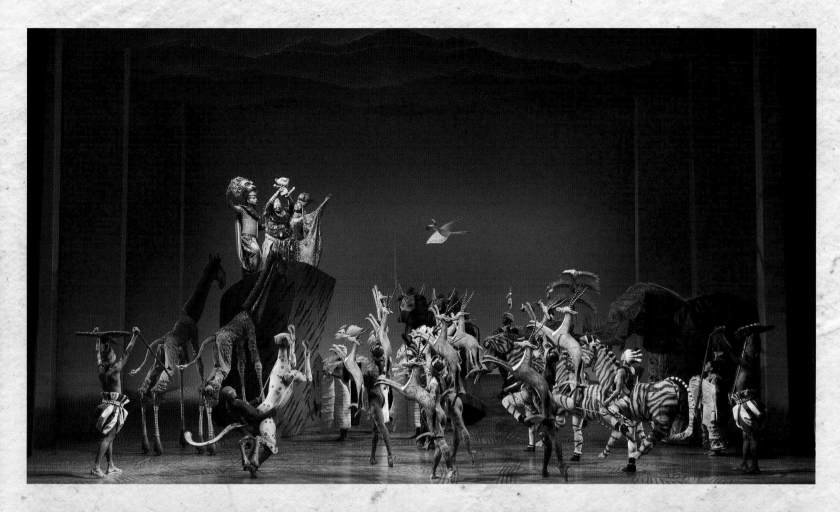

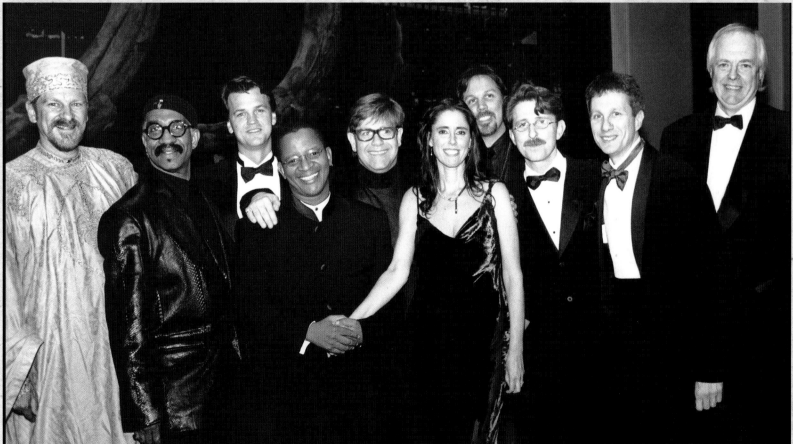

Top: The "Circle of Life" comes to life on the stage.

Bottom: Part of *The Lion King* Broadway creative team on opening night, November 13, 1997: (left to right) Roger Allers, Garth Fagan, Michael Curry, Lebo M., Elton John, Julie Taymor, Mark Mancina, Thomas Schumacher, Peter Schneider, and Tim Rice

Chris Montan

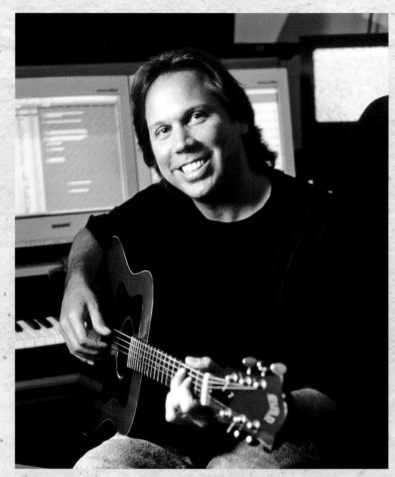

Mark Mancina

The Meaning in the Music

To less hardy souls, the incredible depth of the music of *The Lion King* might have been intimidating. Jon Favreau and his team instead saw it as a vital organic component of the story itself. From their perspective—engaged in a "retelling"—the cultural might of the music was actually both an asset and a storytelling "short-hand" of sorts.

"Just hearing that music strikes you deeply," Favreau says. "Even if you don't know the film or stage show, there is a spiritual strength in it. But if you know the film, and if you grew up with this music—now it can suddenly and immediately evoke the story itself, as well as all the connected memories and emotions that you have from your own past experience with *The Lion King*, or from the time of your life that you were in, or your childhood, or the life events it's connected to."

"Music has always been more important to Disney films than any other," Chris Montan says. "It's a critical creative component of Disney films. Music is part of the mix much earlier in development, and we invest more time and effort and talent into using music to tell our stories. If there's any better representation of the power of Disney music than *The Lion King*, I'd be hard-pressed to say what it is."

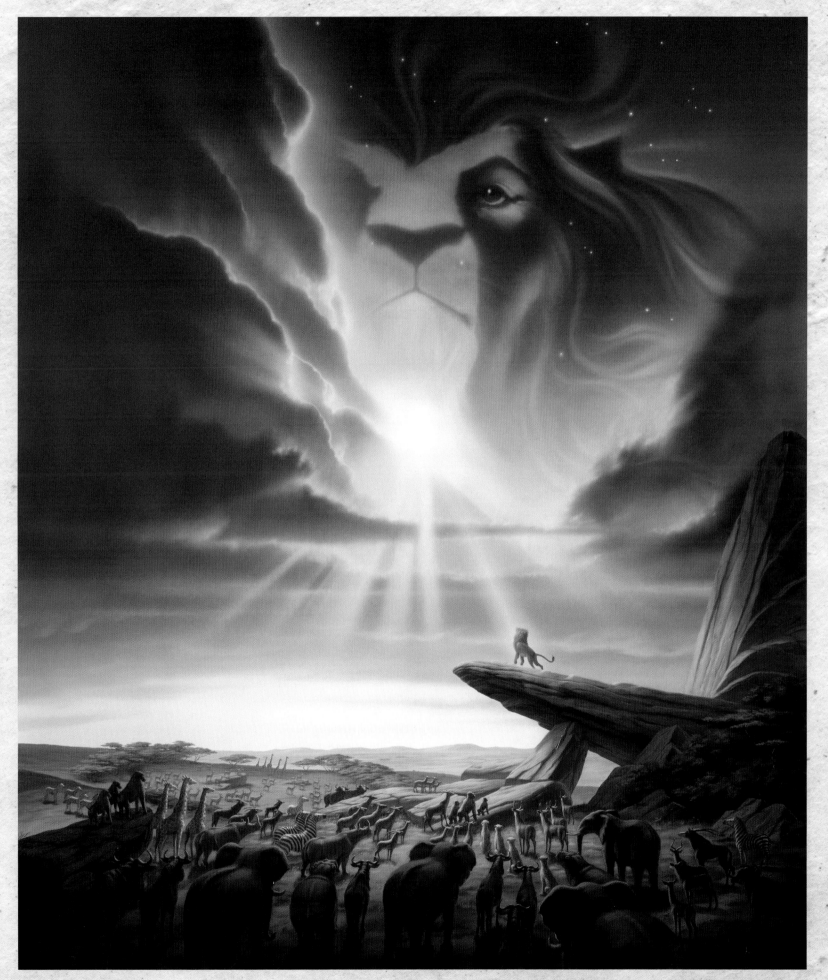

Motion picture marketing key art from the original release of *The Lion King*, 1994.

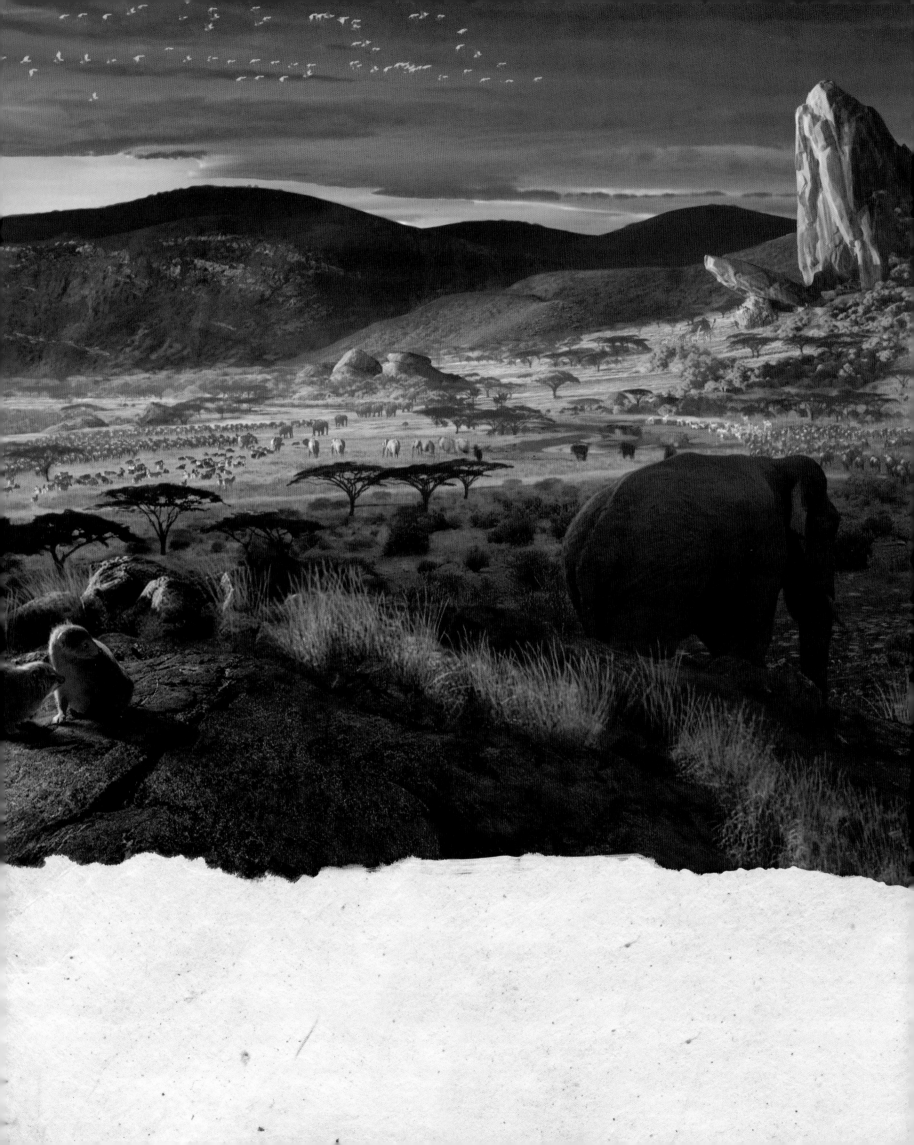

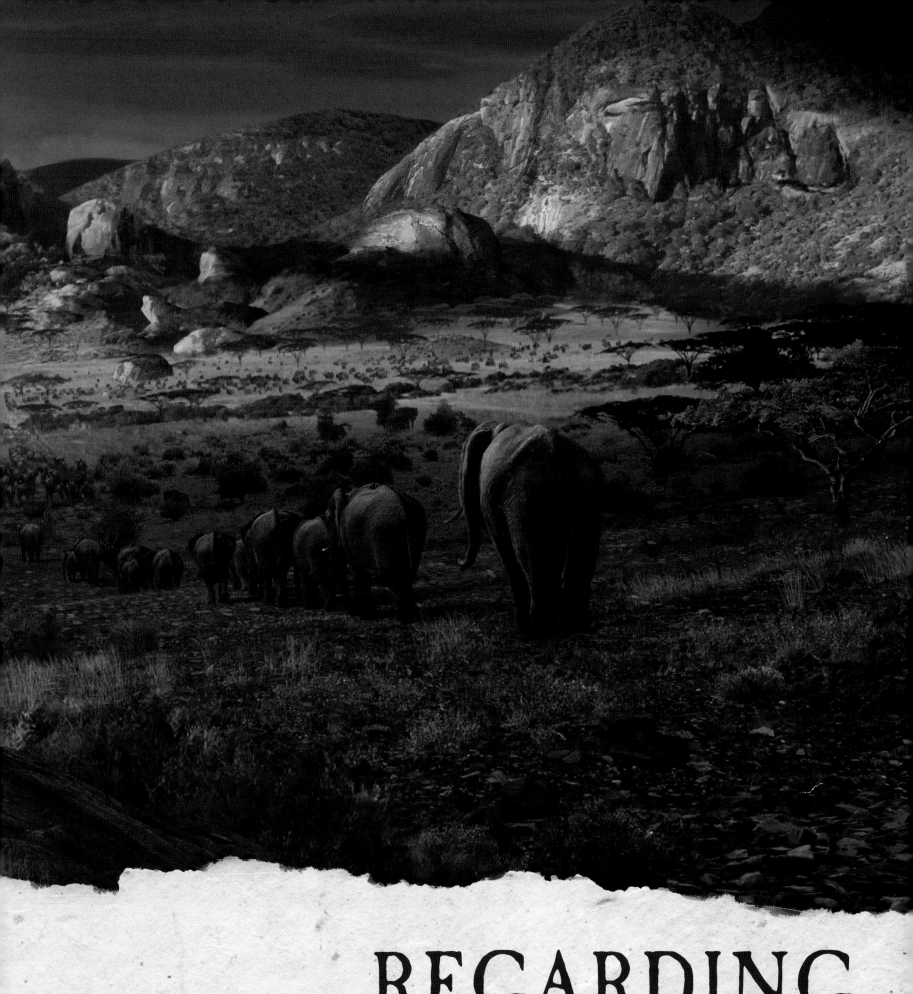

REGARDING
A LEGEND

CHAPTER THREE

A Personal Myth

The Lion King has entered the pantheon of cultural mythology. It is for today's world as much a part of the zeitgeist as any fairy tale by the Brothers Grimm or Hans Christian Andersen. In fact, for today's audiences, it likely is a much more *personal* myth, with far more currency than any fairy tale.

The adaptation and evolution of its story is a large part of the power in *The Lion King* and its connection to world mythology, as well as its continuing innovations in terms of finding compelling new ways to present the story to audiences that make it seem as modern as tomorrow.

Method to the Myth

"These stories have been passed through time, like a torch being handed from generation to generation," writer and Disney historian Craig D. Barton says. "While themes and certain elements are carried through, a story seems to take on new life with each retelling. Sometimes changes are adapted to fit the culture in which they are shared. For example, in early Asian Cinderella stories, the fairy godmother was a fish! In others, these changes conform to the current time period."

Thomas Schumacher agrees. "*The Lion King* certainly echoes the great fairy tales that have become major Disney films, such as *Snow White and the Seven Dwarfs*, *Cinderella*, and *Sleeping Beauty*; [they're] stories that scholars such as Bruno Bettelheim, in his *The Uses of Enchantment* [a psychological interpretation of fairy tales and how they function in children's lives], cite as cultural archetypes over [the] centuries."

Early photorealistic rendering of Pride Rock from *The Lion King* (2019).

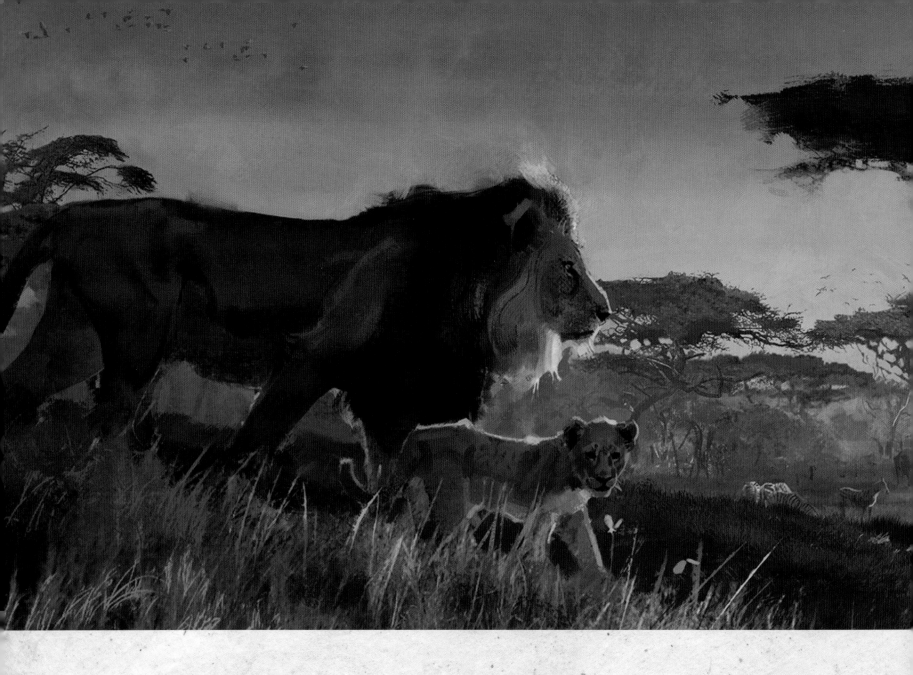

"It deals with those themes of growing up," Don Hahn adds. "And so it's endlessly relatable that way. We dealt with the relationship and the death of his father on screen, in a really open way. And then, even more so than *Bambi*, we dealt with grieving after that process—Simba going into the wilderness, which is almost biblical. So I think people relate to those big, mythological, thematic moments. But simply on an emotional level, just the idea that we're not alone in the world. We're part of a lineage that we are our father's sons, that we have our own children and pass on our aesthetic and ethics to them. And I think that kind of taps into something pretty deep for people."

"It is also a legendary 'hero's journey,' a central theme of epic world literature that mythologists such as Joseph Campbell in his *The Hero with a Thousand Faces* analyze," Schumacher emphasizes. "His theory is that tales of heroes of all kinds, from Buddha and Krishna to Jesus, all share a common mythological root, a primal idea that affirms in man how experience transforms us from a childlike being into an adult.

"In addition, *The Lion King* connects itself to innumerable primal mythos, whether those are biblical narratives, such as the lives of Joseph and Moses, or great works of literature, from medieval epics to Shakespeare's plays," Schumacher continues. "Of course, the *Hamlet* angle gets talked about because of the killing of the king by his brother, and the avenging son. These are also fundamental elements of the *human* experience, not just Shakespeare: betrayal, redemption, acknowledgment, and acceptance.

"*The Lion King* is all these things and more. A secular tale of faith. A mythos of morality for adults who have now grown up with the story from the time of their childhood," Schumacher

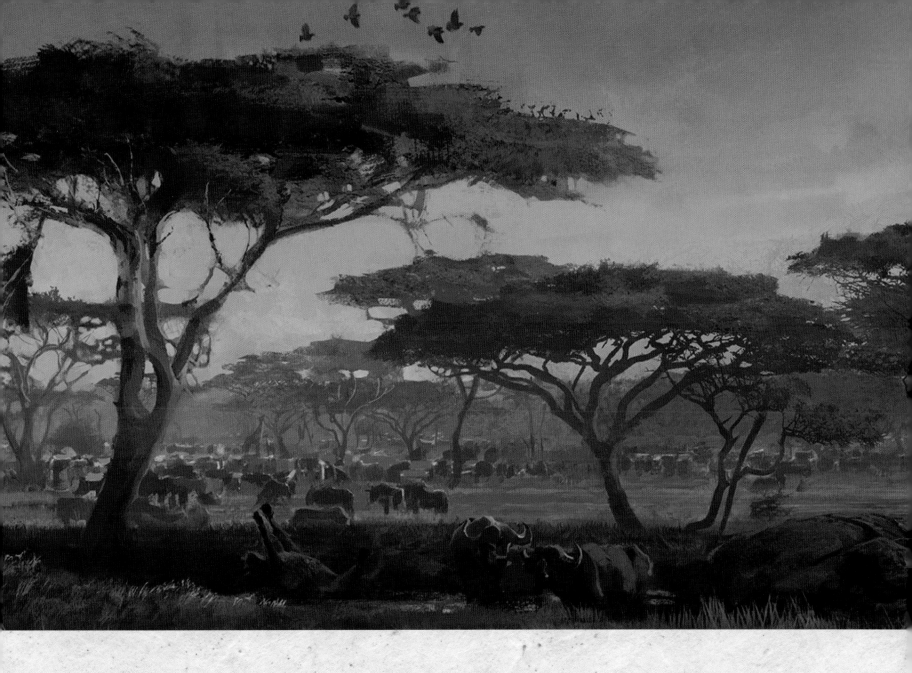

observes. "Because of its powerful themes, music, and the global reach of Disney, so many cultures *own* this property."

Moving the Myth Forward

Jon Favreau understands the proprietary feelings of audiences around the world. He says, "I think part of our responsibility here is to present this as yet a third medium [after the original animated film and the stage production]. If we can retell the story in a whole different way, and have the experience feel completely different, my hope is that fans of the other two versions of this story will be drawn in and find value in what we are doing and see that it does not feel like it is trying to replace anything else.

"They will [hopefully] see it as just another expression of a timeless story that I think we owe to each generation to tell," the director says. "Because the story really speaks to strong themes that I, as a dad and fan of the Disney movies, think deserves to be echoed out to this [new] generation."

Above: Every detail of the African savanna, from individual blades of grass to tree branches to water, sky, and light elements were based on reference material and observations gathered by the filmmakers in Kenya and applied even to the concept artwork, as shown here.

How *The Lion King* Came Alive

During a March 2018 visit to the nondescript industrial warehouse in Playa Vista, California, where *The Lion King* was being "shot," Robert Legato, the movie's visual effects supervisor and mastermind of the so-called virtual production methodology used to reimagine the iconic story, was asked to contextualize how, exactly, *The Lion King* could be called a live-action movie, given the fact that it was made entirely inside computers. In response, Legato invited the author out to the facility's parking lot one afternoon. There, a film crew was snapping together approximately 130 feet of dolly track, running almost the entire length of the parking lot, prepping to capture what very much appeared to be a live-action moving camera shot. Since the production required no physical cameras, stages, actors, lights, or elements, what was the purpose of a real dolly track? A dolly, after all, is essentially a cart that rolls down such a track carrying a moving camera, something that has been used for generations in live-action filmmaking. What relevance could it possibly have for *The Lion King*?

Tradition Meets Innovation

Inside Robert Legato's head, the question was elementary—at least to him, the purpose was glaringly obvious, even if its industry implications are likely to reverberate. *The Lion King* is similar to a live-action movie, he suggested, because the filmmakers' interaction with traditional camera tools to create elements that will be edited together into an emotionally compelling narrative is "a live interaction" happening in real time with real-world tools in an organic fashion, exactly as happens on movie sets.

In other words, to make *The Lion King*, seasoned filmmakers utilized common filmmaking tools in the real world in real time, viewing initial versions of the digital images they were "photographing" through virtual reality goggles, while sophisticated data-capture systems recorded every aspect of their movements and all their creative decisions. That permitted those movements to be replicated in a computer and applied to photo-realistic locations and characters created using the world's most advanced computer graphics techniques. This is called "virtual production," and while not brand-new, per se—as the process builds on the shoulders of work done by the original *Avatar* in 2009 and the 2016 *The Jungle Book*—*The Lion King* definitely takes the concept further than ever before.

"It's no different than why we still call movies 'films' even when they are, in essence, recorded and processed differently today without [typically] using actual motion picture film," Legato says. "A 'film' today actually is a term that describes what the experience feels like [to the viewer], and what the net result will be, rather than describing the actual technical processes anymore. In our case, 'live action' describes the same thing—it's a net result. While [some of] the tools and processes are new and state of the art, the artistry itself and the net result are exactly the same as on a traditional live-action film."

Physics and Cinematic Vernacular

To illustrate all this, Robert Legato patiently explained what was going on in the parking lot that day, and why it was important. Filmmakers, he said, had been working to permit award-winning cinematographer Caleb Deschanel the ability to apply a so-called dolly move motivated by real-world physics to any shot that might require it inside the virtual world where *The Lion King* was coming together. Thus, they intended to move an actual dolly a particular way and capture data their computers would eventually interpolate into an exact digital replica of that dolly move.

"We're capturing inertia of the camera, because that is what we are used to seeing in a movie," Legato explained. "If we just do the [camera move] in a computer, the virtual camera dolly has no weight, and it moves more like [what] would be evident with a computer program. Therefore, in the movie, if the camera is following a charging animal as fast as the animal can go, and then tries to stop its mass once it is up to speed, we want to do it as if it has real-world inertia. And so, instead of applying motion capture data from actors, as they do in many movies, we are capturing data from the movement of a real-world camera dolly pushed by three men as fast as they can, and then slowing up, and applying that to the virtual camera."

The Language of Cinematography

The dolly move wasn't the only area where this strategy was being utilized. Inside the Playa Vista building, in the primary shooting area—called the OptiTrack volume, named for the OptiTrack Active Tracking motion capture system supplied by an Oregon-based company called NaturalPoint and used by filmmakers to precisely track camera movement data—production staff was using

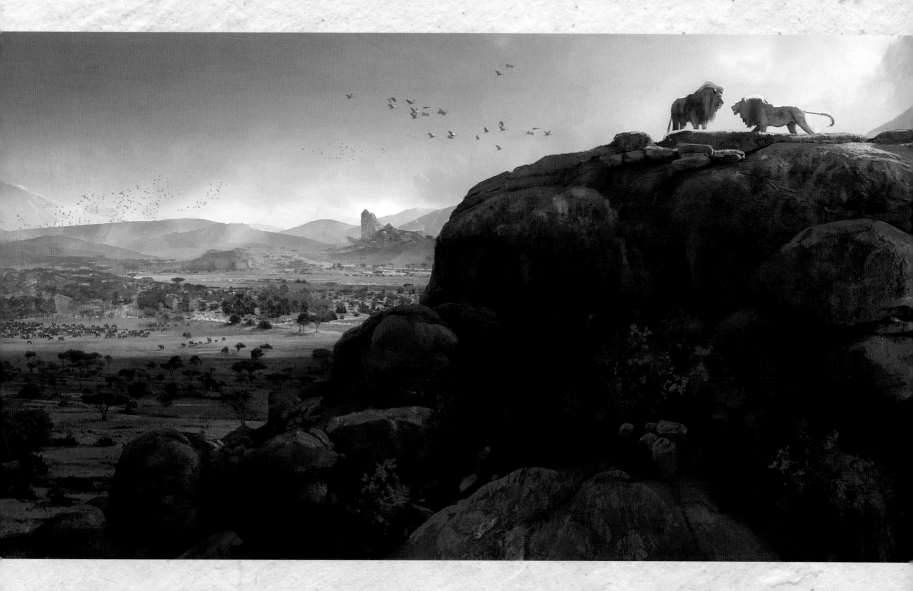

the same approach to capture movement of all manner of traditional camera control systems operated by Caleb Deschanel and others. This included Steadicam shots—essentially a moving camera harness normally worn and manipulated by a skilled camera operator in a live-action movie. Typically, a remotely operated flying drone would carry a small camera while flying over an exterior location or set to capture certain kinds of aerial shots. On *The Lion King*, as "something of an experiment," according to Deschanel, his team decided to try out the idea of flying a small consumer drone inside the volume, with sophisticated sensors attached, bouncing data to over sixty OptiTrack motion-tracking cameras built into a ceiling truss inside the volume.

The experiment worked, and filmmakers were able to build an exceptionally realistic camera move for the iconic extended shot early in the movie in which the flying character Zazu soars over the Pride Lands before landing on Pride Rock and bowing to Mufasa.

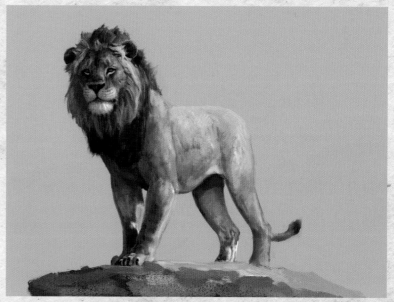

Top: A wide shot visual development piece depicting the beginning of a confrontation between Mufasa and his brother Scar. The filmmakers were then able to manufacture all manner of realistic camera moves, exactly as professional camera operators do them, using the virtual cinematography technique.

Bottom: Concept artwork of adult Simba

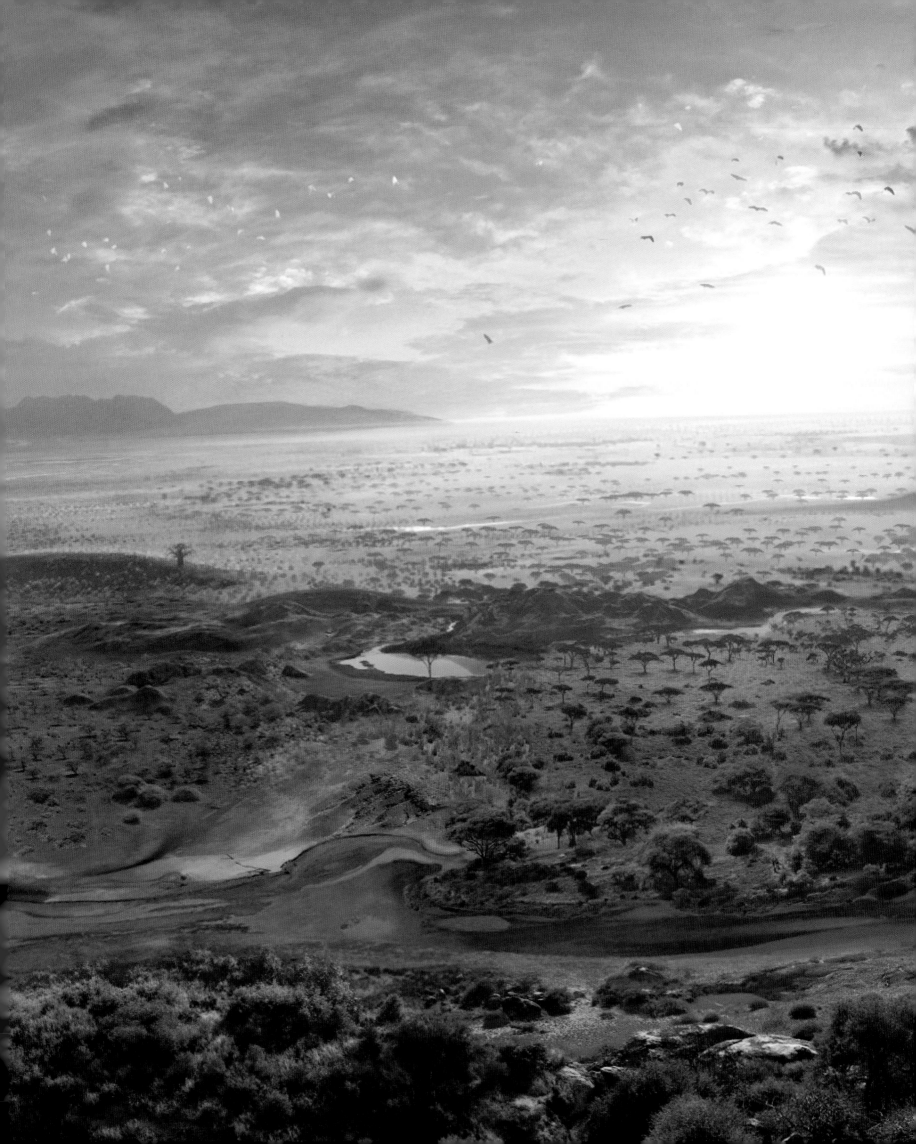

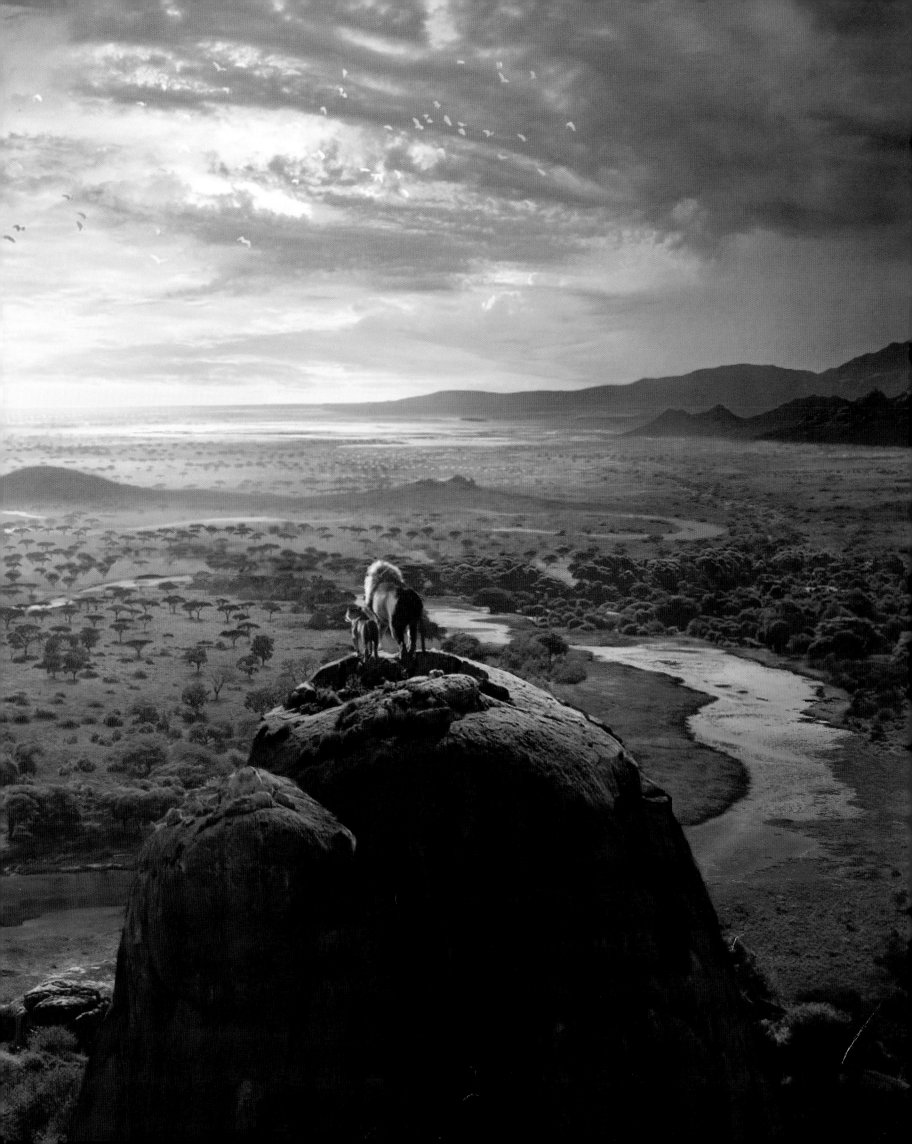

The Meaning of the Method

Such methods were designed to satisfy Jon Favreau's primary edict for how *The Lion King* should be made: "Everything must look and feel exactly like a live-action movie." He explains, "I wanted to do it this way because I was convinced people did not want to see a traditional CG animated *The Lion King*. The original animated movie still holds up incredibly well. But I thought it interesting that, even though people hold the animated film so dear, they were extremely accepting of the acclaimed stage play.

"The story of the stage play did not deviate too much from the animated feature, but I think people accepted it because it was an interpretation in an entirely new medium," Favreau says. "So I think part of our responsibility here was to present this in yet another new medium—to tell the story an entirely different way, and have the experience feel different, even as we adhere to what is really a timeless story.

"Using virtual production allows us to do that. It is an extension of what we did on *The Jungle Book*—putting computer graphics in the director and cinematographer's hands for the first time. On that movie, we could see it all on a monitor as we designed shots. But now, with *The Lion King*, we are literally putting filmmakers inside the monitor, using a set of proprietary tools interfaced with the HTC Vive virtual reality [VR] system and Unity Game Engine."

Favreau adds that this approach permitted realism to subtly percolate into how the film was edited and finalized, because live-action principles were applied to animation from the very beginning. "Because we are using dollies, handheld cameras, cranes, and the same lighting [as we would use in the real world]—since we are using all the same tools to photograph this, albeit virtually—when the editor gets the animated footage, it has all the idiosyncrasies of real, practical footage," the director emphasizes.

Previous spread: Mufasa and Simba look out over their kingdom in this early atmospheric visual development piece.

Right, top: As seen in this visual development piece, the smallest texture nuances, such as cracks in an elephant's skin or scratches on his ivory tusks, were important to include in all aspects of making *The Lion King*.

Right, bottom: Emulating real-world properties like dust kicking up and changing the color of light on the savanna was crucial even during the visual development process, as seen in this concept art.

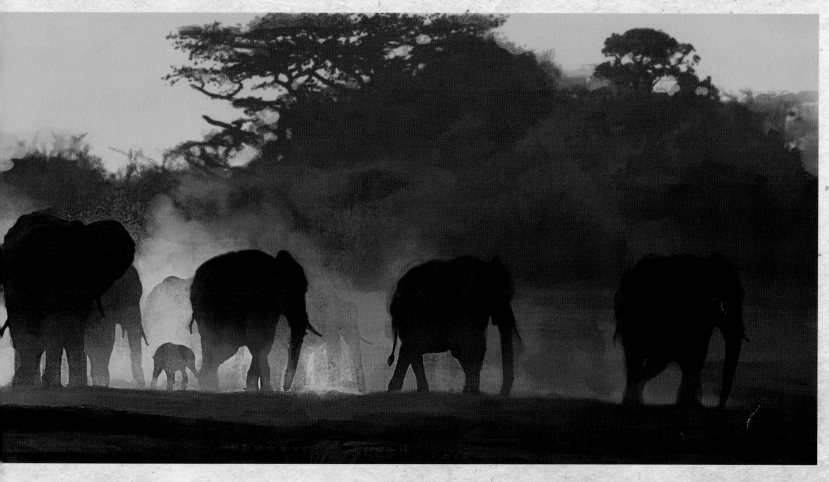

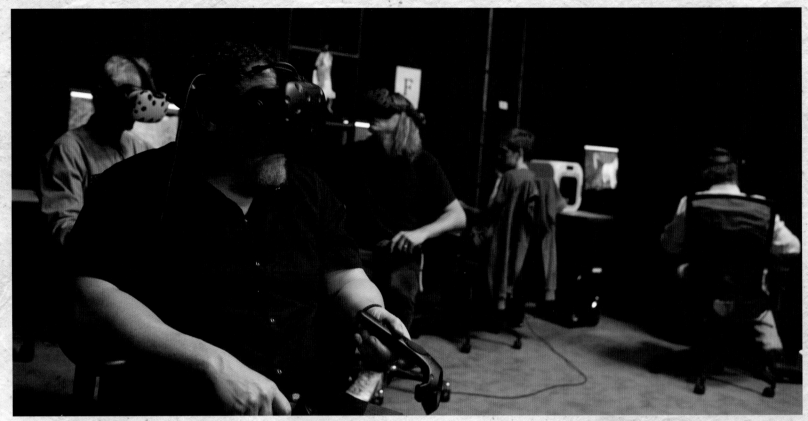

Above: Director Jon Favreau and colleagues use the HTC Vive VR headsets as part of a virtual set scout within the production's virtual stage in a warehouse in Playa Vista, California.

Opposite page, clockwise from top left: Favreau "visits" the virtual world during production; cinematographer Caleb Deschanel uses special controls to select cameras, lenses, and lighting of the virtual set; and Deschanel, under the watchful eye of VFX supervisor Robert Legato, maneuvers a virtual camera using physical camera interface technology.

Pioneering Virtual Production

The missing piece that finally came together to make this technique possible involved advancements in Unity graphics, rendering technology from a company called Unity Technologies—essentially, powerful computers originally designed to process video game images in real time. The vibrancy of this tool gave filmmakers the ability to view and interact with preliminary versions of imagery designed for the movie using the Vive VR system. Thus, they were able to put on VR goggles and "scout" African locations where the action takes place, deciding while standing on that set in virtual space where to place lights, characters, and other elements. They could make such changes with the sweep of a hand, press of a button, or manipulation of a joystick in real time.

At the end of the day, this represents an entirely new filmmaking method. That's why producer Jeffrey Silver describes Unity as "a groundbreaking real-time video game rendering engine that is really a movie studio inside a video game, in the sense that [filmmakers] wear VR goggles using [handheld] controllers to control virtual cameras, virtual lighting, and other tools to design and execute shots. That [technology] was not yet available when they made *The Jungle Book*."

Indeed, as cutting-edge and game-changing as *The Jungle Book* was—after all, it won the visual effects Academy Award in 2017—"that project's technology was not yet ready to put filmmakers literally inside the movie," explains Ben Grossman, virtual production supervisor for *The Lion King*. (Grossman is from a company called Magnopus, which took charge of installing and operating the OptiTrack system and Unity rendering engine.) "That technology was too slow for what we are now able to do. It was created to support the high quality of visual effects, but at two ends of the spectrum are quality and interactivity. We had quality, but at that time no interactivity if we wanted to retain quality," Grossman recalls. "So we evolved as the technology improved to emphasize interactivity for the filmmakers, from the production designer to the director, cinematographer, and visual effects supervisor. Thanks to improvements in VR and improved rendering engines like Unity, we were able to essentially throw out most of the technology from *The Jungle Book* and start over."

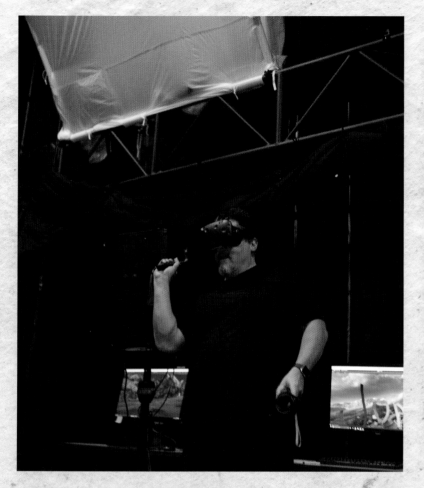

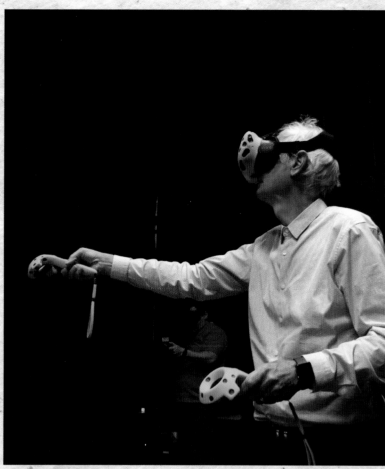

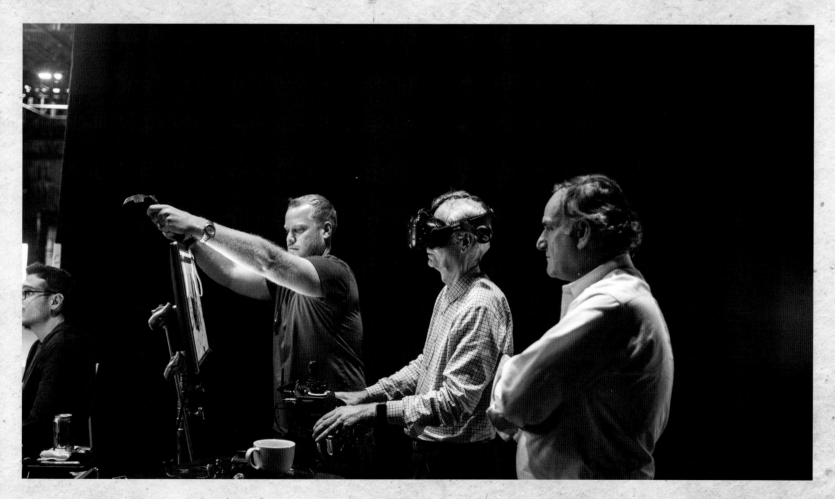

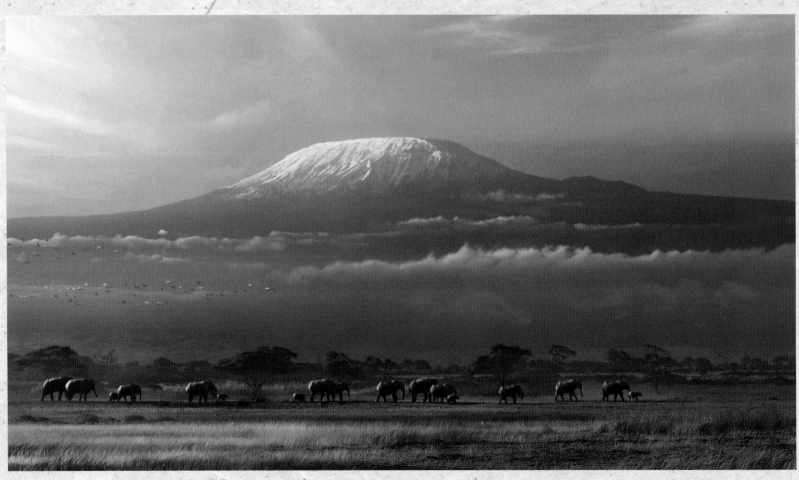

"Now, we can put filmmakers onto locations in the VR world and let them reach up, put their hands on objects, move them around, see cameras and lights, and move them around—interacting with the environment and the [virtual filmmaking] tools," Grossman says. "They can move things interactively to [design locations, shots, and sequences], as opposed to standing over an artist's shoulder giving him verbal instructions."

Creating a Credible Familiarity

Another element of *The Lion King* is that it exclusively depicts real creatures and environments that actual human beings have seen and are familiar with in the real world, as opposed to fantasy elements like many other major film franchises. Further, unlike *The Jungle Book*, this movie has no physical actors or elements whatsoever, yet was required to look as if everything was as real as the reference imagery that Caleb Deschanel photographed when filmmakers took the crucial preproduction trip to Kenya in 2017. Therefore, the production made bold technical strides across the board in terms of linking these methodologies with the industry-leading computer

animation techniques pioneered by the London-based visual effects house MPC, building on their award-winning *Jungle Book* animation work, to insert unprecedented realism into the animals that star in *The Lion King*. "Much of the new technology is really procedural where you use a tool in order to populate the savanna with the assets or to create textures that will repeat and then you can apply them everywhere," notes MPC set supervisor Audrey Ferrara. "You still need the human eye to keep it in order because it can become really messy really quickly. Then, sometimes, it just appears in front of your eyes and you think, *is this real or animation? I can't really tell the difference right now.*"

These are new and important strides on the filmmaking landscape. That's why Robert Legato emphasizes that *The Lion King* has opened the door for filmmakers to take such tools and techniques past superhero or fantasy genre fare and into "all sorts of things rooted in reality, where you have the fidelity and the luxury of being able to have live-action filmmakers shoot with some degree of comfort."

Opposite page, top, and bottom: Concept artwork of the sun setting over the savanna and a rendering of Tanzania's famed Mount Kilimanjaro.

This page, top: A research photograph of an acacia tree against a cloudy sky.

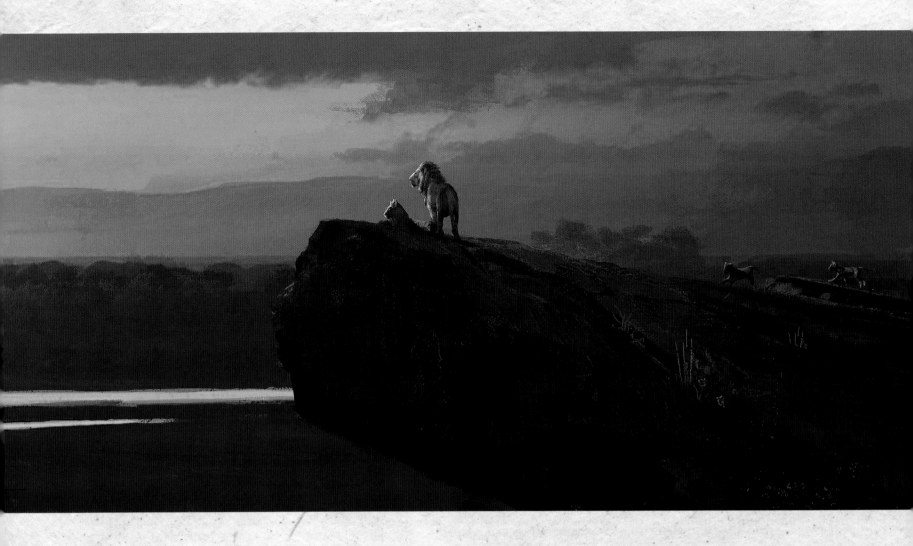

Emotional Integrity

"For me," says Robert Legato, "it's a little bit like going back to the studio system, where now the backlot really looks like Africa, or New York City, or whatever you need it to look like. If the set looks like the location, and the characters look real, then what is the difference whether it was shot [live] or in a computer?"

Caleb Deschanel adds that it's not only in the way it looks, but also in how the movie feels emotionally.

"It's the emotional reality that you care about," Deschanel says. "[The technology's] ability to make things photo-real allows Jon [Favreau] to create emotional realities. The tools are how we tell a story and communicate with the audience. So this is a realistic movie in the sense that when you watch it and feel those animals are real, it helps you to care about them in the context of the story-telling. This movie allows you to relate to these characters, because we are putting you into their reality.

"Other than the fact that they talk," Deschanel notes, "these animals do not do anything that the same animals cannot do in real life. Jon was very adamant about that. I think there is a real strong emotional connection between the audience and these characters. You get the same emotion out of them that you would in any movie, and that enhances realism."

Indeed, Favreau insists he decided to pursue this method of filmmaking for *The Lion King* not to see what technical vistas his team could conquer, but rather because he felt it was the best way to help the audience revisit the famed story while "simply allowing themselves to be drawn into the emotional journey—to experience it more intimately. It all really just comes down to storytelling, and these amazing tools really help with storytelling."

Above: Concept artwork captures the meticulous reference material, such as the photographs on the right, to help artists capture the setting for *The Lion King*.

Opposite page: The center and bottom research photographs of African landscapes at different times of day next to the top concept artwork illustrate the goal of achieving hyper-realistic environments in the film.

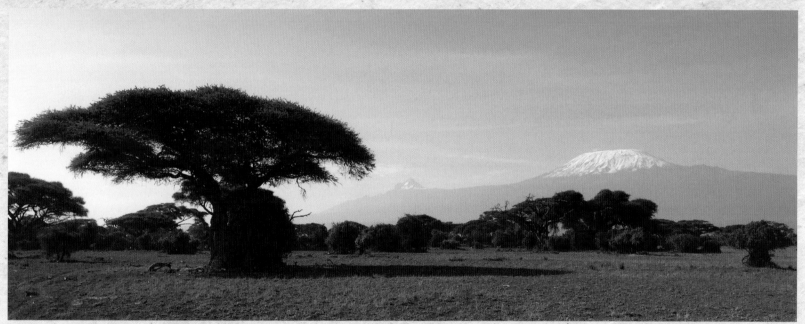

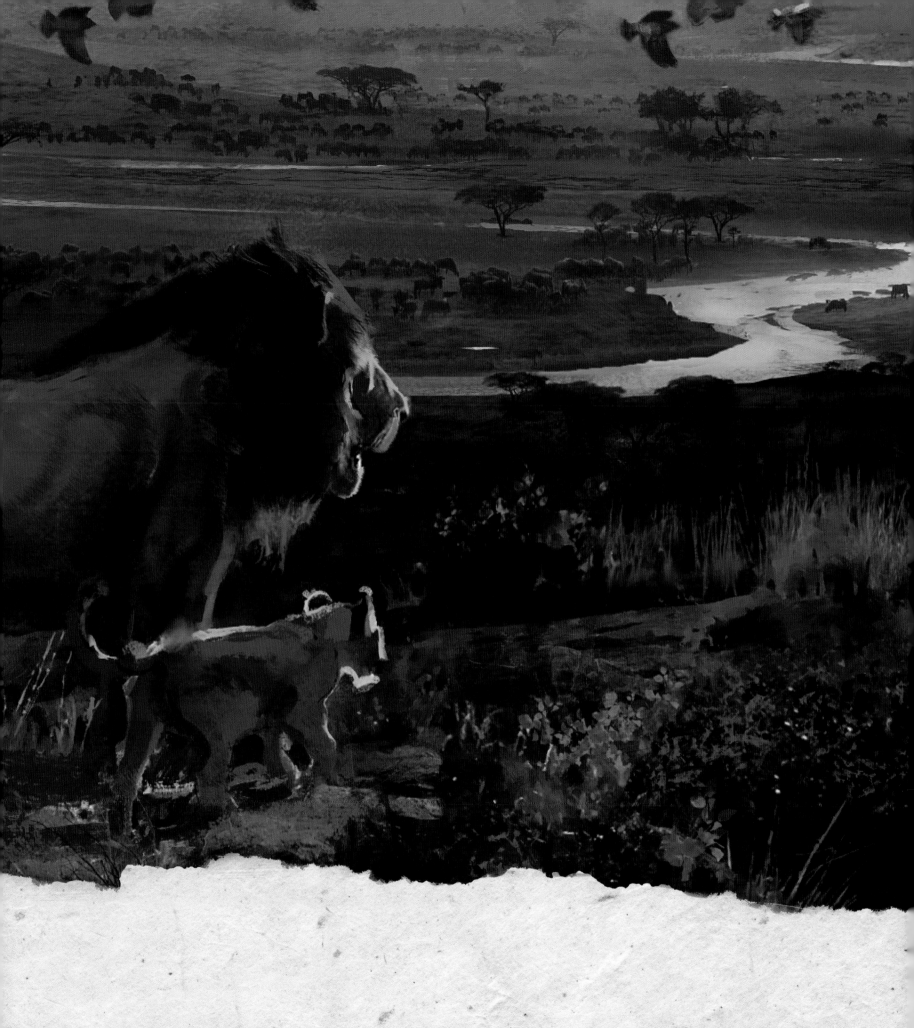

PRIDE LANDS

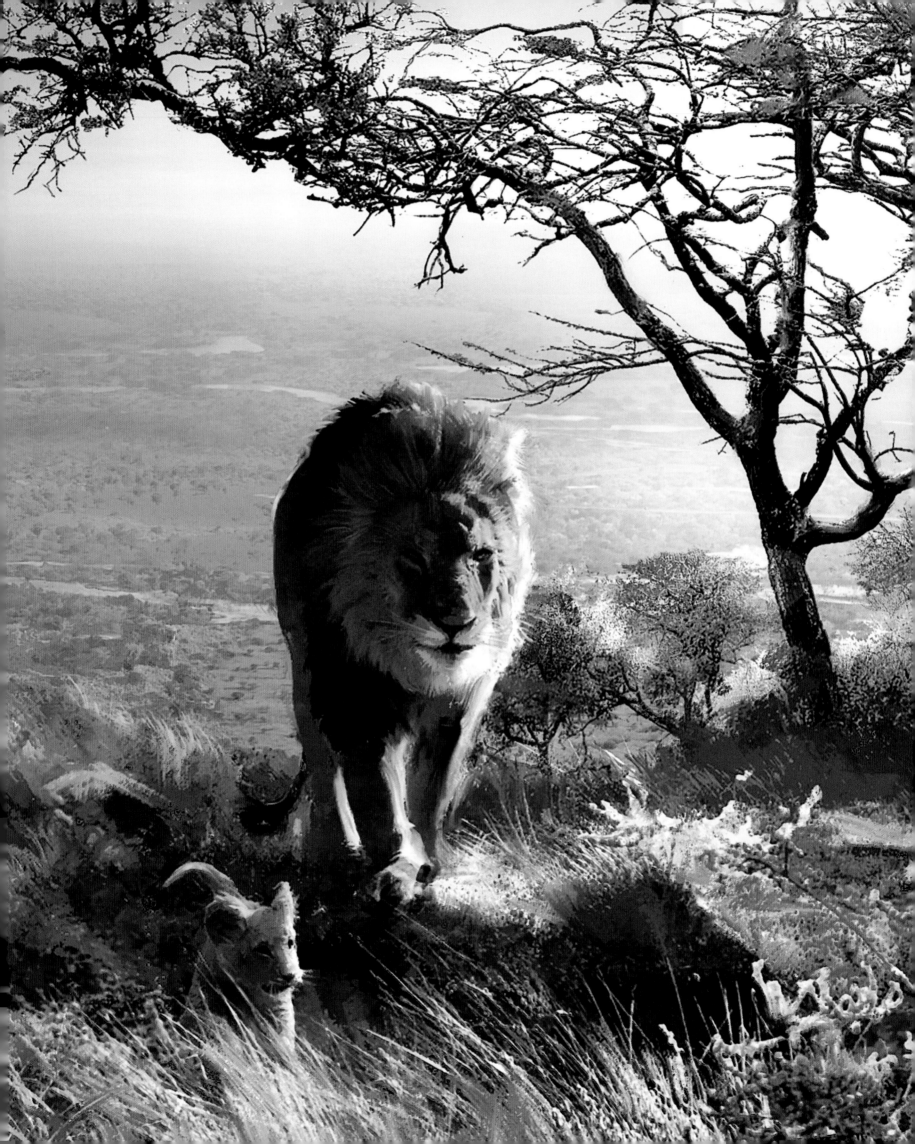

CHAPTER FOUR

The Place in Story, the Story of Place

The story structure and character action of *The Lion King* is informed and enhanced by the use of its settings to convey large narrative ideas. The various environments of the film support the overall story, enhance understanding of the characters, and move the plot forward. It's a level of storytelling that is both highly designed and sophisticated, and may even go unnoticed by much of the audience. In many ways, the locations of *The Lion King* are *felt* as much as seen or heard.

In a typical hand-drawn animated film, there is a willing suspension of disbelief due to the nature of the medium. Drawings move within environments that change in detail and even scale based on the needs of an individual shot or setup. "Successfully done, the backgrounds contribute much to the audience's enjoyment, and, like music, can create a depth of feeling in the mood and enhance the dramatic quality of the whole film," wrote Disney Legends and animators Frank Thomas and Ollie Johnston in their landmark work, *Disney Animation: The Illusion of Life*. "Walt felt this was so important that he asked the background men to try several different paintings of key scenes with a variety of colors and techniques to stimulate their imaginations and help them find the best approach."

As animation moved from hand-drawn and hand-painted media to CGI technology and techniques, the same principles were applied—but with heightened realism, or in many cases a heightened caricature, in order to enhance creative goals or defer to foreground character action.

Designing the worlds of a reimagined *The Lion King*, in which the appearance and vernacular of the familiar medium of nature photography serve as the design aesthetic, an alchemy of sorts was required—a careful balance of realism, caricature, and camera technique—so that the settings and environments could maintain their credible realism while still serving as effective and efficient storytelling tools.

Visual developmental art of Mufasa and Simba from *The Lion King* (2019) illustrates the filmmakers planning for detailed views of the Pride Lands.

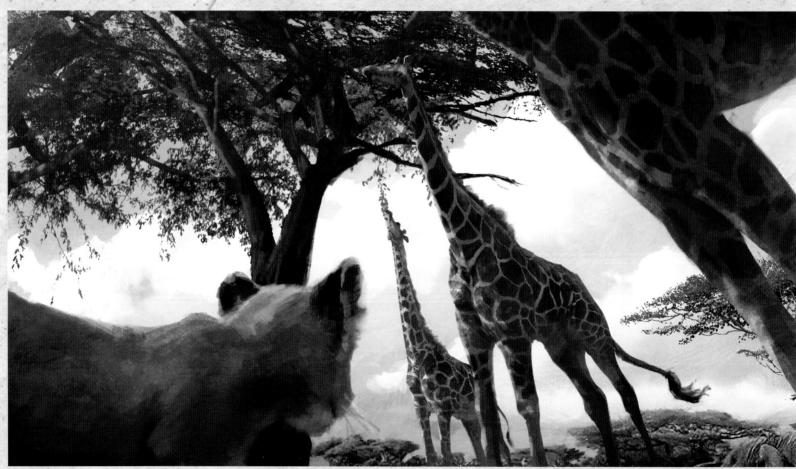

A Mythic Kingdom

The realms of *The Lion King* present a varied representation of Africa and create a mythological classic and timeless African "kingdom" in which the story unfolds. As Broadway scenic designer Richard Hudson once commented about the story settings, "One of the most remarkable things about *The Lion King* is that it is not set in any specific time . . . the design possibilities were endless, so long as the scenery evoked Africa, and so long as it helped tell the story."

The overall look and feel of the Pride Lands, though based entirely on reality, was painstakingly configured to the specific needs of the story by production designer James Chinlund's team.

As home to the proud *Panthera leo* society at the center of the story, the Pride Lands serve as the primary location in *The Lion King*, housing within it the other key locations: the Elephant Graveyard, Rafiki's world, Wildebeest Gorge, and the Cloud Forest. The Pride Lands hold all the outward symbols of the peace, prosperity, and harmony of a wisely and well-ruled society, with the beloved Mufasa as its monarch.

In fact, cinematographer Caleb Deschanel calls the Pride Lands "the anchor to the whole story."

Planting the Environments of *The Lion King*

Building the realistic environments and landscapes where the action in *The Lion King* unfolds was a massively complicated task. Filmmakers, joined by the visual effects expertise of MPC, had to *make* every single thing audiences see look real. "We're making the savanna, the Cloud Forest, the mountains, and the fields: every single little pebble and every single blade of grass," explains MPC set supervisor Audrey Ferrara. "It's a huge amount of things." Those same elements also had to simultaneously serve the story's creative needs.

Thus, a specific process was developed for the environmental work, starting with a protracted design phase and finishing with stunning animation and visual effects work done at the MPC facility in London. As executive producer Tom Peitzman describes it, "The whole thing starts with the script, and then from the script it goes into storyboarding through the story department headed by Dave Lowery."

According to Lowery, that department spent "about a year drawing" all manner of storyboards for every scene and moment in the movie, eventually turning them into what is called a 2-D

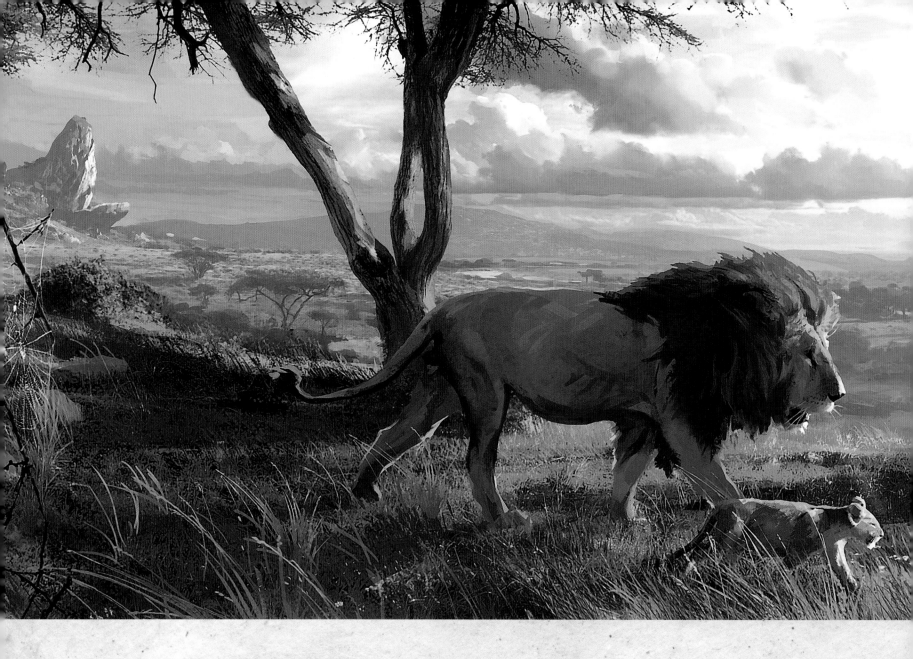

animatic—editing the hand drawings together and adding temp voices and music to create a preliminary version of the entire film.

"The animatic was then reviewed by Jon Favreau and production designer James Chinlund, and James started creating specific, detailed looks for each environment," Peitzman explains.

Chinlund and his team based those looks on the reams of reference material filmmakers brought back with them from their preproduction trip to Kenya.

"Using all that research, our illustrators—Seth Engstrom, Joe Studzinski, Jaime Jones, and Nathan Schroeder—began in parallel with our 3-D modelers to start to flesh out spaces," Chinlund says. "Our goal from the beginning was to create a world map that was cohesive—making sure the Pride Lands were located in relation to the Cloud Forest in relation to the Elephant Graveyard in a consistent way. We wanted the viewer to feel secure and grounded in a stable sense of geography."

The production's Virtual Art Department (VAD) eventually created simplified digital pre-visualizations of "the whole massive world," according to Adam Valdez, MPC's visual effects supervisor on the project. Those simple environments were then married with pre-animation headed up by animation supervisor Andy Jones—animated individual actions that needed to happen within particular scenes. Those master scene files, in turn, were then sent back to the production to be utilized as basic backgrounds for the virtual photography process in the computer, "scouting" and then shooting action within those virtual environments using VR goggles.

VR Location Scouting

Tom Peitzman elaborates that the highly strategic process of building these early versions of the environments was crucial to

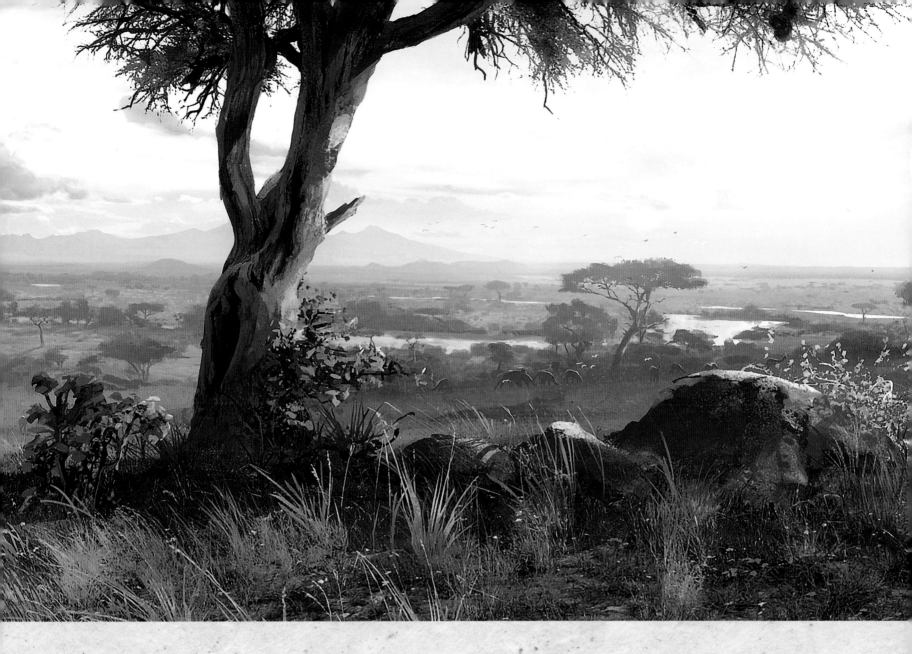

the overall virtual production methodology, because it provided filmmakers with a rough template of the entire *Lion King* world. The virtual-production team relied on that template to figure out how to shoot characters and elements moving around each location.

"The filmmakers first scout the location [in the virtual world], and then Andy Jones takes that information and his team pre-animates what a lion and secondary characters should be doing on it," says Peitzman. "That master scene file includes suggested camera coverage that they will talk about ahead of time, before Caleb Deschanel and Jon Favreau start shooting each scene and making their own decisions as they would on a live-action movie."

Over time, MPC's Digital Environments team built higher-end, proof-of-concept 3-D models called design stills—basically just single rendered frames of each area within the larger environment. Those were then presented to filmmakers for approval. As production moved along, MPC perfected techniques and new tools for building and placing literally thousands of elements into

each environment, such as rocks, trees, fallen trees, plants, termite mounds, debris, water, dust, and so on. Computer intensive animation lighting and rendering processes came last, and even after that, nearly endless adjustments based on creative needs as directed by Favreau were ongoing throughout the postproduction process—removing a tree or moving a camera, for example.

In particular, artists labored to put more specific detail into zones of the terrain that came into contact with characters at any time to ensure greater accuracy of action.

Above: Visual development artwork helps filmmakers experiment with camera angles and color palettes before entering the final film stages. Here Mufasa and Simba explore the expanse of the Pride Lands, which was delicately designed and built in computers to exactly resemble reference material from Africa.

Page 70, top: Concept artwork of Zazu soaring over the grasslands

Page 70, bottom: Concept artwork of young Simba watching giraffes graze

Page 71: Concept artwork of a dimly lit sky over Pride Rock

Physical Modeling

Indeed, James Chinlund elaborates that while Jon Favreau, Caleb Deschanel, and Andy Jones were walking through the preliminary version of a particular location to scout where and how they wanted to shoot action, in parallel, the Digital Environments team frequently created *physical* models of particular locations to allow additional refinement. These were created using 5-axis CNC (computer numerical control) foam carving machines made by a company called DMS (Diversified Machine Systems) and supplied by a set-design vendor called Vision Scenery so that model maker Jeff Frost could physically detail and finalize those models to filmmaker specifications with human craftsmanship. Those sculpted models would eventually be scanned *back* into a computer, and the production would ultimately hand over a package of illustrations and 3-D model files to MPC. There, artists would "take our sculpts and prep them for the stage [where they would be viewed using VR technology], while animation would simultaneously prepare animated elements for the shoot," Chinlund adds.

"And then," he continues, "the team would shoot in the sets while, in the background, MPC was taking the environments and rebuilding them for postproduction. This is where the real magic happens as they take a relatively rudimentary model and an incredibly detailed but 2-D illustration, and eventually create a piece of the world in true, photo-realistic majesty."

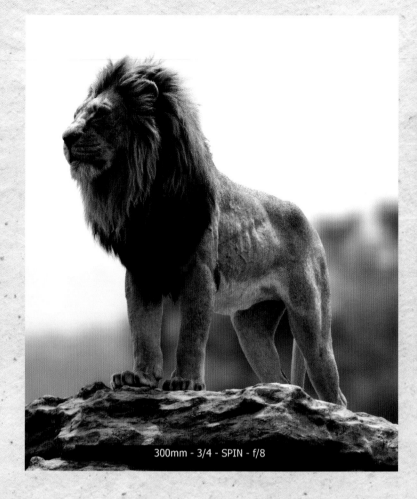

300mm - 3/4 - SPIN - f/8

Right, top and bottom: Two different lighting conditions of a digital Mufasa to see how he looks backlit and frontlit help give the character a real-world look.

Opposite page, top: A digital sculpt of Mufasa in the character's early stages of model rendering.

Opposite page, bottom: Final photorealistic image of the character. Note the attention paid to skin, fur, muscle, and other textural details.

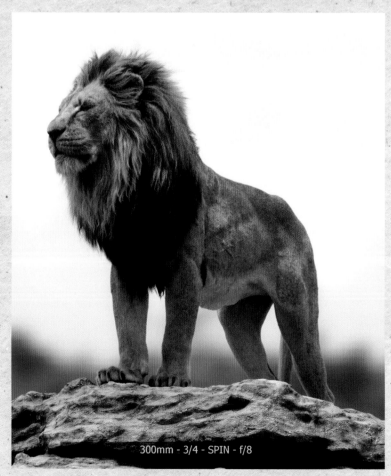

300mm - 3/4 - SPIN - f/8

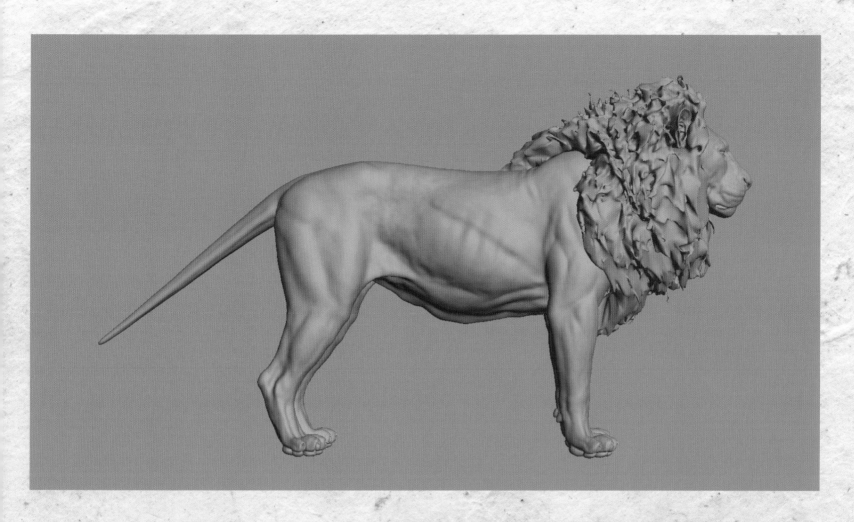

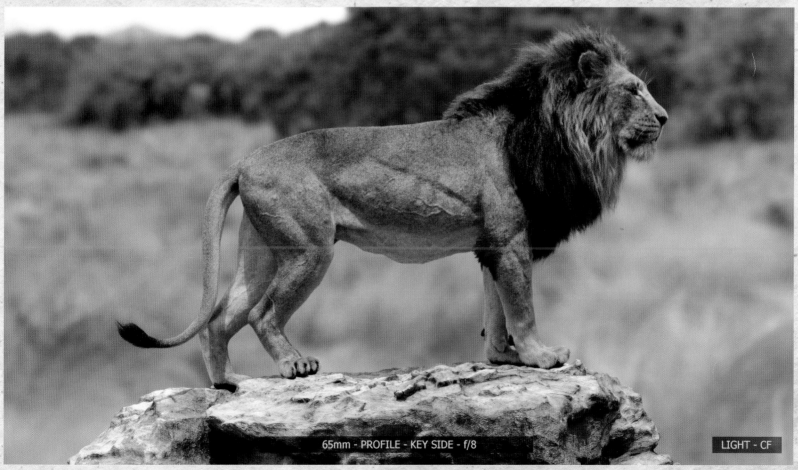

65mm - PROFILE - KEY SIDE - f/8

LIGHT - CF

During the visual development process, some still frames were captured with a virtual camera and "painted over" to give the visual effects team a template when finalizing the look and textures of the animal characters and the environment, resulting in a piece of art known as a paintover. In this paintover, the iconic Pride Rock was developed around the notion that it was an African rock formation that fit into and corresponded with other rock terrain that might naturally exist in the area.

A Royal Palace for a Lion King

A mythic kingdom and noble monarch require an impressive castle; in this case, the iconic Pride Rock.

James Chinlund explains, "In the original film, Pride Rock stands as a tower of rock in the middle of a huge verdant green landscape, entirely unmotivated by hills or other rocks. Building that in the animated world, our concern going in was where did those rocks come from?

"That question was the starting point for us—how much other terrain, rock, landscape could we bring in to make Pride Rock feel familiar, like the Pride Rock we all know and love, but at the same time feel motivated by geology and the terrain around it, so that you accept it visually? If you see a rock

formation in the middle of an empty landscape, your eye immediately trips an alarm, saying something doesn't feel quite right. A lot of what we were doing on such spaces generally involved trying to capture the romantic quality from the original [animated film], while making it feel grounded in truth.

"So, finding a way to anchor Pride Rock into the terrain that felt familiar and real was the challenge," Chinlund continues. "That's why our Pride Lands and Pride Rock are direct amalgams of things we saw in Kenya. There are, in fact, rocks on the landscape that come directly from actual scans of rocks we found in Kenya, and the watering hole is based on a location that we found there. The textures and colors and qualities of the rock that is Pride Rock were based directly on rock formations in Kenya."

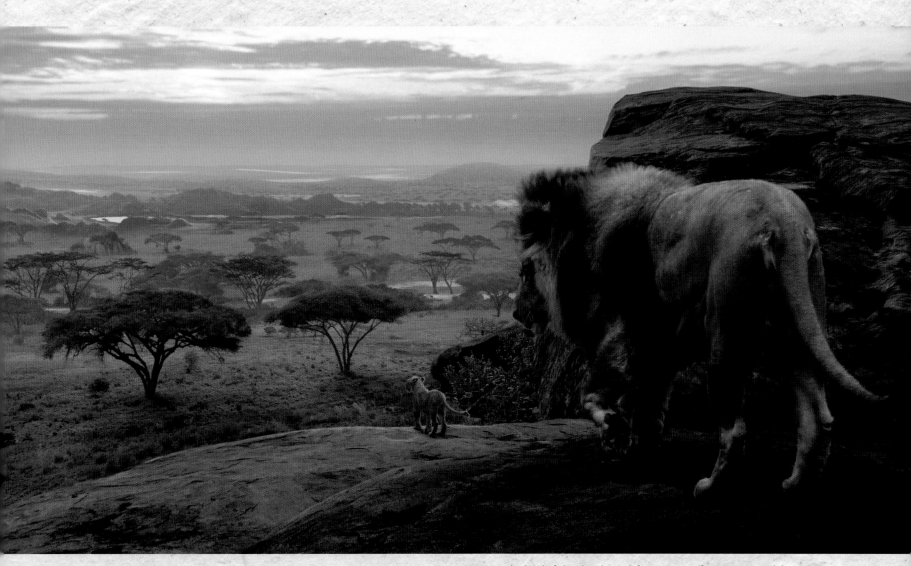

Note the level of detail in the rock formation's surface texture, and the nature of the extended terrain—elements replicating image data from detailed scans, photographs, video, and material samples captured in Kenya in this paintover.

Character Building and *The Lion King*

As with the film's environments, the birth of every character in *The Lion King* started with two building blocks: concept art and real references from the filmmakers' Kenya trip, along with subtle nods to what production designer James Chinlund calls "the archetypal characters of the original animated film." It was all part of a process that, in most cases, took upwards of nine months before fleshed-out, final digital versions of each character were set.

"But translating an animated character into a photo-realistic creature required a full rethink," Chinlund emphasizes. "Digging deep into research and our experiences scouting was always the kickoff. Jon [Favreau] and the team would look through the research and we would land on a group of key images that

captured the feeling we were pursuing, and that would launch our character illustrators [Vance Kovacs and Justin Sweet]. They would produce both paintings and 3-D sculpts of our characters, which went through rounds of reviews with Jon and the team. Then, when we got close to final, we would output a 3-D print of the character for last looks using our in-house [SprintRay MoonRay II] 3-D printer."

Those key images or "mood boards" were crucial. "Each character would have images chosen to give reference for things like body or head shape, color, fur characteristics, and so on," says MPC's Adam Valdez. "Our artists would then refer back to those reference boards when crafting the CG characters, combining individual components of reference with the direction of the concept art."

Character Model Building in 3-D

Once Jon Favreau had approved a character's final design, all assets reflecting that design were handed over to MPC artists so that they could start the process of building 3-D versions of them. The first step in that process involved refining the so-called "digital sculpts," similar to traditional clay sculptures, where artists would block in design and the feel of a character, including an artist's sculptural representation of a character's fur or feathers.

That work was then compared during a validation process to reference material from Kenya, and the character would essentially be reworked from the ground up to refine anatomy and proportions to produce what is called a "skin model" to go to the Groom Department. That department was responsible for designing a character's fur or feathers, focusing first on overall form or volume or flow of the fur, and then burrowing down into increasingly finer details to further define subtle structures and clumps of real fur.

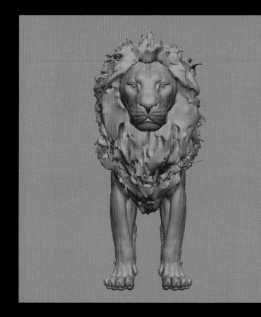

Characters were then simultaneously sent to the Texturing and Animation departments. Tests were performed to compare movement to video reference of real animals, and to further refine any aspects of a character's design that got in the way of evolving their movements toward realism. Simultaneously, texture artists applied color and patterns to animal fur, worked on eyes and eye shading characteristics and more, until that all-important balance between concept art and reference footage had been achieved.

"We put each character through a computer version of a photo shoot that was comprised of five wide-angle and five telephoto lenses at various different distances and angles that were framed as such to represent a typical shot in the movie, such as close-ups or over-shoulder shots," Adam Valdez explains. "We did the photo shoots in six different lighting conditions that represented the broad scope of lighting in the entire movie. The aim at that point was really to get a feel for technically how our characters react to conditions like cloudy, overcast skies or harsh midday desert sun, and so on, and also creatively to see how they feel holding the frame of a shot all on their own—are they drawing the audience in?"

Right and opposite page: As a first step in designing digital versions of the characters in their early stages, filmmakers created digital sculpts; an shown here with (top) Mufasa, Sarabi, Sarafina, Simba cub; (middle) Nala cub, Zazu, Rafiki, Scar; and (bottom) Timon, Pumbaa, Simba, and Nala.

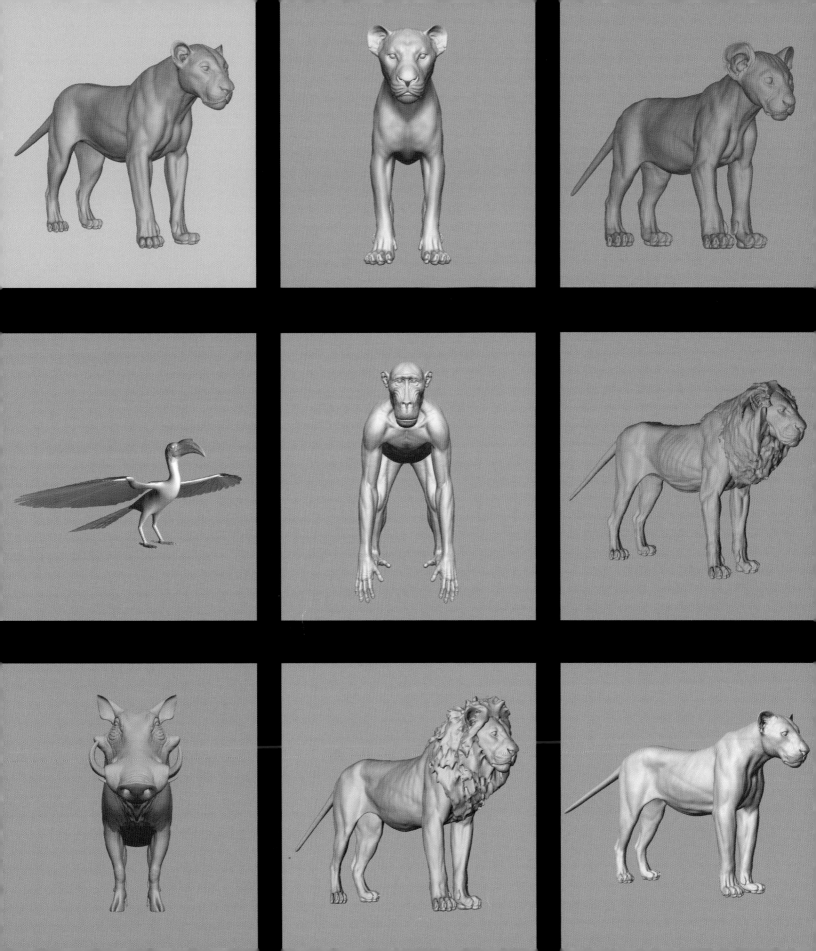

TIMON: WELL, KID?

SIMBA: OH, WELL...

SIMBA: HAKUNA MATATA.

SIMBA: ... YET...

SIMBA: ... SATISFYING.

TIMON: THAT'S IT!

Elements of Detail and Performance Nuances

From that point, MPC focused on a wide range of minute details in various areas, including movement of muscle, flesh and skin simulations, facial behaviors, improving textures to account for things like pores on skin or wetness on noses, and how fur matted or moved differently depending on its condition or how light was shining on it. Numerous final animated screen tests were conducted for each character to assure they emerged as representations of living, breathing animals.

One delicate challenge revolved around the best way to depict characters when they speak or sing since, obviously, that is the one aspect of the characters that is not meant to directly emulate reality. Animation supervisor Andy Jones says the methodology for depicting speech in a realistic manner revolved around a combination of figuring out what angles were best to photograph talking animals and being as realistic as possible about what ways their mouths could theoretically move.

"Jon [Favreau] didn't like any shots that look right into the mouth, so he tried to have us tilt the head down so we are not staring directly into the mouth," Jones says. "We were careful with that so as not to continually and directly remind the audience about the one thing that is not real. But, at the same time,

we did our best to make sure that we were not adding phonemes in terms of how each animal can physically move their mouths. So, every kind of muscle control we have around the mouth makes them move in realistic ways, the ways they can really move their mouths. We found lip-synch through that approach—moving mouths into shapes that, for instance, a cat can really do, and trying to have the right kinds of sounds coming out to match those shapes.

"The other strategy was to try and get the animal's breathing timed with the talking," Jones says. "We had the belly muscles and diaphragm tighten so that you feel like the animal is forcing air out his mouth as he is talking, timed with particular syllables. With female lions, whose necks we can actually see because they do not have manes, we added particular esophagus and neck movements to help sell the fact that they are talking, with tongue and larynx moving."

Opposite page: Early development storyboards from the grub eating scene of "Hakuna Matata"

Above: A rough storyboard depiction of Simba prancing with his friends Pumbaa and Timon on a tree branch. Likewise, this was the starting point for animators to design and build highly sophisticated and realistic movements into final versions of the characters.

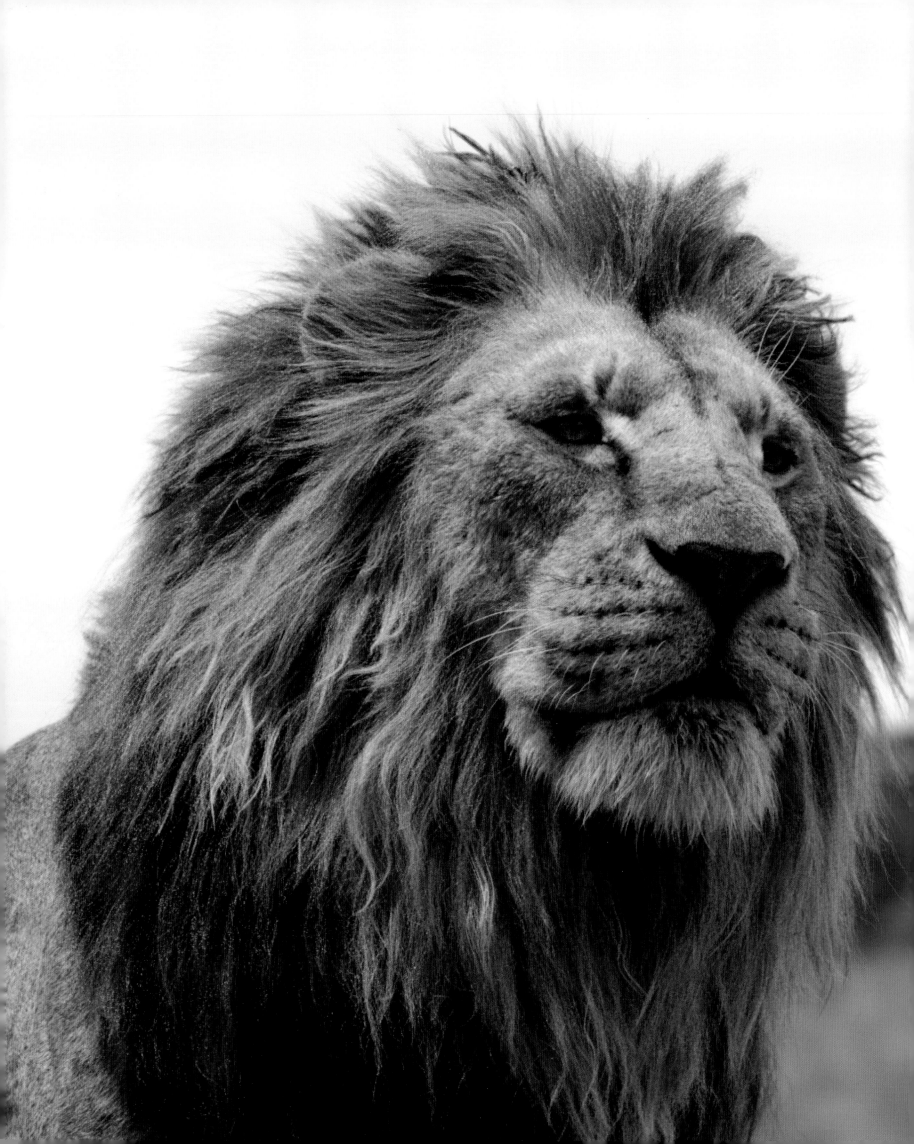

MUFASA

Meet Mufasa

Mufasa is the leader of the lion pride and father of Simba, and, of course, his conflict with his brother, Scar, lies at the heart of the story. Production designer James Chinlund refers to Mufasa as "the story's father figure," who "sets the high bar for lion masculinity."

The voice of Mufasa is provided by the same actor who originated the role in the 1994 animated feature, a performer the *Washington Post* said possesses "one of the best-known voices in show business, a stirring *basso profondo* that has lent gravel and gravitas" to his projects, including stage performance, film acting, character voices, and commercial voice-over.

James Earl Jones is unquestionably one of America's most celebrated actors. In a career that has spanned more than sixty years, he has been recognized with Tony, Emmy, and Grammy Awards for his stage, television, and recording work, plus both an Oscar and a Tony for Lifetime Achievement, an honorary Doctor of Arts degree from Harvard University, and a National Medal of Arts. The *Los Angeles Times* called him "one of the greatest actors in American history," and Allmovie.com aptly described Jones as "one of America's most distinguished and versatile" actors. After his Broadway debut in 1958, performances in the stage and film versions of *The Great White Hope* made him a star; he won a Tony Award and a Golden Globe Award for the stage role and an Academy Award nomination for Best Actor in a Leading Role for the film version of the play.

On Broadway, Jones surely earned his place in theatrical history for his performances in *Of Mice and Men*, Athol Fugard's *Master Harold . . . and the Boys*, August Wilson's Pulitzer Prize–winning *Fences*, and as King Lear for that production's stint during the New York Shakespeare Festival in 1973. He also starred in revivals of *Driving Miss Daisy*, *On Golden Pond*, *Cat on a Hot Tin Roof*, Gore Vidal's *The Best Man*, *You Can't Take It with You*, and *The Gin Game*.

Though well-known for his acting in films ranging from *Dr. Strangelove* to *Coming to America*, and *The Hunt for Red October* to *Field of Dreams*, it is Jones's powerful voice that tends to resonate with audiences. As an actor, Jones finds something liberating in performances that solely utilize his vocal skills. "Being behind the mask of . . . the lion is much easier," he explains. "You're free. Like the Greeks, the Greek acting [where actors hold masks before their faces]."

But that freedom doesn't always make the work simple. In finding Mufasa for the first time, he began with missteps. "My first mistake was to try to make him regal," Jones says. "What they really needed was something more like me. They said, 'What are you like as a father?' I said, 'Well, I'm really a dopey dad.'"

Jones, then, brought the sensibility of his own parenting into Mufasa and struck the perfect balance. "He was authoritative," the actor says, "but he was just a gentle dad."

Designing Mufasa

Filmmakers based Mufasa on literally "thousands of examples of lions from photography and scouting, and things we experienced in Kenya and then [Disney's] Animal Kingdom in Florida, really trying to distill all those feelings into this powerful dad," James Chinlund adds. "Physically, we also took a cue from the powerful voice of James Earl Jones, trying to wrap all that depth and power into the character."

Filmmakers ended up giving Mufasa dark brown fur with lighter fur at the front and a distinctive swooping shape around his face, with fur on top of his head long and flowing backward. His colors are rich oranges and browns, similar to his family members Simba and Sarabi, with a large full muzzle and white chin.

As to Mufasa's performance, Andy Jones says it was built around his flowing mane, to accentuate his mood and feelings. MPC's team upgraded its "fur dynamics and simulation" pipeline for the project in order to accomplish the kind of subtle texture and movement in Mufasa's mane, and those of other lions, to achieve performances they were seeking. In particular, MPC's advanced tools allowed filmmakers to replicate particularly complex behaviors of a real lion's neck or mane, including subtle sliding and wrinkling movements on the skin of a lion's neck, while maintaining a certain rigidity to the overall mane due to the density of hairs and how they clump together.

"We had to give the mane the right flow and movement per shot," Jones explains. "This film is about the circle of life, that we all play a part in something much bigger than ourselves. Mufasa is connected to the elements, so it seemed fitting that his mane would flow in the wind and its movement would play a part in many scenes."

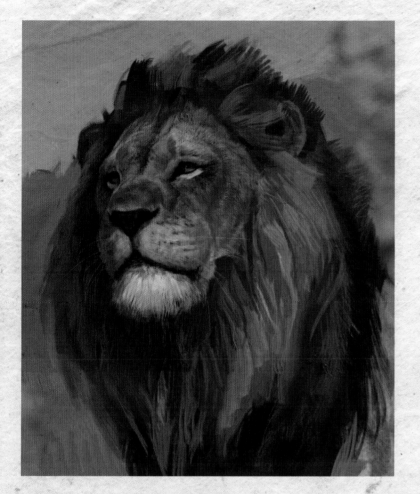
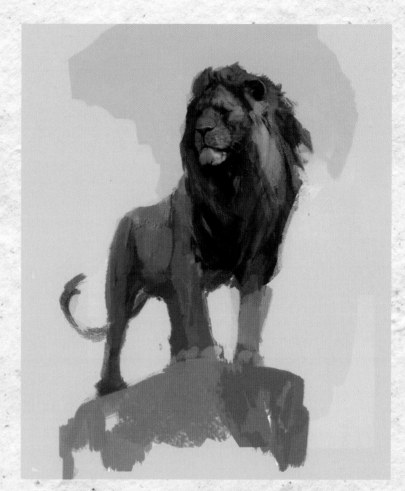
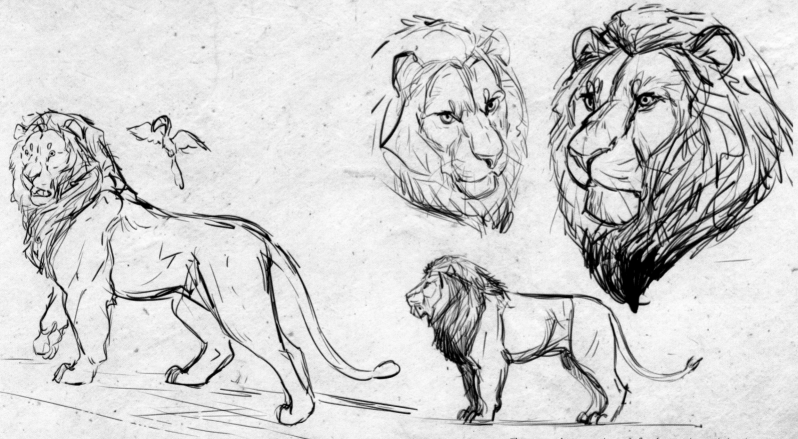

This spread: A sampling of sketches and visual development art depicting the regal Mufasa. Note that all of them prominently feature his flowing mane, a physical feature at the center of how filmmakers eventually animated the character.

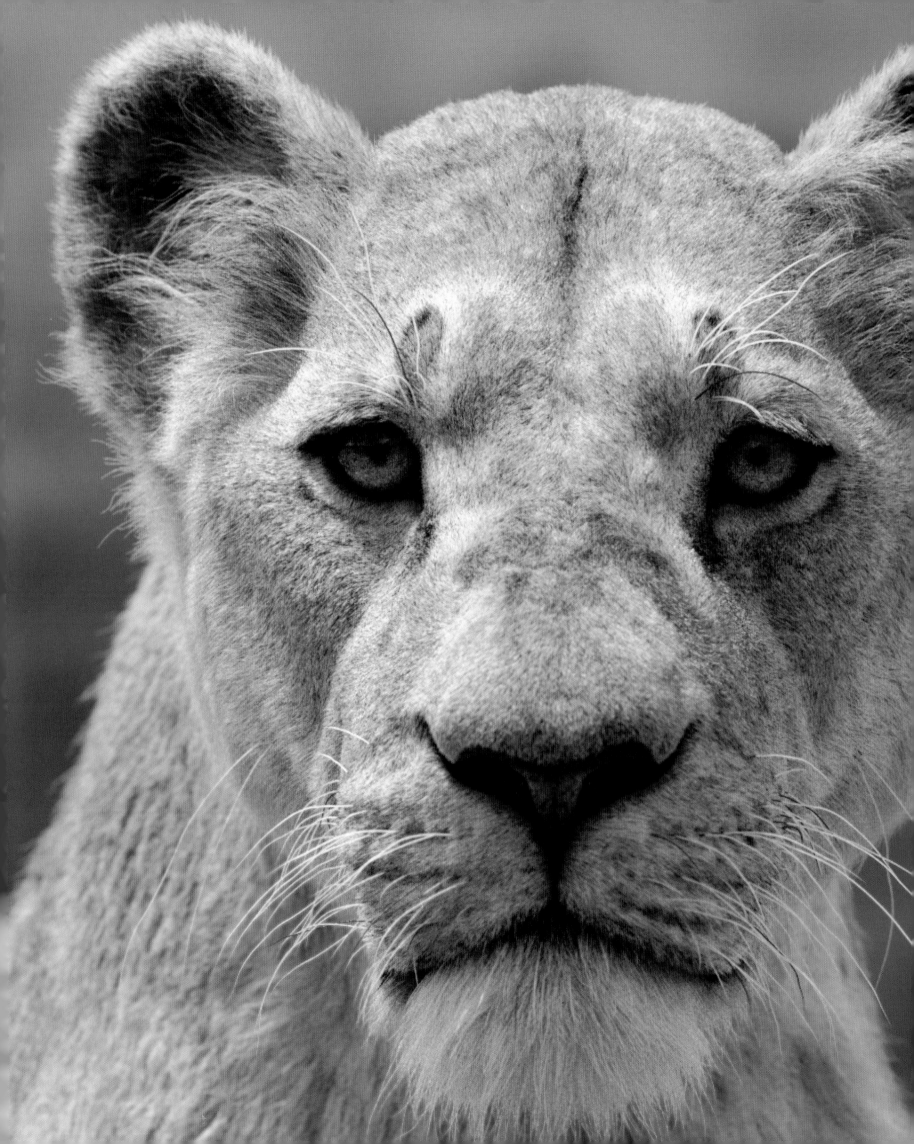

SARABI

Meet Sarabi

Sarabi (Alfre Woodard) is the movie's proud lion
queen, bride of Mufasa, mother of Simba, and the
personification of a sleek, athletic, regal lioness.
Film, stage, and television actress, as well as producer and
political activist, Woodard provides the serene and wise voice
of this revered royal. Woodard has been nominated for an
Academy Award and Grammy Award—and seventeen times
for an Emmy Award, of which she won four. She has also won a
Golden Globe Award and three Screen Actors Guild Awards.

Woodard began her career at Arena Stage in Washington, D.C. in 1974, and three years later had her breakthrough in the Tony Award-winning *For Colored Girls Who Have Considered Suicide/When the Rainbow Is Enuf*. She made an auspicious film debut the following year in Alan Rudolph's *Remember My Name*. Woodard has spent a career crossing the country and every medium; she has excelled and been celebrated in all of them. Oscar-nominated in 1984 for Best Supporting Actress in *Cross Creek*, she also won her first Emmy that year for *Hill Street Blues*. She was nominated for two Emmys for *St. Elsewhere*, and won a Golden Globe, Emmy, Screen Actors Guild, and several other awards for the HBO film *Miss Evers' Boys*. She won another Emmy for *The Practice*. Woodard has also starred in *Desperate Housewives*, *Memphis Beat*, *State of Affairs*, and the Marvel series *Luke Cage*.

The actress has also starred in films such as *Grand Canyon*, *Heart and Souls*, *Crooklyn*, *How to Make an American Quilt*, *Primal Fear*, *Star Trek: First Contact*, *K-PAX*, *The Core*, *The Forgotten*, *The Family That Preys*, *12 Years a Slave*, and *Annabelle*.

Her first voice performance for Disney was that of Plio in *Dinosaur*. She also voiced Polly in the acclaimed Disney animated short *John Henry*, and speaks for the Queen Mother, Dondi Reese, members of the Dora Milaje, and Miss M'Buye in *Black Panther: The Animated Series*.

Even with such a long, varied, and prolific career, Woodard is by no means "finished." "One thing that I love about acting is you continue to learn all your life," she says. "You never lose the millennial in yourself, and you get more formidable because you've got more experiences to add with that light that can't get put out."

Woodard is a founder of Artists for a New South Africa, an organization devoted to advancing democracy and equality in that country. In addition, Woodard serves on the board of directors of the Academy of Motion Picture Arts and Sciences (AMPAS).

Designing Sarabi

In developing Sarabi's look, filmmakers "played with the idea of her power, a sort of square jaw, a powerful queen—definitely representing the strength and the power of the pride," explains production designer James Chinlund.

More generally, however, the creative team faced a challenge with Sarabi because she was a lioness, and thus, had no mane, posing the problem of how to make her look different and more individualized than other female lions in the movie.

"How do you differentiate the lionesses from each other when ordinarily they would look so similar?" Chinlund ponders. "With male lions, you have the mane to play with, and you can get a distinct look through the way you groom the mane. But with lionesses, it was more about navigating shades of gray."

In response to this, Sarabi and Sarafina, the mother of Nala, share slender, delicate features, and both have an athletic structure. "But Sarabi has a more solid body type—she is more forceful," Chinlund adds.

Indeed, the character is the largest lioness in the pride, stronger and more mature in build than other females. And, as a member of the royal family, Sarabi shares the rich orange and brown color palette seen in Mufasa and Simba. But she also has her own distinctly shaped white chin fur and larger, more piercing light yellow eyes.

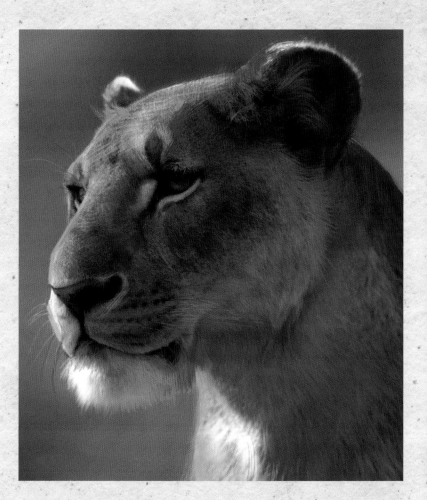

Above, and opposite page, top: Note the regal square jaw, distinctive white chin fur, and piercing yellow eyes of Sarabi in both her photorealistic version as well as in earlier visual development art.

Opposite, bottom: Fully rendered character models of Sarabi, mother of Simba, and Sarafina, mother of Nala, were designed to emphasize athleticism and sleek body types.

Pages 90-91: Visual development art of the adventurous cubs

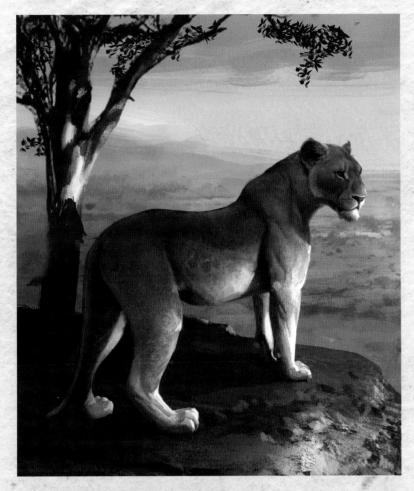
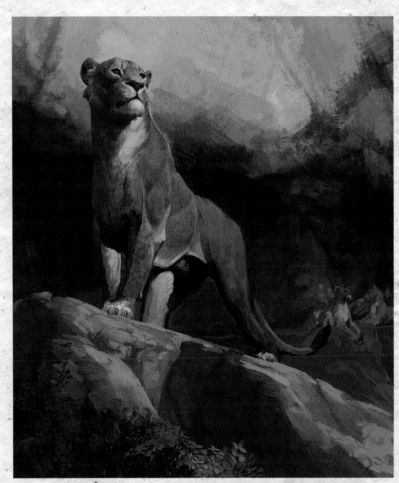
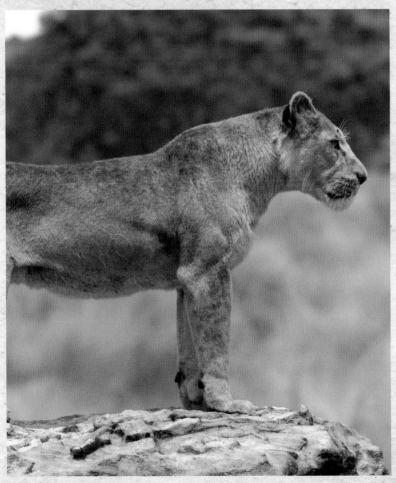
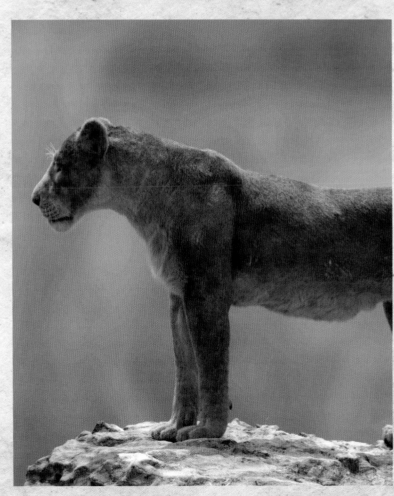

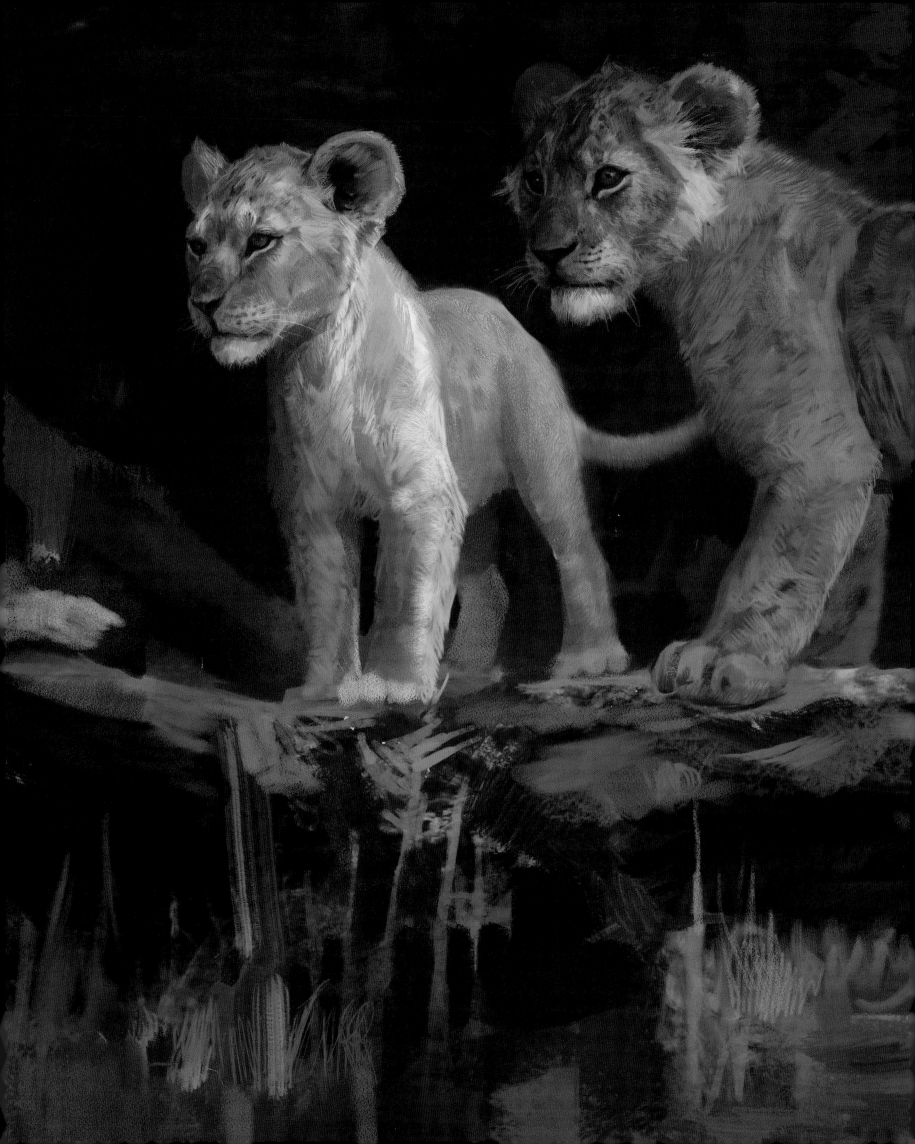

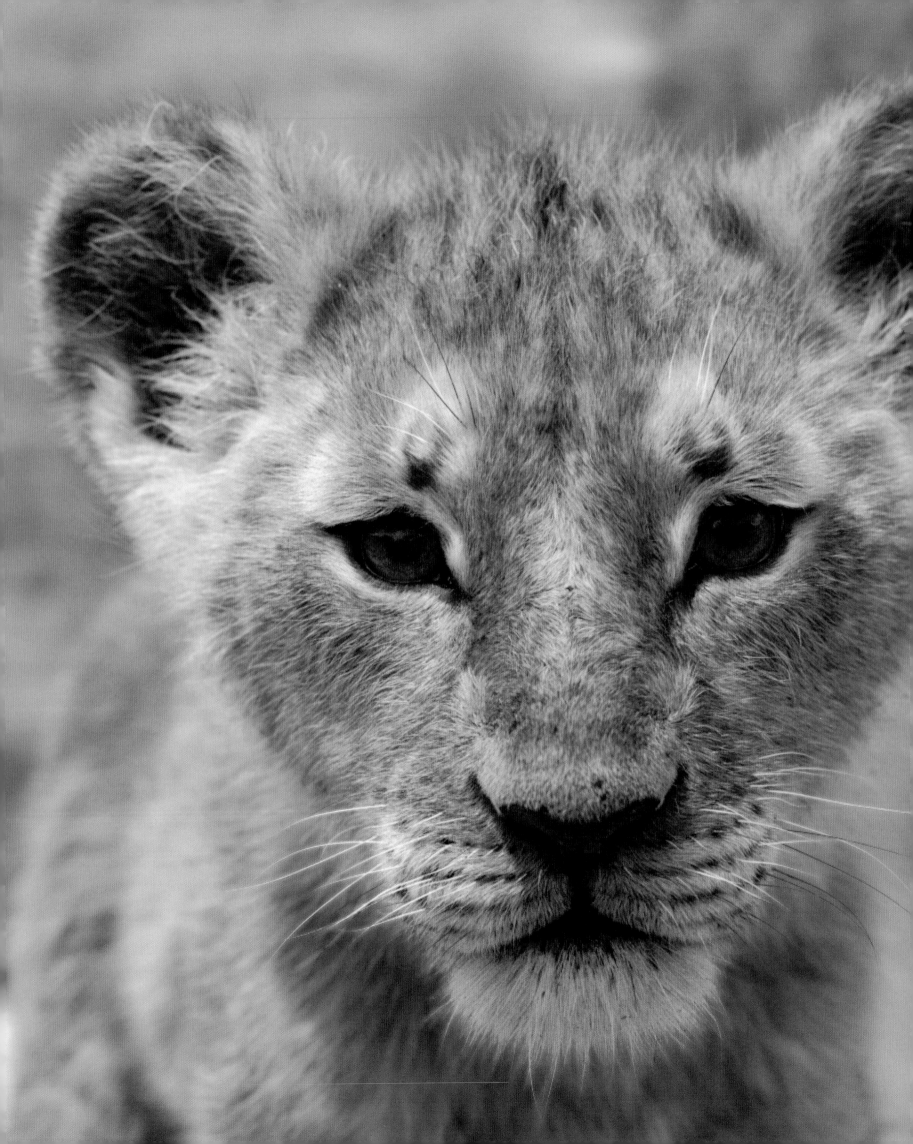

SIMBA CUB

~~~

**Meet Young Simba**

Young Simba, son of Mufasa and heir to the Pride Lands, begins his life as so many youngsters do—headstrong, and oblivious to the notion that decisions and actions have consequences. Banished from his homeland, Simba's journey is measured not just in miles but in the maturity he must develop and the courage he must summon to return and take his rightful place.

JD McCrary brings the innocence and energy of young Simba to perfect vocal life. JD and his brother, Josh McCrary, began their careers as a singing duo called AmaSing in 2015; JD also appeared on two episodes of *K.C. Undercover* that year. In 2016, he made a guest appearance in the video for Childish Gambino's song "Terrified," and the following year appeared on *I'm Dying Up Here* and *Teachers*.

JD performed the Jackson 5 classic "I Want You Back" live on *Little Big Shots* and "Who's Loving You" on *Ellen*, and appeared in Tyler Perry's *The Paynes* on the Oprah Winfrey Network. It was while working on that series that JD heard about auditions for a new retelling of *The Lion King*.

"I did have to audition. There were thousands of kids who were there, and I was in Atlanta at the time, shooting my TV show *The Paynes*. It was a self-tape that I had to do. Right around the same time, Tyler Perry said I was able to go home for a break . . . so I went home to Los Angeles and was able to meet the production team in person. I found out the next day I got the role! Shortly after that I started recording!"

A Disney fan, JD was excited to join the cast. "My favorite Disney movies would have to be, of course, *The Lion King*, *Aladdin*, and . . . I like *Cinderella*; it's a really good movie . . . and *Hercules*!"

JD also joined Disney's Hollywood Records as the youngest male solo artist ever signed by that label.

He enjoyed the process of voice recording for *The Lion King*, a departure for a performer used to being seen, and frequently in front of live audiences. "It's very different because you don't really have to use any body language," the young actor says. "You have to get all the action done with your voice. And I get to wear whatever I want!"

## Designing Young Simba

Since the Simba cub character is essentially the star of *The Lion King* for almost half the film, getting his design and performance correct was central to the movie's success. The process of researching their approach was among the most pleasurable aspects of the project for production designer James Chinlund and animation director Andy Jones, because they got the rare opportunity to observe lion cubs in their natural environment.

"Andy and I had a magical day at [Kenya's] Maasai Mara one day watching a young cub with his family," Chinlund recalls. "I noticed cubs, though cute, have incredible attitude. Seeing them move around, they have such powerful legs, yet are so floppy. You can really see the power that is in their futures, even though they are still clearly identifiable as toddlers."

Therefore, the process of designing the young Simba was all about capturing that feeling. "We wanted to express the idea of a kid who is slight, yet too big for his britches at the same time," Chinlund adds. "He's in a rush to grow up, with a twinkle in his eye, and clearly a tremendous power inside him that he has yet to realize."

Jones adds that in animating the character, filmmakers tried to give the cub "a swagger—[creating] a confident cub who thinks he can do it all, even if he has trouble just climbing a rock. His body is a bit too young, and his motor skills and dexterity have not quite caught up with his perceived prowess."

Texturally, the cub is defined by his rich and warm fur colors, along with his distinctive partial mane of lighter fur framing his face, and a subtle peak of fur on his head. Young Simba also features colored spots, common to lion cubs, over the white parts of his fur, and a long streak of dark-tipped fur covers a large portion of his back.

"His chin has strong and distinctively shaped white fur that echoes his father's," adds Jones. "He has alert hazel brown eyes with strong light and dark markings in the surrounding fur, and is slightly larger in comparison to the Nala cub."

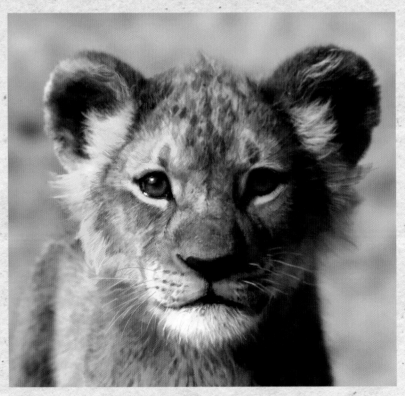

**Above and opposite page, top:** These paintovers of Simba cub features a partial mane, a small peak of fur on his head, and colored spots common to lion cubs. His chin is reminiscent of his father, Mufasa.

**Opposite page, bottom:** A photorealistic version of Simba.

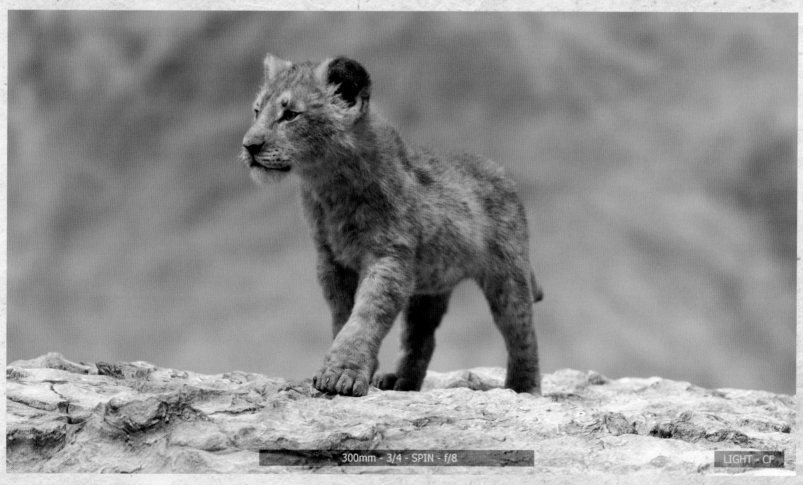

300mm - 3/4 - SPIN - f/8

LIGHT - CF

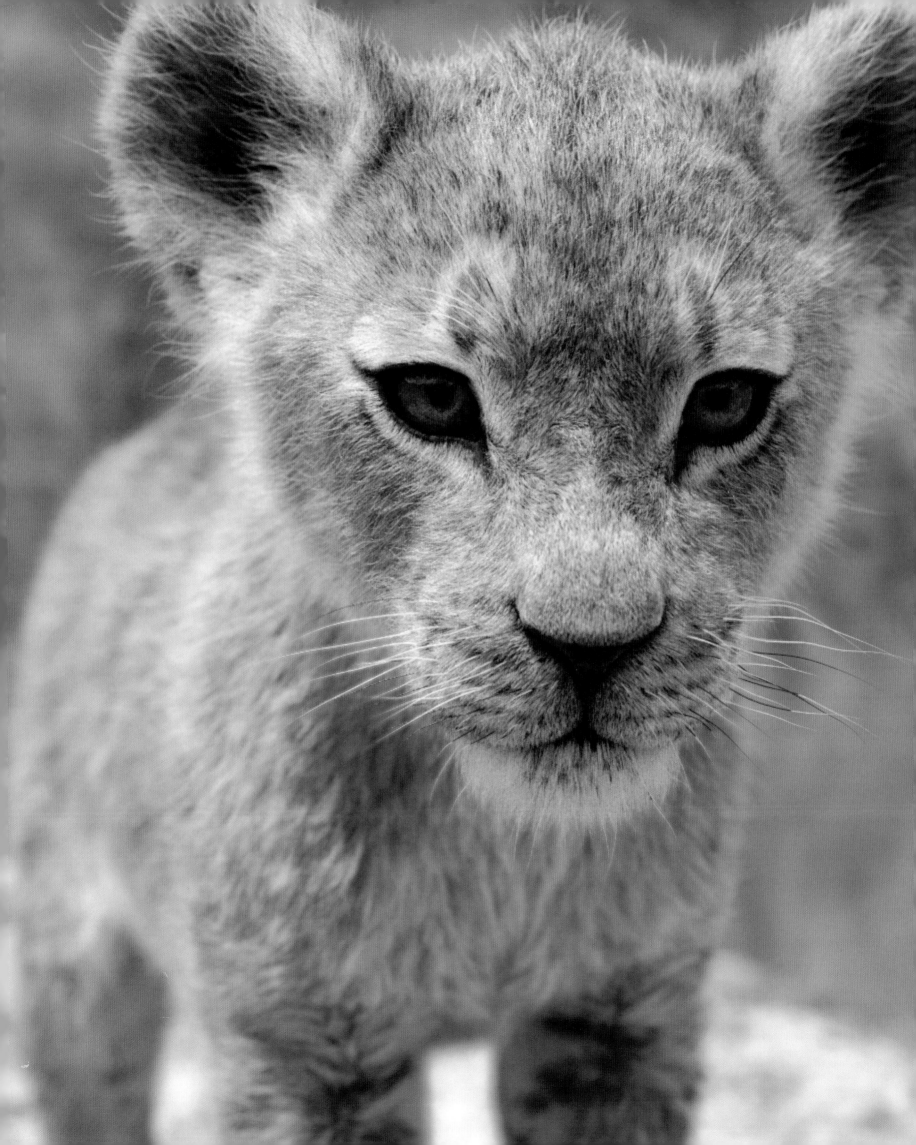

# NALA CUB

### Meet Young Nala

The young lioness cub Nala is a central figure in *The Lion King*. As Simba's childhood best friend and playmate, she has an important role in his development and in helping him surmount key challenges along the way—and in transforming her own childlike bravado into the essence of true courage.

Shahadi Wright Joseph is no stranger to the role—at the age of nine, she was the youngest actor to play young Nala in the history of the Broadway cast of Disney's *The Lion King*. She began her dance training in 2007 at Purelements: An Evolution in Dance (a nonprofit founded by her parents, Kevin A. Joseph and Dina Wright Joseph and Lakai Worrell), where she studied classical ballet, West African, modern hip-hop, and Caribbean dance.

The fourth-generation New York resident is involved in her school choir. When Shahadi is not performing in the theater, she enjoys knitting hats and making videos on her tablet with sister Sundari Adia Wright Joseph.

## Designing Young Nala

As animation supervisor Andy Jones puts it, early in the movie, Nala is "much like human kids—the girl is a bit ahead of the boy. She is smaller than Simba, but in many ways, a few years ahead of him in terms of rational thinking and dexterity. When they play fight, she gets the upper hand, and her overall navigation skills are much better than Simba's."

Thus, a big challenge in animating Nala was in getting her movements correct as juxtaposed with young Simba's. "We had to get that soft and cuddly feel to their movement, especially in the more dynamic sections where they are running, jumping, and tumbling," Jones elaborates.

The Nala cub's overall fur color is lighter than Simba's, with strong spots on her fur and forehead. She also has distinctive dark lines framing her light olive-green eyes and a sleek face, but with lots of wild fur around her ears and jaw. Her general build equals Simba's as a cub, even though she is smaller overall.

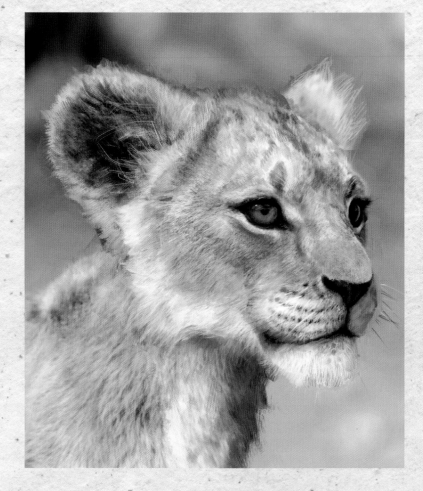

**Top:** A paintover image of Nala cub's face features strong spots on her forehead and dark lines framing her light eyes.

**Opposite page, top:** In this visual development art of Nala and Simba, you can see both cubs have similar athletic builds.

**Bottom:** Concept artwork of the best friends visiting the waterhole based on a site that filmmakers actually visited in Kenya.

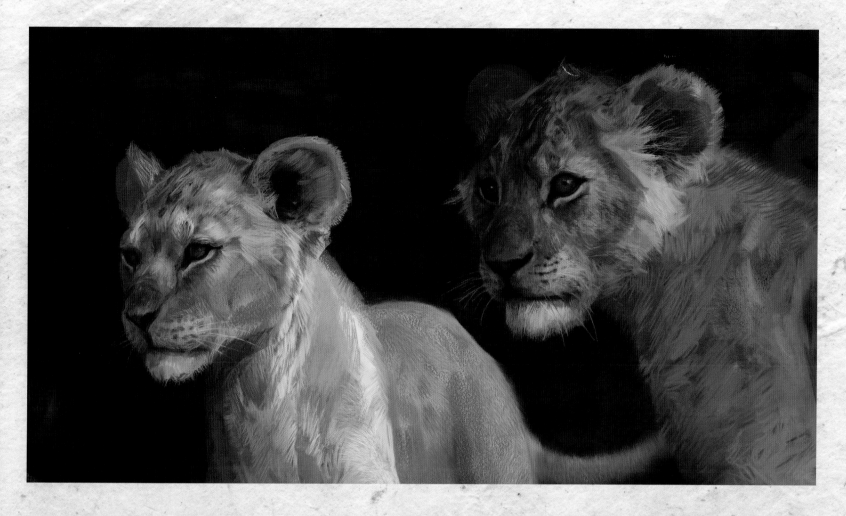

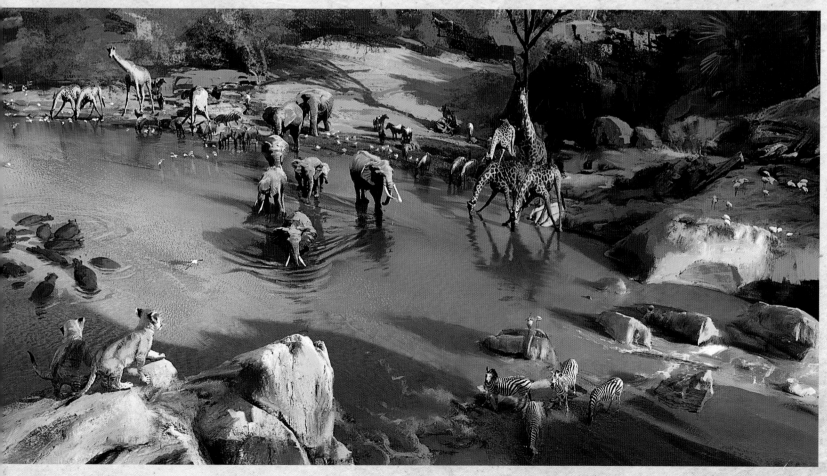

# ZAZU

---

**Meet Zazu**

Zazu is the king's majordomo, a trusted
advisor to Mufasa who sometimes provides comic relief,
as well. He's a fussy bird who is perhaps a bit self-
important, though Zazu also takes on the role of a
caretaker and conscience for the young prince, Simba.

Mining a media identity as a smart, acerbic, and funny "Brit," the role of the harried hornbill is artfully assumed by Emmy- and Writer's Guild Award-winning writer, comedian, political pundit, and television host John Oliver. He observes two key cultural connections to the *Lion King* tale: "I guess, generationally, people my age, who grew up with it—it's pretty much hardwired into your system as a classic, right from that opening scene. As a British person, I respond to it because it's still a story which has a fundamental respect for the concept of monarchy. . . ."

Oliver first gained fame as a cutting-edge political stand-up comedian, a status he has maintained ever since—to the degree that he was included in the 2015 *Time 100* issue, as a "comedic agent of change . . . powerful because he isn't afraid to tackle important issues thoughtfully, without fear or apology." He was "Senior British Correspondent" for *The Daily Show*, and ultimately won three Primetime Emmy Awards for his writing on that program. Oliver wrote and starred in the Comedy Central stand-up special *John Oliver: Terrifying Times*, followed by the series *John Oliver's New York Stand Up Show*, which he hosted for four seasons. With longtime collaborator Andy Zaltzman, Oliver co-writes and co-presents the satirical comedy podcast *The Bugle*. Oliver has acted and provided voices on television, including a recurring role on the sitcom *Community*. He has won six Emmy Awards and two Peabody Awards since 2014 as the host of the acclaimed and popular HBO series *Last Week Tonight with John Oliver*.

When asked about the rigors of his preparation for such an important cinematic role, Oliver muses, "I think you're mistaking me for Daniel Day-Lewis. If you're asking me whether I lived as a bird for six months? No, I didn't do that. I'm not an actor, really. All I have is this voice, louder or softer. That's it. I have no range. You might want to ask James Earl Jones, someone with the skill to back his answer up.

"What I do is, I read the words on the page, and then I kind of vomit them through my mouth," Oliver remarks. "And that is where my process begins and ends. Again, I cannot overstate the extent to which I have done literally *no* research on what birds do, because as far as I'm concerned, that's the animator's job. I'm basically trying not to mess up the script."

Clearly, Oliver's well-honed comedic sensibilities and British perspective are well suited to the eccentric personality of Zazu.

## Designing Zazu

Zazu went through "perhaps the most interesting evolution for us in that we were not sure a performance by a bird character could be charming or as entertaining as it was in the animated film," recalls Dave Lowery, the project's head of story. "A bird, when you look at it realistically, does not have a lot of character in their movement. They kind of twist their heads back and forth perhaps, or do the head-bob thing and look at you with one eye or another. But there is very little eyebrow expression and virtually no mouth expression—they just open and close their beaks."

Indeed, Zazu was designed and built to exactly resemble the look and characteristics of an actual African hornbill bird, but he is also among the funniest, most articulate characters in the movie.

"We had to play with the idea of how to get a bird to emote," says James Chinlund. "He is a direct translation of a hornbill from nature, but he talks and is very clever. So, in the design, we did a lot of careful work around the eye, with patterning and also a few extra folds and things to try and get different expressions out of him. He is pretty much verbatim to what we found in nature with how he looks and flies, but we were inspired by the haughty performance of John Oliver."

Andy Jones notes that real African hornbills actually "have a cockiness to them with the way they go about their business in terms of surveying their territory and searching for food." Filmmakers felt this was a characteristic that matched Oliver's "high-strung, sure-of-himself vibrato," according to Jones.

"The biggest concern with the character was lip-synch," Jones continues. "We knew Jon Favreau would give us no quarter for a deforming beak and anthropomorphic eyes and brow shapes. So we looked at the natural movements of these birds—their rapid, twitchy head motion. We animated that movement just right to time well with dialogue, accenting just the right words to help sell that this bird was thinking and saying these lines. We also found these birds can splay feathers on the tops of their heads, much like cockatoos. We used this to show agitation and accent some of the dialogue, much like a human might use their brows."

Zazu features a specific ridge halfway down his orange-red beak, a distinctive "Mohawk" of feathers on his head—white on the sides and black in the middle flowing down his neck, which helps define his distinctive hornbill "sickle" silhouette.

**Opposite page:** Visual development art of Zazu, who was painstakingly built to exactly replicate an African Hornbill bird from nature. Getting the bird to emote in a way that worked cinematically was the big challenge for animators.

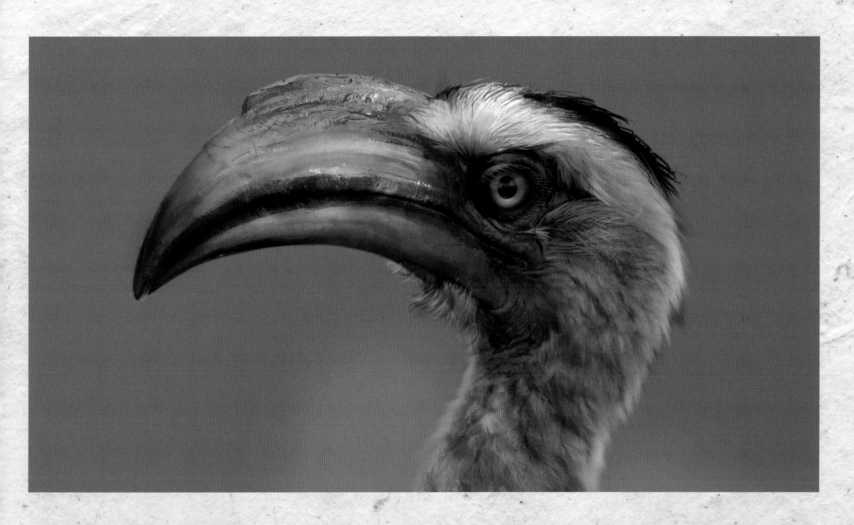

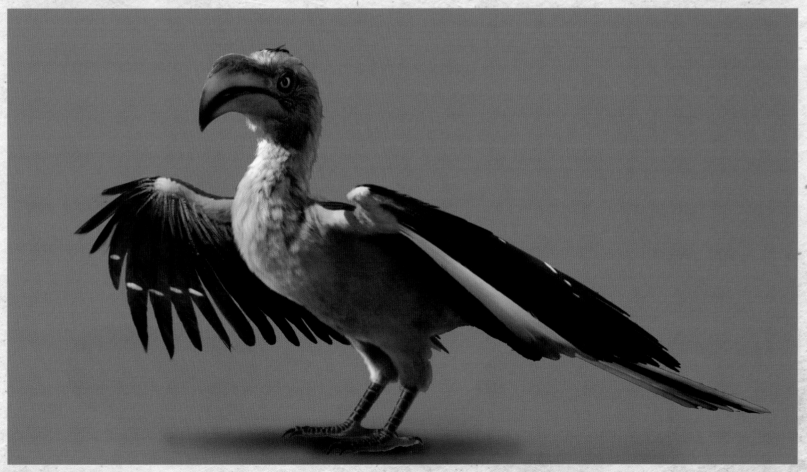

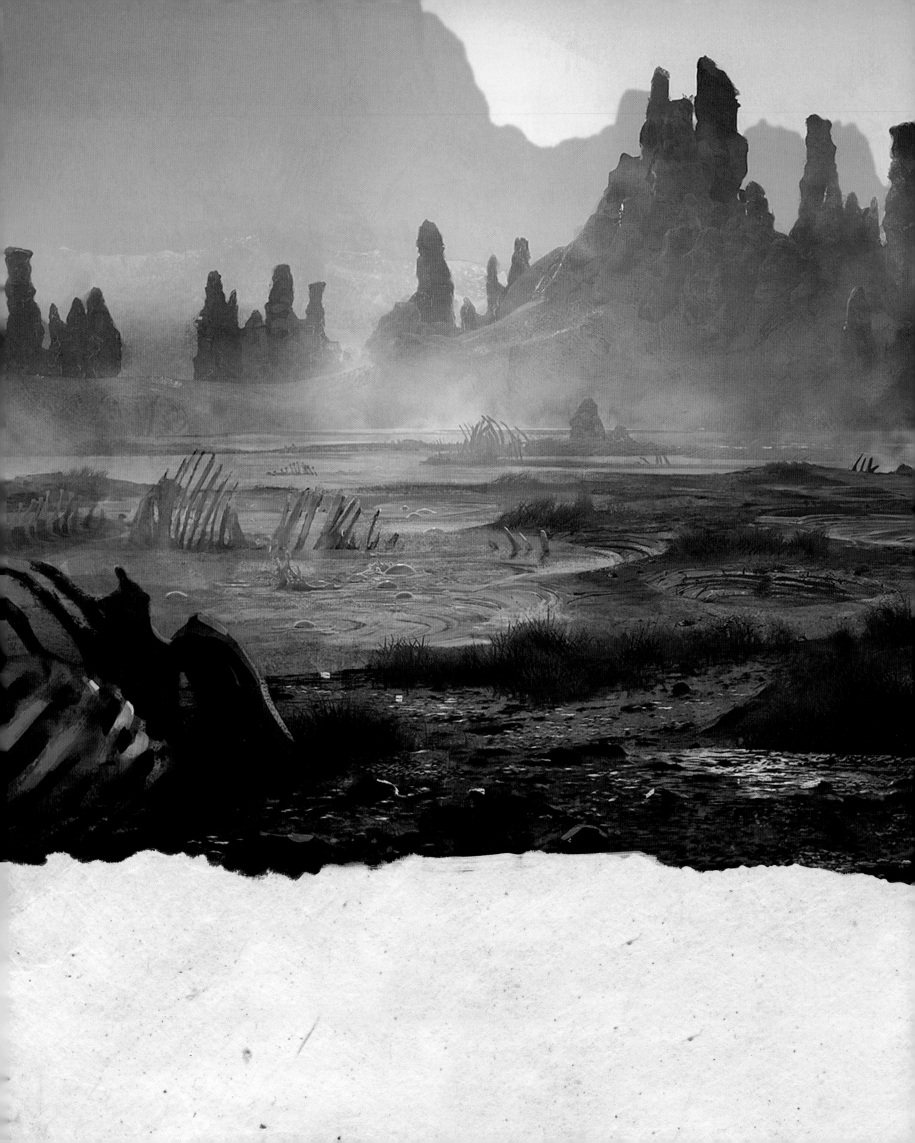

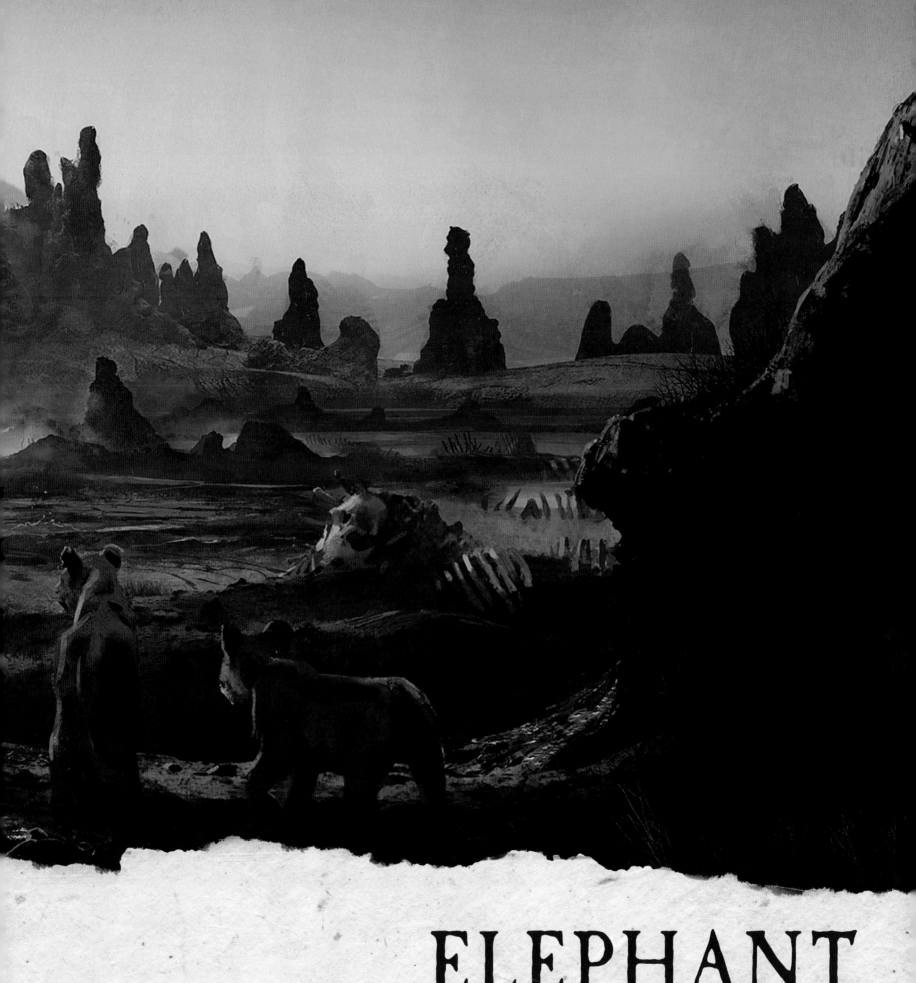

# ELEPHANT
# GRAVEYARD

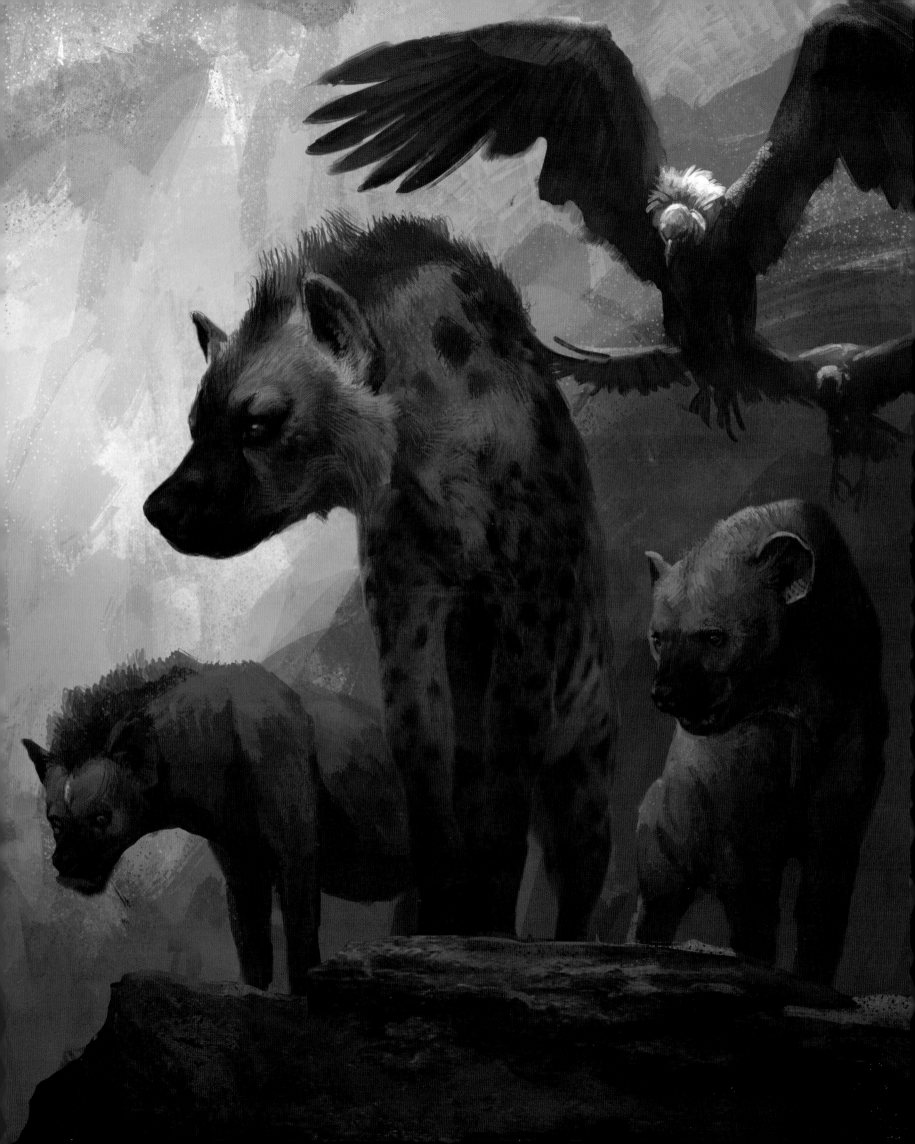

# CHAPTER FIVE

### Elephantine Myth and Reality

Like lions, elephants roam in social groups, following a female leader or matriarch. Older males, or bulls, form groups of male elephants and travel separately. Elephant herds follow precise migration routes, which have remained unchanged for generations. But injured, old, or weary elephants may settle in places with easier access to water and food. They don't choose these locations for mystical reasons or because they are preparing for death, but for the most practical reasons of survival.

However, in time—due to a lack of dietary variety, illness, injuries, or old age—these smaller pockets in the overall elephant population die, resulting in a noticeable concentration of carcasses within a single location. Some of the "elephant graveyards" occur because of environmental factors, such as drought or poisoning. Herds of elephants died in close proximity to a series of poisonous lakes in East Africa, for instance, and Lake Rudolf in Kenya has an abundance of elephant remains because herds that used it as a watering hole were felled by a deadly salt content in the water.

There is a long-standing sentimental notion that the elephants return to these "graveyards" to pay their respects to the lost. While there's no evidence to support this idea, researchers from Great Britain's University of Sussex discovered that elephants *do* interact with the remains of their own kind when they come across them. They do not ritually travel to solely pay respect to these remains, but if encountered during migration, they have been observed stopping and giving attention to them.

The Elephant Graveyard was one of the most complicated locations to design for *The Lion King* because, as production designer James Chinlund notes, "It's a fantastical place in that it is not represented in nature. There is no one place where elephants go to die and leave their bones."

It's a mythological place in the story narrative—a dark, shadowy, misty location outside the boundaries of the Pride Lands, littered with elephant skeletons, where only the hyenas dare live, and where they conduct their nefarious negotiations with the film's antagonist, Scar.

Visual development art of the main hyenas—Azizi, Shenzi, and Kamari—and some menacing vultures echoes the foreboding mood of the Elephant Graveyard scenes in *The Lion King* (2019).

## A Sacred Place Emerges

Because there is no one-to-one location match for the Elephant Graveyard in the real world, filmmakers faced the challenge of "how to pursue something familiar to the audience but grounded in reality so that we could explore different ideas about how this place with a collection of bones might happen," James Chinlund relates. Their real-world reference turned out to be a large sulfur lake called Lake Abbe. There, they discovered what Chinlund calls "incredible towers of limestone formations [known as limestone chimneys], and also mud pits. So we played with the idea of something similar to the La Brea Tar Pits [in Los Angeles]—a place where animals would have gone seeking water before becoming trapped by mud. And with their corpses lying around the edges of these mud pits, hyenas would naturally gravitate to such a place, because it would be ripe picking for scavengers."

Opposite page: Ominous paintovers of the Elephant Graveyard with its "incredible tower of bones" that the hyenas call home.

Above: Limestone rock "chimney" formations surround the real-world Lake Abbe, which spans two African countries, Ethiopia on the west and Djibouti on the east. They provided key design reference for the Elephant Graveyard, since no such location actually exists in nature.

## Building Towers

Filmmakers thus designed what James Chinlund calls "incredible towers" of bones that almost resemble a castle where the hyenas could base their kingdom. "That wound up being a really serendipitous solution for us, considering there was no real elephant graveyard for us to emulate."

Design of the Elephant Graveyard's towers also employed new 3-D printing and carving technologies, as did certain other portions of the movie. Chinlund's team was able to print out physical foam models of the towers from digital files, sculpt and refine them, and then scan them back into the computer and add those data to their digital sculpts.

"That was a real interesting tool to help us visualize the environment," Chinlund says. "I had done some 3-D printing before, but never used it in quite the same way to inform design like we did on this movie. Particularly for the Elephant Graveyard, we did some sculpting on the towers and were then able to reinform the development of that design in digital space. It was an interesting sort of boomerang process, where you take it out of the computer into the physical world, and then put it back into the computer again."

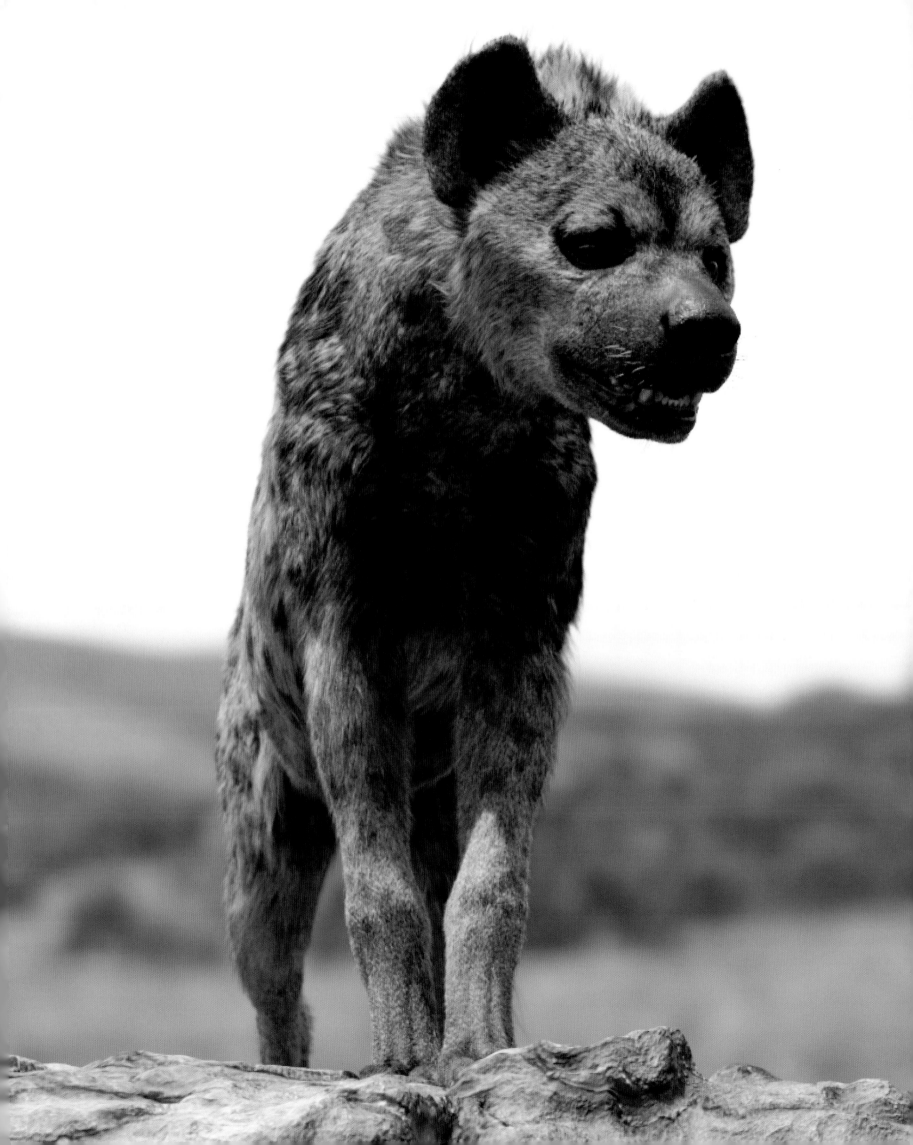

# SHENZI

## Meet Shenzi

"She's the leader of the gang, and it's true about actual hyenas," says Alex Kupershmidt, an original animator of the character. "They're led usually by females, by what is known as an alpha female, so her character was always cool, always scheming, very rarely lost composure. . . ."

Shenzi may sometimes seem almost sassy, but she has a longer and more calculating view—and has a longer fuse than most of her companion hyenas. Her intelligence is clearly superior, and her planning and command in serious situations are evident. Her sense of humor is a malicious one. Although her loyalties may seem obvious, in the end she is loyal to only one.

Bringing an inspiring vocal life to Shenzi is German Ugandan stage, screen, and television actress Florence Kasumba.

Famed for her work in German and Dutch films, Kasumba is probably best known for playing Ayo in *Captain America: Civil War*, *Black Panther*, and *Avengers: Infinity War*. She also played Senator Acantha in 2017's *Wonder Woman* and the Wicked Witch of the East in the television series *Emerald City*.

Kasumba was inspired to become a performer after seeing the musical *Starlight Express* at age twelve, and she earned a degree in acting, singing, and dancing from Fontys University of Applied Sciences in Tilburg, the Netherlands. While she was still a student, Florence landed her first professional film role, Silke, in the Dutch motion picture hit *Ik ook van jou* (*I Love You Too*). After graduating, she performed in musicals such as *Chicago*, *Cats*, *West Side Story*, and *Evita*, plus starred as Lisa in Germany's premiere cast of *Mamma Mia*. Kasumba has a strong history with the Disney Theatrical Group as well, appearing in productions of *Beauty and the Beast* and *The Lion King*—as well as in the title role of Germany's premiere production of Elton John and Tim Rice's *Aida*.

Her thoughtful perception of the character was highly influential to the filmmakers. "Hyenas and lions have been at war all the time, so she is someone who wants to have power," Kasumba says. "She is also someone who doesn't feel comfortable with her life. . . . She is a leader, but she's also a threat—and definitely someone you can't trust.

"I try to get all my information from the script, so I went through it and got little hints—Shenzi has a few lines where you get the idea, 'Okay, others respect her . . . she's "somebody" . . . [but] people are scared of her; she enters, and everyone is quiet,'" Kasumba observes. "These were things about her that I didn't feel when I watched the original animated film. I had a feeling those hyenas were funny—you can always laugh with them. These hyenas are dangerous."

## Designing Shenzi

The nefarious hyena clan in *The Lion King* posed similar design and animation challenges to those of the lion pride—in that figuring out variations in the look and performance of important hyenas in the film was difficult, since all hyenas typically look similar. In the case of Shenzi, the path to illustrating her individuality lay in her leadership position as hyena queen and the vocal performance of the actress playing the role, according to production designer James Chinlund.

"We wanted to capture a queen who commands a shadowy empire," Chinlund explains. "So we looked at the [vocal] performance of Florence Kasumba. Her voice was a deep, powerful inspiration for us. She also has incredibly powerful eyes, so we played with markings on Shenzi, this sort of triangular shape on her forehead, a slight rusty sort of Mohawk—anything we could do to give her sort of a regal countenance."

Head of story Dave Lowery adds that the portrayal of Shenzi, and all the hyenas, is darker and more serious than in the original animated movie, "almost like a gangster movie, with more

gravitas when she goes to make a deal with Scar in the Elephant Graveyard. There is more threat there, more at stake as the two sides negotiate over how they can work together to take over the Pride Lands."

Shenzi is the largest hyena, with a heavy spotted pattern on her body and a distinctive mane that is long and rich orange in color. She also has hooded, dark eyes and specific fur patterns around her eyes and on her forehead.

**Page 110:** The photorealistic version of Shenzi was designed to highlight her intelligence and leadership position.

**Opposite page, and above:** There is a threatening tone to her character and pack, too, as these visual developmental artworks illustrate.

# KAMARI

### Meet Kamari

Completing leadership of the hyena clan,
essentially hired out to serve as Scar's hench-
men, are the male hyenas Kamari and Azizi.

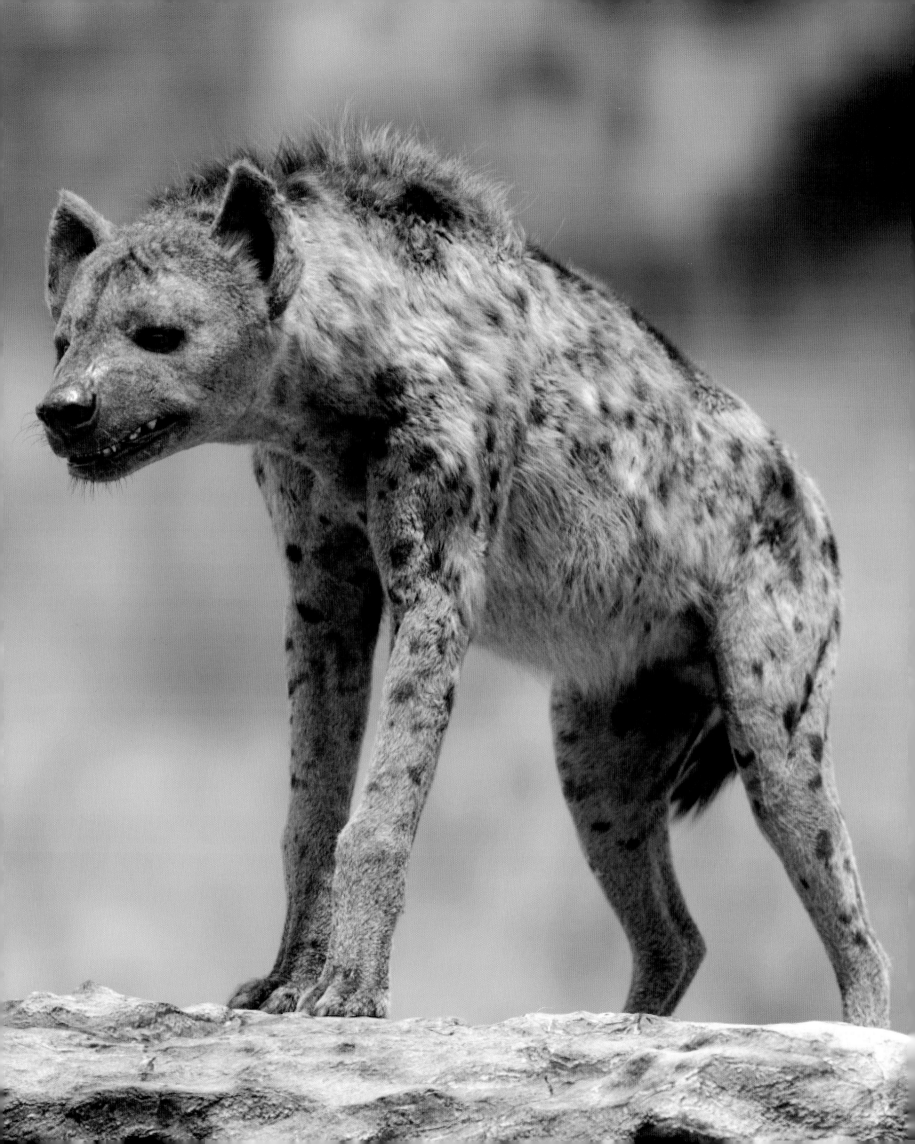

Actor, comedian, writer, and producer Keegan-Michael Key provides the voice of Kamari. Key may be best known as co-creator and co-star (with Jordan Peele) of the Emmy and Peabody Award-winning series *Key & Peele*, and his six seasons in the ensemble of *Mad TV*. Notable television appearances include the first season of the series *Fargo*, a recurring role on *Parks and Recreation*, *Reno 911!*, *Gary Unmarried*, *Playing House*, and *Friends from College*. His several films include *Let's Be Cops*, *Tomorrowland*, *Pitch Perfect 2*, *The Predator*, *Dolemite is My Name*, and *All the Bright Places*; he produced and starred in the film *Keanu* with Peele. Key has even appeared on Broadway, making his debut in Steve Martin's comedy *Meteor Shower*.

The actor's voice work is also demand, he has been heard in the films *The Lego Movie*, *Hotel Transylvania 3: Summer Vacation*, *Toy Story 4*, and the TV series *Archer*, *Bob's Burgers*, *SuperMansion*, *Bojack Horseman*, *The Dark Crystal: Age of Resistance*, and *Green Eggs and Ham*—but *The Lion King* marks a connection with Key's lifetime love of Disney.

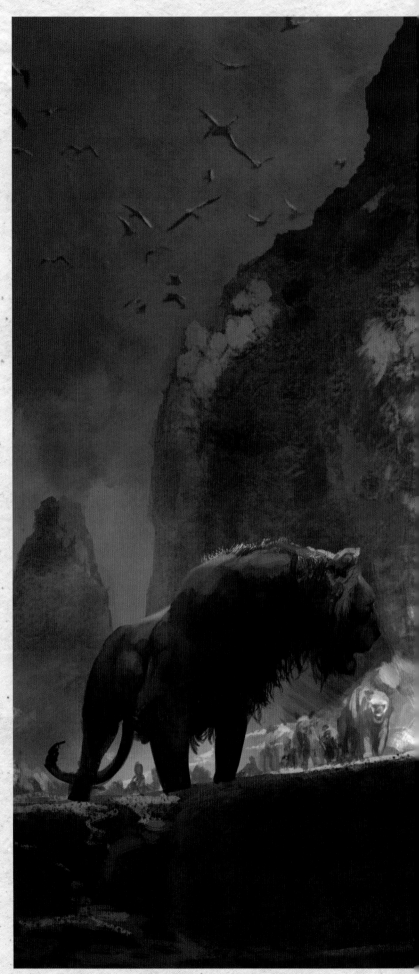

**Above:** Early sketches of Kamari

**Opposite page:** Visual development art of the hyena pack having a clandestine meeting with Scar to plot their takeover of the Pride Lands.

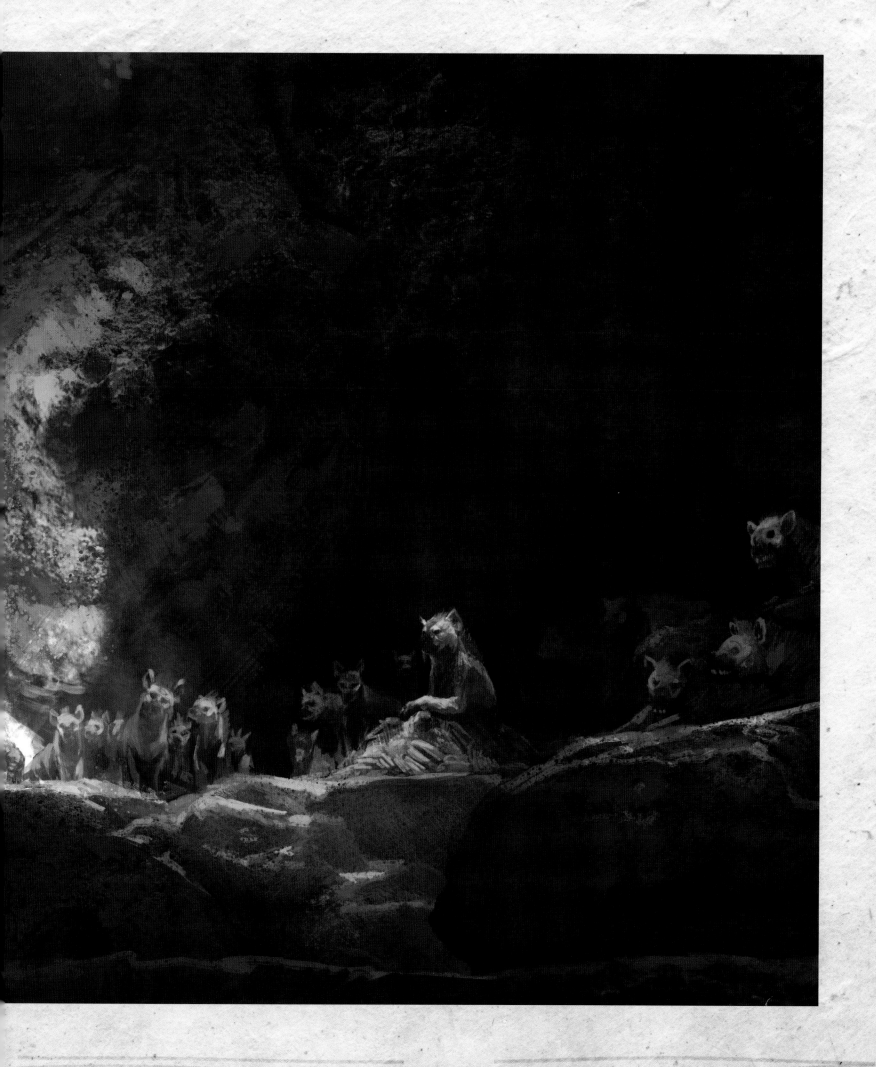

# AZIZI

## Meet Azizi

Enjoying his partnership with Keegan-Michael Key by playing Kamari's companion hyena, Azizi, is actor, comedian, and television host Eric Andre. "Keegan's awesome," Andre says, "He's such a brilliant improviser, and he's such a giant comedic brain—he makes life a lot easier."

Eric Andre earned a BFA in double bass performance from Berklee College of Music in Boston, after graduating from Dreyfoos School of the Arts in West Palm Beach, Florida. He began his career as a stand-up comedian, and had roles on the TV series *Two Broke Girls*, *Don't Trust the B- in Apartment 23*, and *Man Seeking Woman*. He is the creator, host, and co-writer of *The Eric Andre Show* on Adult Swim, and also voices Luci in the Netflix animated series *Disenchantment*.

As for his entry onto this prestigious project, Andre is reflective. "They just offered [it to] me. I just say yes to everything. I don't even know what this is. I don't even know where I am. I love Jon Favreau, and I love *The Lion King*—it was a pretty easy yes.

"I am a sociopath, so I connected with the hyenas a lot, because they're concentrated evil . . . I loved the hyenas in the original, and I love that they are comic relief for a pretty serious . . . family movie. I can laugh like Krusty the Clown [from *The Simpsons*]. I can laugh like the Cheshire Cat from *Alice in Wonderland*. So, any character where I can laugh maniacally, I'm pretty excited to play."

## Designing Kamari and Azizi

As in nature, hyena society in the movie is matriarchal, and females are larger and more dominant than males. Therefore, Kamari and Azizi are both noticeably smaller than Shenzi. Kamari has an overall skinny build with light-and-dark-spotted fur, dark patches on the top of his mane, and a distinctive angular and asymmetrical dark pattern around his eyes. Compared with Shenzi, his fur is more monochromatic and his mane is shorter and darker.

Azizi is the largest male hyena in the story, though he's still smaller than Shenzi. He features a stockier build, darker fur, and a less strong spotting pattern on his body and face than Kamari; plus, he has a very small mane. As with many male hyenas filmmakers watched and photographed in the wild, Kamari and Azizi have been in a lot of scraps, and thus both of them have numerous cuts and scratches, particularly on their muzzles.

At the same time, the male hyenas are meant to be bumbling sidekicks, "with an almost Ralph Kramden and Ed Norton sort of feel to them," according to Dave Lowery. "Azizi is more powerful and lumbering, while Kamari is more wily and cunning."

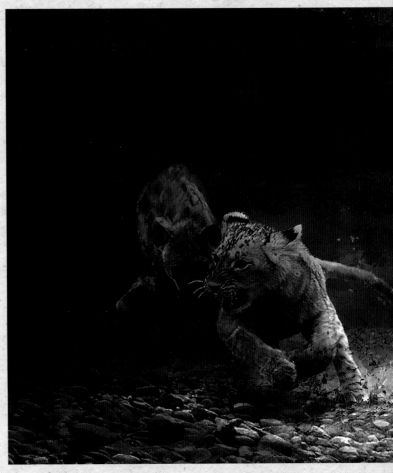

**Above and opposite page, top:** Early visual development art of Azizi

**Opposite page, below:** The visual development piece of the hyenas chasing Simba.

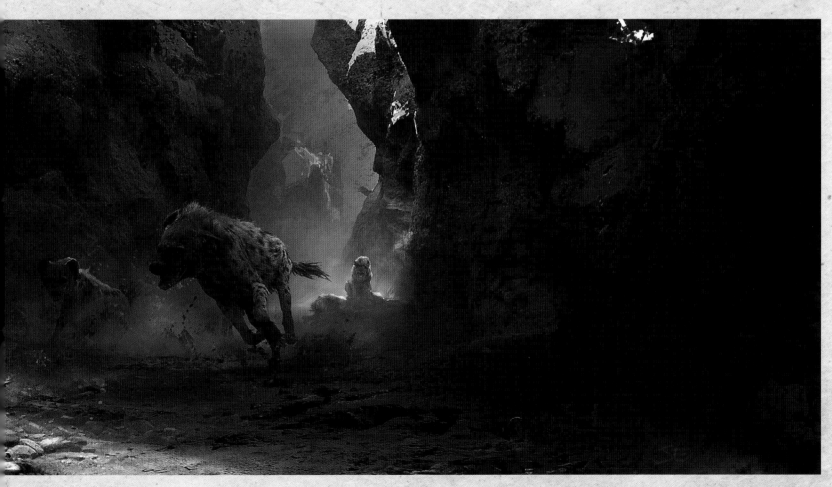

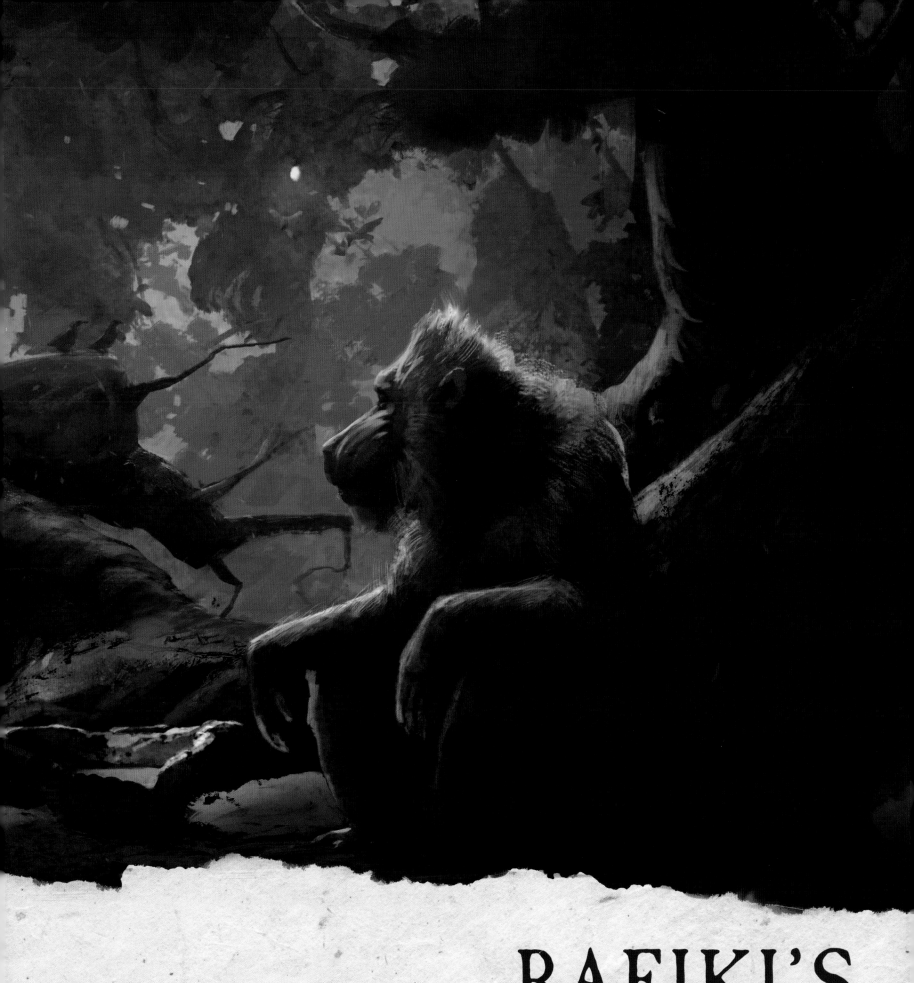

# RAFIKI'S WORLD

# CHAPTER SIX

## A Shaman's Realm

Shamans are beings of magic and faith, at once grounded in the daily realities of a society but ever-connected to the realms of nature and the spirit. Rafiki is the shaman of the Pride Lands, and a revered and respected seeker and teacher.

A shaman frequently enters altered states of consciousness to know and interact with worlds or ideas beyond the literal, and to help channel transcendental energies into this world. The shaman seeks truth, health, and a balance in the circle of life; to bring guidance to misguided souls; and to ameliorate illnesses of the soul caused by magical mischief, impure objects, substances, or life events—or even the ancestors, either through malevolence or neglect of their memory.

The term *sangoma*, as employed in Zulu and congeneric languages, is effectively equivalent to shaman. Sangomas are highly revered and respected in their society. For harmony between the realms of life and death—vital for an untroubled life—the connection between ancestors and the living must be shown unwavering respect and understanding.

Although intimately involved with their society, shamans frequently separate from it in order to observe their calling in a "place apart" such as a forest or cave, since the practice of the art and magic of the shaman requires solitude and concentration. In some myths, the shaman figure takes the form of a teacher/wizard such as Merlin, living in a half-world of spirit and the earthly.

For Rafiki, a home of his own was created to reflect his meaning, his purpose—and his singular personality.

Visual development art of Rafiki from *The Lion King* (2019).

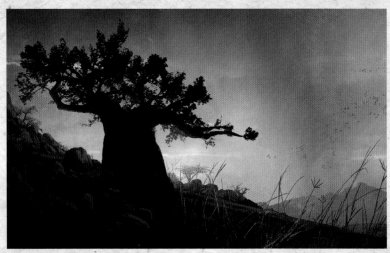
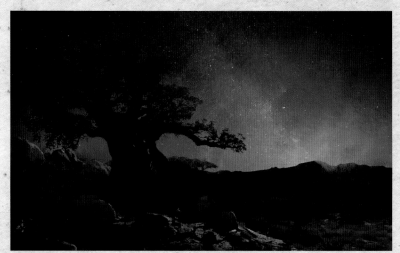

## High Up in the Baobab Tree

Rafiki's importance in the story, and in the culture of the Pride Lands, dictated a particularly special place to "base" the character. At the end of the day, filmmakers settled on making his home a baobab tree—a unique, fruit-bearing tree and water source that exists only in arid climates, and a well-known and iconic feature of African bush country. James Chinlund says filmmakers strategically designed Rafiki's tree "as its own ecosystem, with the idea that Rafiki is sort of the conductor of a symphony of life going on all around him."

Therefore, the tree features weaverbird nests and a wide range of bugs and other small creatures that live inside Rafiki's orbit, with him functioning as "the master of this contained world," as Chinlund puts it. "It was partly designed along the lines of [the BBC's famous] *Planet Earth* documentaries."

Head of story Dave Lowery adds that "we tried to make his world a little mystical or magical up in that tree, with glowing incandescent bugs swirling around there at night, and lots of birds—a kind of hub for certain animals. They are tiny guys who pass through his tree, and in a sense, Rafiki knows them all. That

gave the location purpose, and it's quite beautiful when you see how it has been lit by Caleb Deschanel."

A key example of the mystical yet contextually believable "magic" that occurs in Rafiki's world is the glyph, or icon, that he creates on his tree to represent his friend Simba. In the original animated movie, Rafiki creates the symbol by essentially painting it. But since director Jon Favreau wanted only realistic movements out of the characters, and an obviously different tone, he devised the idea of Rafiki herding his insect friends together and blowing powder on them, leaving a mark on his tree that turned out to be Simba's symbol.

"It was sort of like a magic trick that you could explain through coincidence or a sort of synergy of the natural world," Chinlund explains. "It relieves us of the onus of presenting Rafiki as a human-like character, and left the door open that we were keeping him as a monkey who uses his environment in ways that are physically possible and plausible for the audience to believe."

**Above:** Visual development art explores the different moods of Rafiki's home in the baobab tree through atmospheric color shifts. All lighting for those different times was painstakingly designed by cinematographer Caleb Deschanel in the virtual world, and then executed during post-production.

Note Rafiki's calm and wise eyes and muscular build
in this visual development character portrait.

# RAFIKI

## Meet Rafiki

Rafiki is an extremely important character in *The Lion King*—a strange and wise mandrill who serves as "an avatar for the viewer" as we move through the story, in the words of James Chinlund. Rafiki is shaman, guide, teacher, and conscience. Using an elixir of magic, nature, and common sense, Rafiki is Simba's guide on a hero's journey.

A peculiar combination of gravitas, eccentricity, and authenticity is brought to the role by Bonisile John Kani, South African actor, director, and playwright.

Best known to movie audiences today for the role of T'Chaka in the Marvel Studios blockbusters *Captain America: Civil War* and *Black Panther*, Kani's career began in Port Elizabeth, South Africa in 1965, when he joined an actors' group called the Serpent Players (their first performance was in the former snake pit of a zoo). There he honed his craft and collaborated on innovative shows that were performed to great acclaim.

Those accomplishments were followed by two renowned plays, *Sizwe Banzi Is Dead* and *The Island*, co-written with Athol Fugard and Winston Ntshona. The two plays were presented in repertory at the Edison Theatre in New York City for a total of fifty-two performances. Kani and Ntshona shared the 1975 Tony Award for Best Performance by an Actor in a Leading Role in a Play for *Sizwe Banzi Is Dead*. Kani also received an Olivier Award nomination for his role in *My Children! My Africa!*

In 1987, Kani became the first black man to play the title character onstage in a production of Shakespeare's *Othello* in South Africa,

which was still under apartheid at that point. "At least I'll be able to kiss Desdemona without leaving a smudge," he said then, poignantly.

First performed in the Market Theatre in Johannesburg, South Africa, *Nothing but the Truth* was Kani's debut as sole playwright. It is a story of rivalry and reconciliation focusing on two brothers, one who stayed in South Africa to fight apartheid, the other who left only to return with its demise. The play was widely praised, and won the Fleur du Cap Awards for best actor and best new South African play.

Kani is executive trustee of the John Kani Theatre Foundation, founder and director of the John Kani Theatre Laboratory, and chairman of the National Arts Council of SA.

## Designing Rafiki

Rafiki is a realistic-appearing mandrill with a distinctive red nose and light blue ridges on his face, a large and wrinkled muzzle, and eyes framed with a large protruding brow on top with heavy skin wrinkles to the sides. He also has a large head of

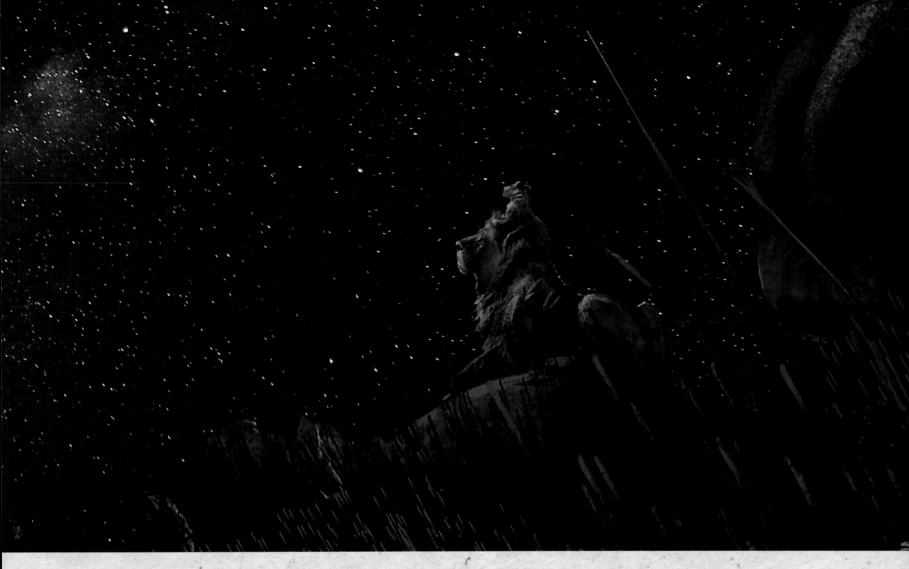

long, wispy, white fur, all striped with patterns distinctive to the mandrill species. Dave Lowery points out that Rafiki's fur is "messy and eccentric, sparse in areas like the shoulders, revealing his skin, and he has an old, wizened face. He is old, weathered, and wrinkly, but his eyes are bright and piercing."

However, Rafiki is a lot more than his realistic design. He is a shaman for the Pride Lands' animals, and yet looks like a real mandrill. This posed a challenge to filmmakers, because the role Rafiki plays in the story is the most humanlike role, and yet, "we had to make his movement more realistic and less anthropomorphic than [in the animated film]," according to animation supervisor Andy Jones. "That meant no tools—no cane, as he had in the original movie. That proved quite challenging for the animation team to bring out the mystery of a shaman-like character with limited props."

Dave Lowery adds that "we didn't want him doing martial arts and things with his stick, as in the original movie, so we had to get back to basics and make that work for our scenes with appropriate behavior." Therefore, filmmakers gave Rafiki what Lowery says was "more exploration than most of the other characters." By that, he means director Jon Favreau

actually took the time to perform the character on video for his colleagues to give them an acting reference. Additionally, well-known motion-capture actor Terry Notary came in and performed apelike movements for reference cameras to give animators additional guidance to go along with their observations of real primates in the wild.

"We drew from the footage, of Jon, for the scene of the first time we see Rafiki in his tree, creating the [Simba glyph]; and then over time, we came up with several different versions of how he does it," says Lowery. "I believe Jon did something similar to give reference for the King Louie character in *The Jungle Book*."

"At the end of the day," adds James Chinlund, "he is a monkey that exists parallel with the lions, on the same plane of evolution. They are not meant to be humans or evolved. They happen to speak and sing, but they do not use tools. So creating Rafiki was a big challenge, to give him that shaman-like aura and still have him feel authentic and wild."

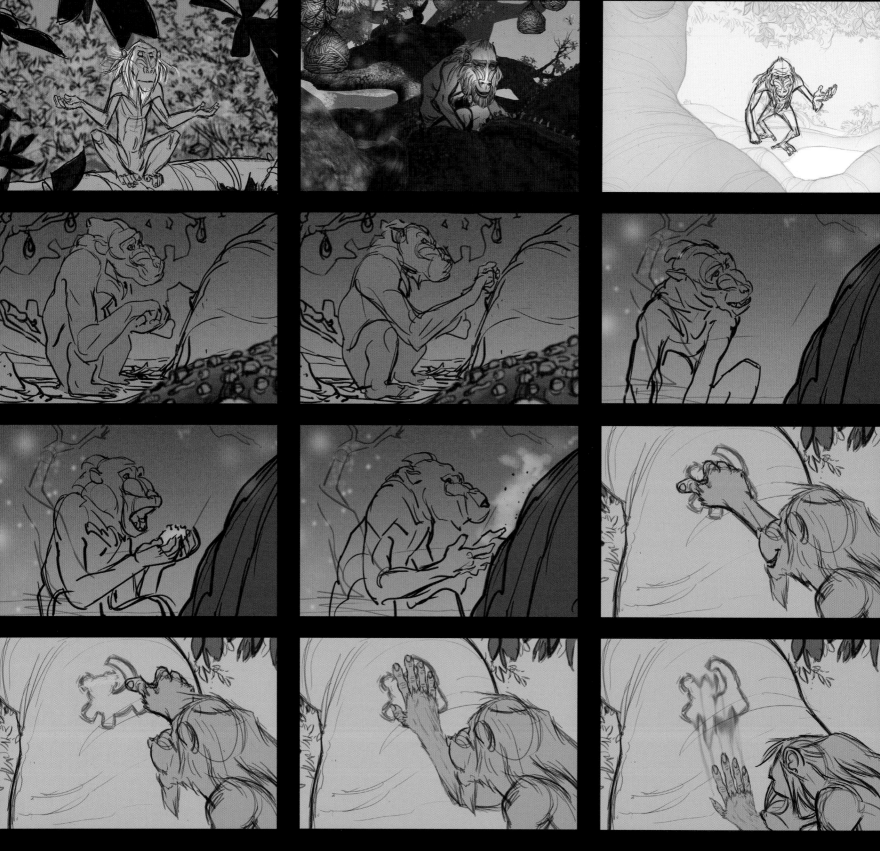

Pages 130-131: The mood during Mufasa and Simba's moment looking upward at kings of the past, shown in visual development art, pairs well with the essence of Rafiki's magic and importance in the film.

Above: A series of story sketches illustrate Rafiki's physical actions as he builds the iconic glyph of Simba.

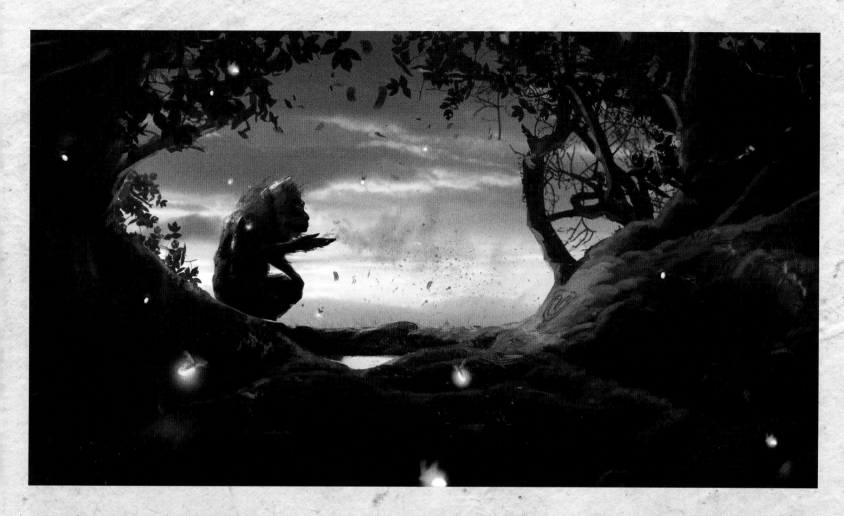

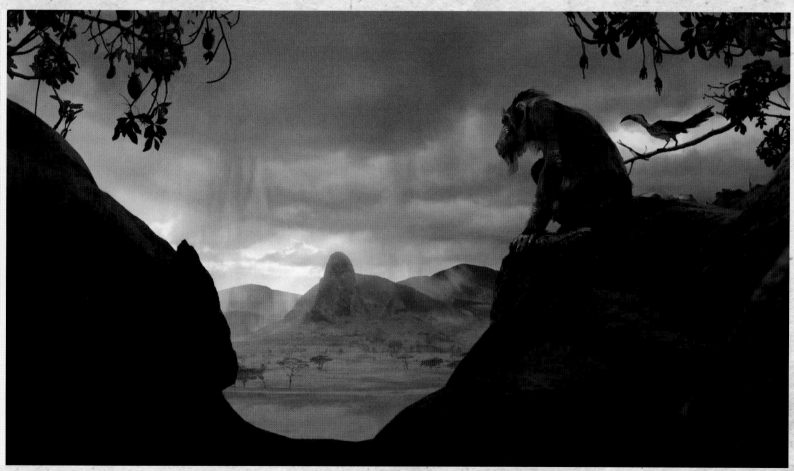

# WILDEBEEST
## GORGE

# CHAPTER SEVEN

### The Migration of the Wildebeest

Every year, a great migration occurs in East Africa. Herds of wildebeest and zebra—and a host of predators as well—make a circuit across the Serengeti Plain, moving from Tanzania into the Maasai Mara in Kenya and back, following the new vegetation that results from the seasonal rains.

Wildebeest calving season begins in February, and between April and May, the long journey to the Maasai Mara begins. More than a 1,500,000 wildebeest, 200,000 zebras, and 350,000 gazelles are part of this remarkable processional, moving north toward Maasai Mara before returning south again, a perilous 1,800-mile route for survival. Typically, a quarter million wildebeest do not live to make the return.

The dramatic and cinematic possibility of such a mass exodus—millions of hooves pounding the earth, the sheer force and spectacle of such an event—has served its tragic purpose, though with decidedly different executions in each iteration of *The Lion King*.

The stark contrast between light and shadows in this visual development art depicts the sense of despair during *The Lion King* (2019) scene where Simba comes upon his fallen father in the gorge.

**Right and below:** Reference photos from the Africa scout were used for canyon research for the film's gorge location.

**Opposite page:** A series of story sketches designed to help map out the depth and breadth of the wildebeest stampede sequence at the gorge. The bottom right art suggests the epic consequences the moment has on Simba's life.

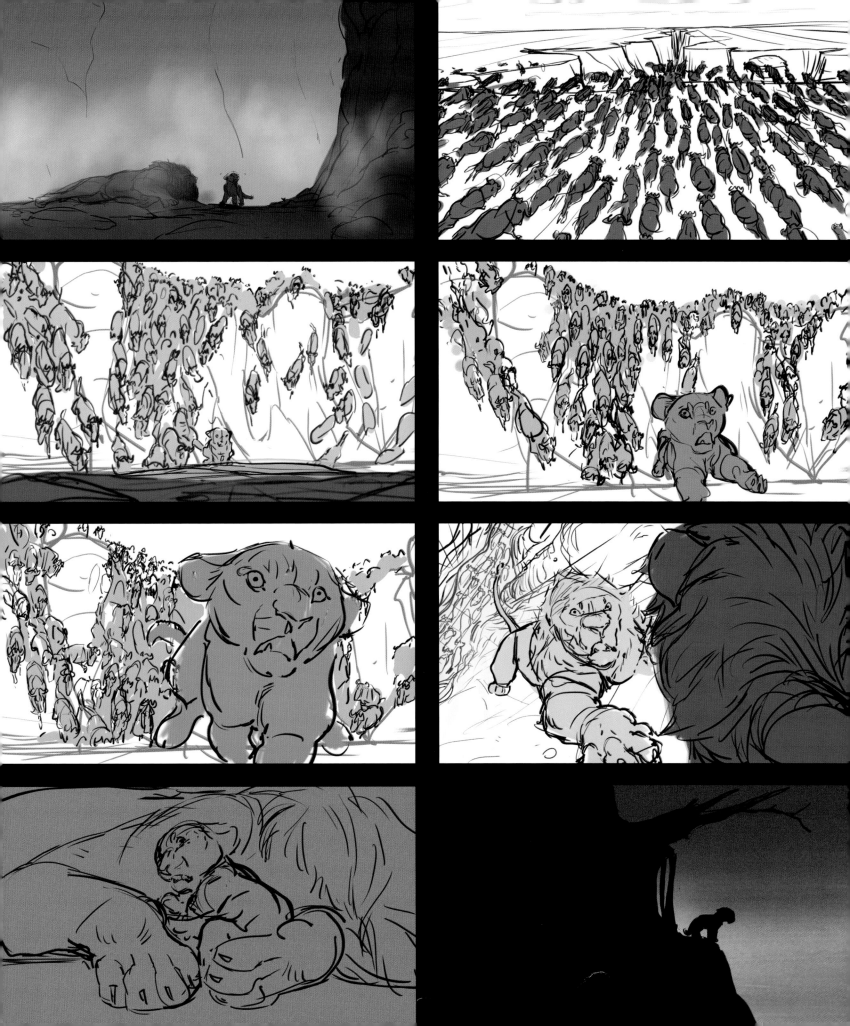

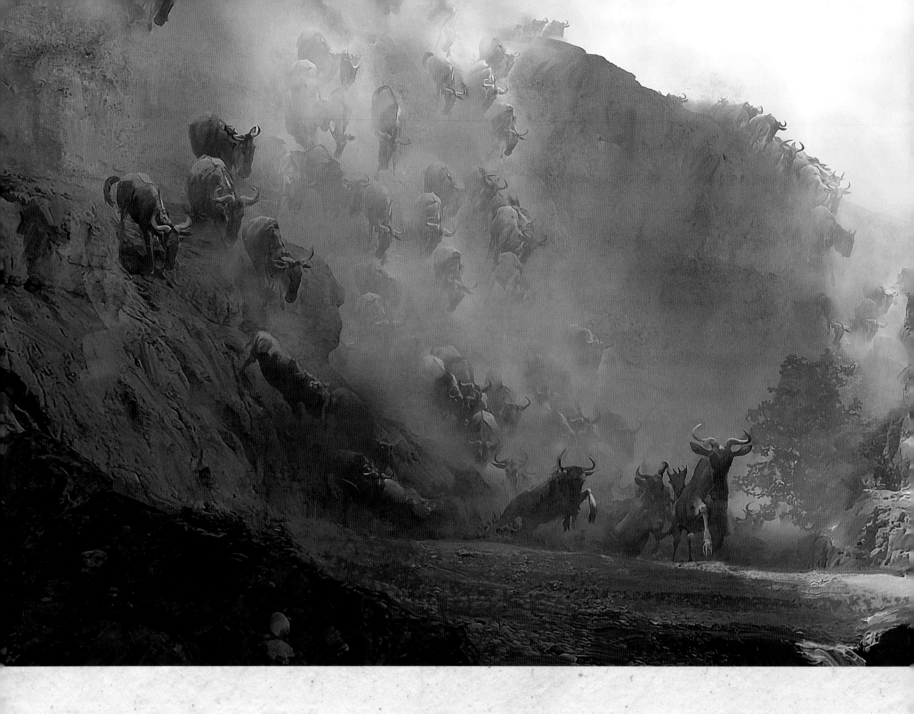

## An Ominous Locale and Tragic Event

The jagged dry canyon, or gorge, that cuts through the heart of the Pride Lands is a key location in the movie. It's there that a wildebeest stampede leads to an epic tragedy at the story's foundation—the death of Mufasa at the hands of his brother, Scar, and witnessed by his son, Simba.

## Rampaging Through the Canyon

According to James Chinlund, the overall design of the terrain and bringing it to photo-realistic life was not that complicated; filmmakers had gathered intimately real reference material during their preproduction trip to Kenya and had expert artists available to put it together at MPC in London. However, cinematography and lighting were crucial to making the location, and events within it, look and feel as if they came from the real world. And that, he adds, was important because the death of Mufasa has a much different vibe to it when seen through the prism of what is, essentially, real-world photography.

"The gorge is a powerfully mythic site in this story, since our big concern was how to treat the death of Mufasa," Chinlund states. "In an animated film, you have more latitude for how to treat this event, and it is not as shocking when you see the body. But to see an actual dead lion, and have his son confront that in photo-realism, had us all on edge as we figured how Jon [Favreau] wanted to portray that scene.

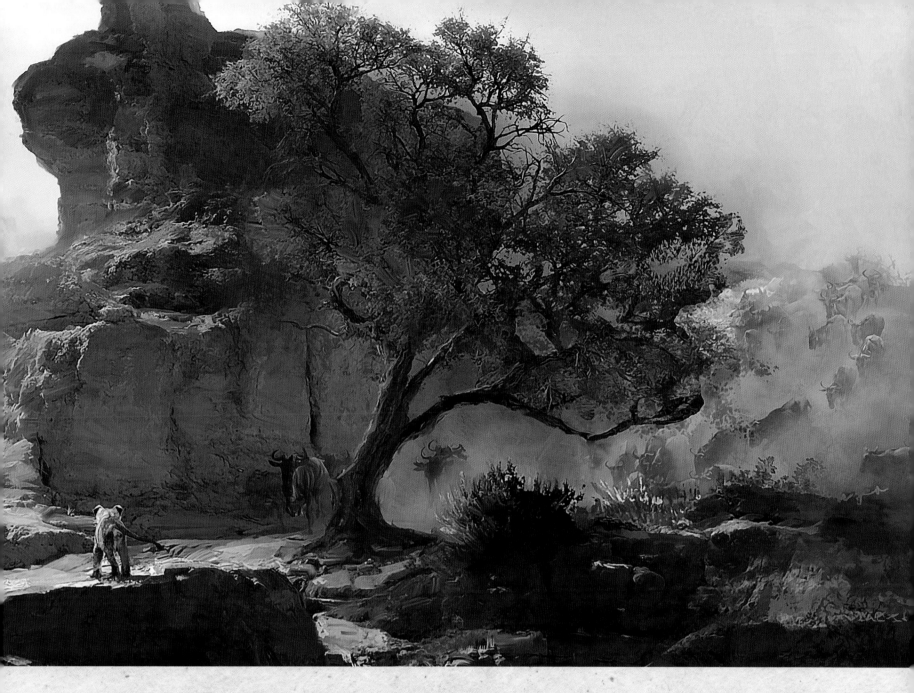

"With that said, what we were looking for regarding the development of the environment there was to create a sort of beautiful, end-of-day, low-raking light scheme, with lots of dust in the air. That gave us a romantic and soft atmosphere that could play in silhouette and sort of heighten the romantic side of what is an incredibly horrific and sad moment. So we did everything we could to create that through rich ochre tones and warm light to soften it and take the edge off as much as we could."

Executive producer Tom Peitzman emphasizes that it's precisely this kind of environment and power-packed action sequence that illustrates the advantages of the film's virtual production methodology.

"In our virtual world, it is easy to reset repeatedly one hundred wildebeest running through a rugged canyon," Peitzman says. "Whereas, in live photography, even on a documentary, you would get one take of maybe three or four of them running where you need them to be, and that's it. With our tools, we can reset and keep doing it, and it will always be the same part of the gorge. And Caleb Deschanel can put his camera in so many different spots each time. He can chase them, or be in front of them or above them, and yet have them doing the same things, but from different angles. That helps give this sequence stunning realism."

**Above:** Visual development art depicts wildebeest rampaging through the gorge, directly toward young Simba. Take note of the sophisticated lighting scheme drawn here and eventually built in the virtual world by cinematographer Caleb Deschanel to give a romantic, yet gritty, warm tone to the sequence.

**Pages 142-145:** The gut-wrenching sequence in which Scar kills his brother, Mufasa, as the wildebeest rampage and the tragic aftermath of their confrontation—including Scar's manipulation of his nephew Simba to blame himself for the tragedy—are depicted through visual development art. Note all animal movements replicate what such animals are actually physically capable of doing.

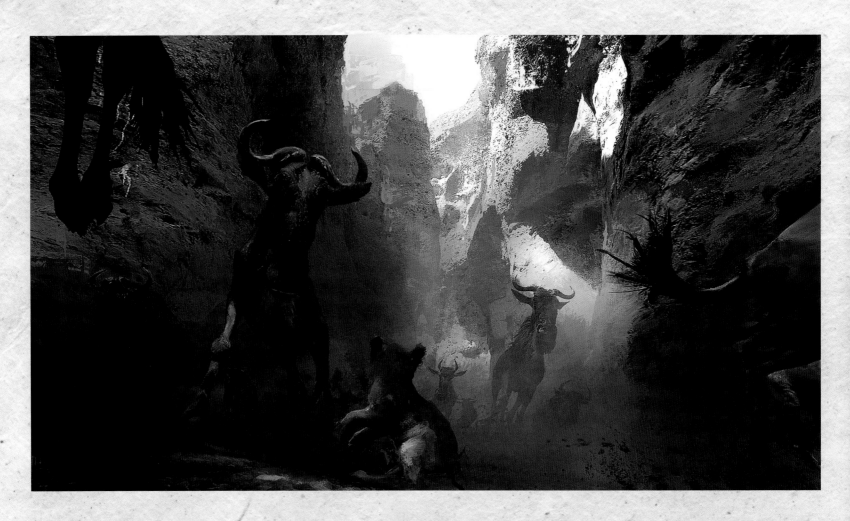

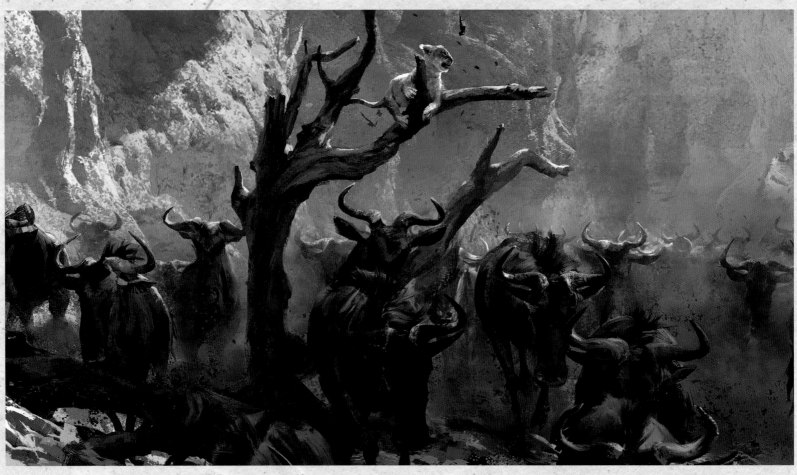

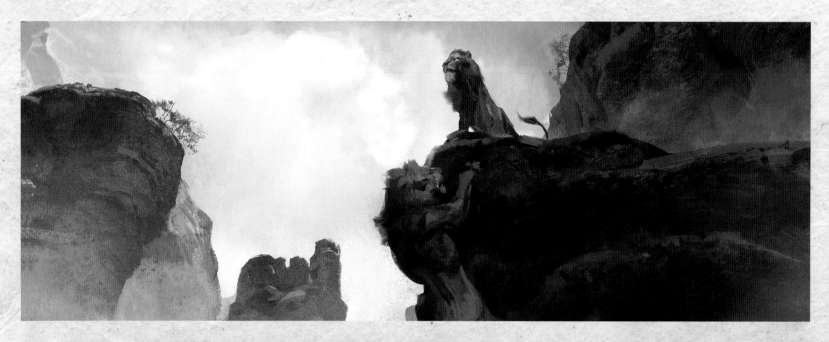

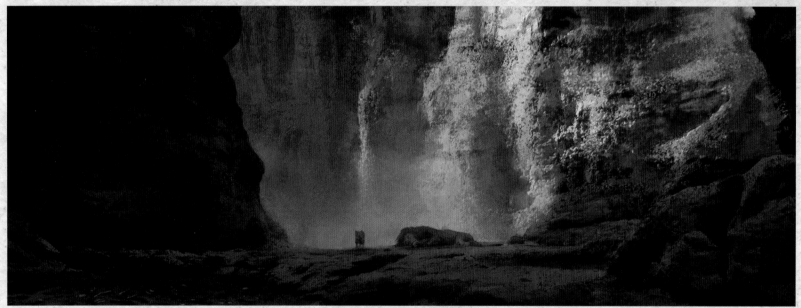

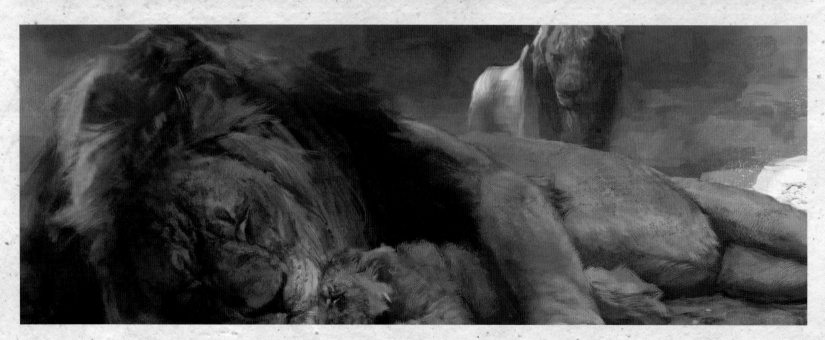

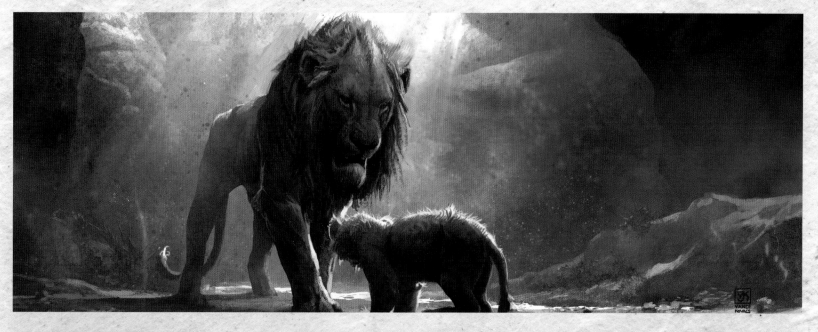

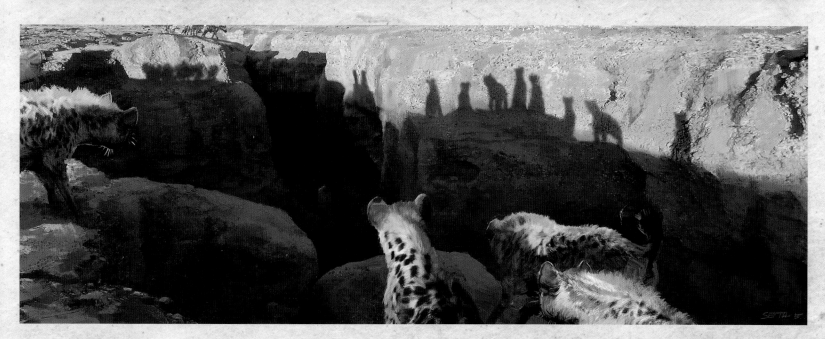

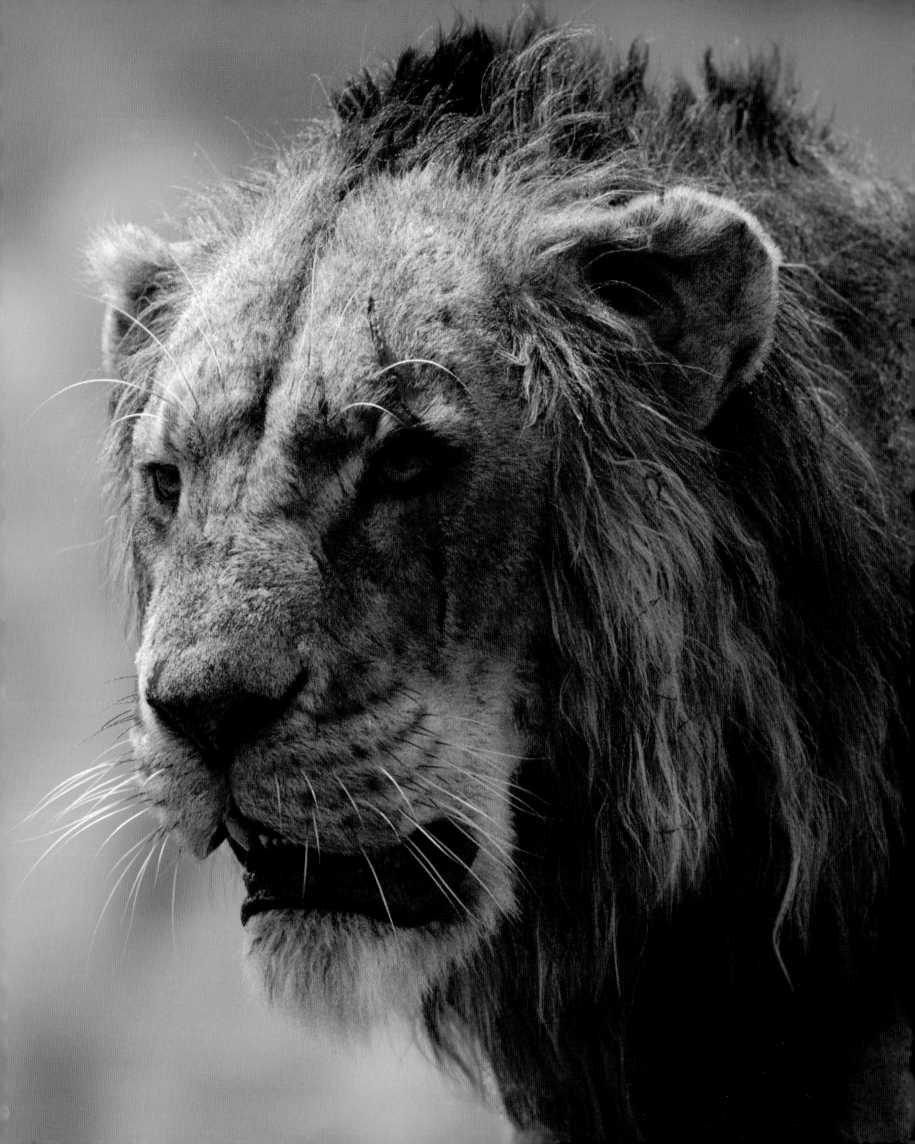

# SCAR

:///=///=///=///=///=///:

**Meet Scar**

Scar, the villain in *The Lion King*, may have the deepest and most complex psychological motivations of any character in the movie. He is Mufasa's brother and Simba's uncle, and is consumed with jealousy and anger over what he believes is an unfair preference within the lion pride for Mufasa's side of the family.

Eventually, of course, he will kill his brother in such a way as to make Simba believe himself to be responsible, and take over as the lion king, before having a final reckoning with his grown nephew.

"Scar is a very complicated, malevolent character—and therefore kind of fun to play," says Academy Award- and Golden Globe Award-nominated and BAFTA Award-winning Best Actor Chiwetel Ejiofor, who brings Scar's vocal performance to the film. "He wants power. He wants it all, and there's nothing that he won't do to get it. He's written with a slyness, almost with a little twinkle, and that is incredibly interesting and fun to step into."

Ejiofor joined the National Youth Theatre and was accepted into the London Academy of Music and Dramatic Art (LAMDA). At age nineteen, after just three months at LAMDA, Ejiofor was cast by Steven Spielberg to play a supporting role in the film *Amistad* alongside Morgan Freeman and Anthony Hopkins. He has since been seen in feature films including Stephen Frears's *Dirty Pretty Things* (for which he won Best Actor at the British Independent Film Awards, the Evening Standard Film Awards, and the San Diego Film Critics Society Awards), *Love Actually*, *Kinky Boots*, *Inside Man*, *Children of Men*, *American Gangster*, *Talk to Me*, *2012*, *The Martian*, and *Doctor Strange*. For *12 Years a Slave*, he received Academy Award and Golden Globe Award nominations, along with the BAFTA Award for Best Actor.

Onstage, his portrayal of the title role in Michael Grandage's *Othello* at the Donmar Warehouse won Ejiofor hearty praise and best actor recognition at the 2008 Laurence Olivier Awards and Evening Standard Theatre Awards. His other stage roles include Chris in Roger Michell's *Blue/Orange* and Romeo in Tim Supple's *Romeo and Juliet*.

He has complemented his film and theater work on the small screen in *Murder in Mind*, *Trust*, *Twelfth Night or What You Will*, and *Canterbury Tales*. His performance in *Tsunami: The Aftermath* earned him a Golden Globe Award nomination and an NAACP Image Award. He was further nominated for a Primetime Emmy Award for Outstanding Lead Actor in a Limited Series or Movie for his performance in *Dancing on the Edge*.

In 2008, Ejiofor was appointed Officer of the Order of the British Empire by Queen Elizabeth II for services to the arts. He was elevated to Commander of the Order of the British Empire in the 2015 Birthday Honours.

"I love the idea of audiences rediscovering something," the actor says of his role in *The Lion King*. "But this is taking it to another stage, it's taking it further and deeper. It's engaging and it's fun and funny at times—and a really great story. There are *all* of those elements that, I think, an audience is going to enjoy."

## Designing Scar

To balance the complex motivations and story needs surrounding the character of Scar with Jon Favreau's parameter that all visuals adhere to what we might see in the real world, filmmakers "played with the idea that Scar was sort of the runt of his litter—not necessarily runt-size, because we needed to balance his power with Mufasa's to make it a fair fight—but runt as in not getting a fair shake," suggests James Chinlund. "Therefore, he has a receding hairline, a slightly bleached-out color, his eyes are much lighter—things that might suggest that perhaps he didn't receive as many nutrients as a young cub as his more powerful brother."

Indeed, Scar is slightly smaller and skinnier than Mufasa, but still powerful in his own right. His body is covered with cuts and scars, particularly a long vertical scar over his left forehead, eye, and cheek, with his left eye slightly discolored due to that old wound. His mane is dark brown and dirtier than Mufasa's, and "his face appears lethargic, with his eyes hooded as he looks out from under his brows," explains Ben Grossman. "In fact, his face is visually long, which is extenuated by his tendency to let his jaw hang open and the fact that his mane grows higher up his forehead than other lions."

Cinematographer Caleb Deschanel says light and shade also played a key role in completing the illusion that brings Scar to life. "We tended to put him in shade, or for night scenes with the hyenas, we added elements that suggest he is a dark character," Deschanel relates. "And that is how we visualize him in his cave."

In fact, Scar's cave was also part of the illusion. According to Chinlund, filmmakers designed it based on the notion that "he lives in a shed out back, meaning we put him on the dark side of Pride Rock in a drippy, dark area. As much as we could, the idea of light and darkness, having him lurking in shadows, with Mufasa occupying the sunny side of the rock and Scar the dark side, was meant to reinforce the more sinister aspects of the character."

**Page 146:** Note the signature scar over Scar's left forehead, eye, and cheek in this photorealistic rendering of the character.

**Pages 150-153:** Visual development art portrays the epic Pride Rock battle between a grown-up Simba and his uncle Scar—aided at times by his allies, the hyenas—against a backdrop of lightning sparked fire and a raging storm.

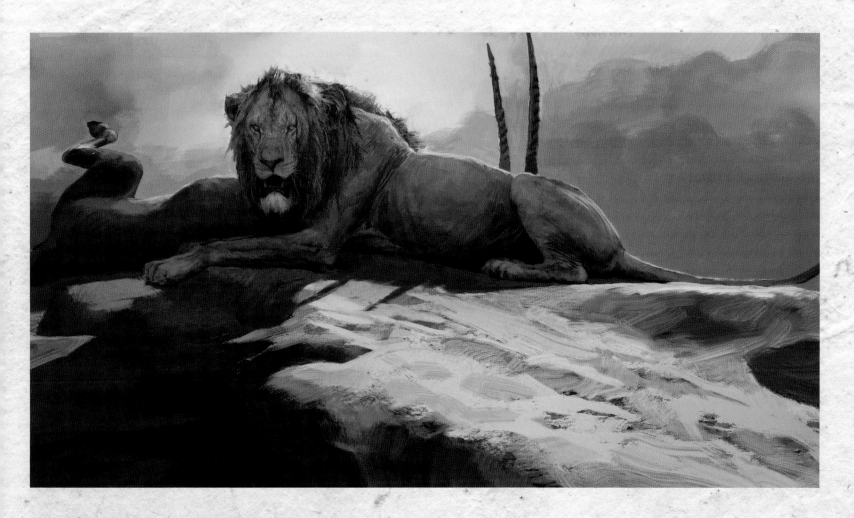

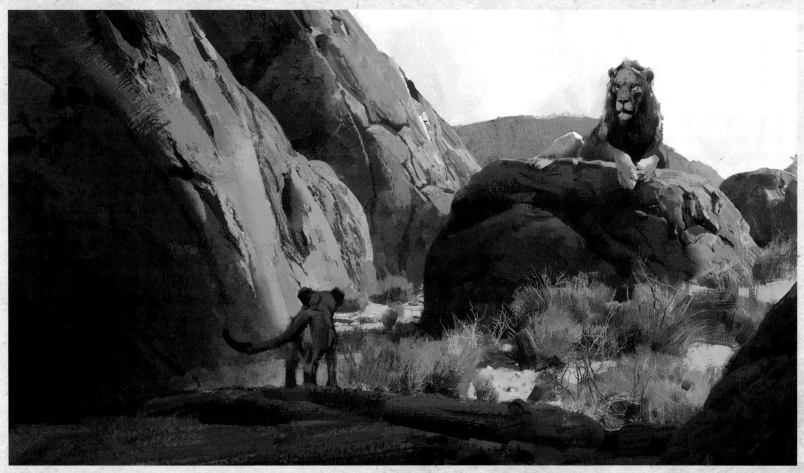

The long, skinny nature of Scar's body, strategically designed to make him appear far less nourished and regal than his brother, is prominent in this visual development art.

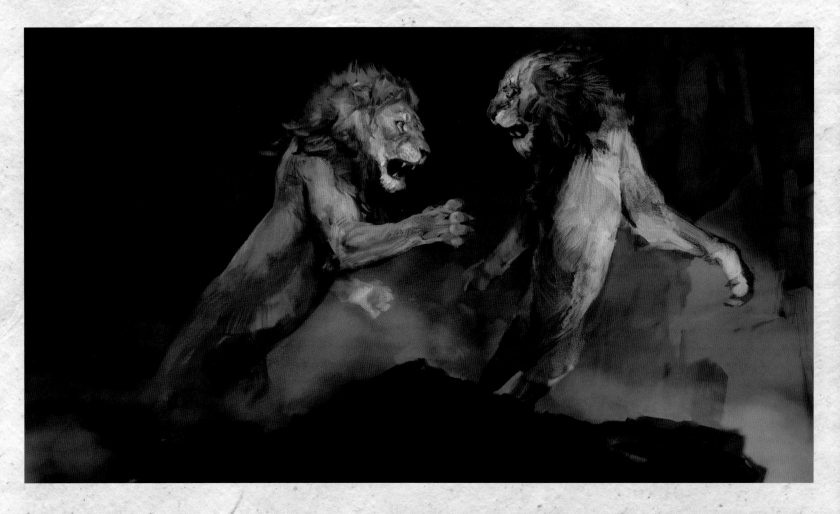

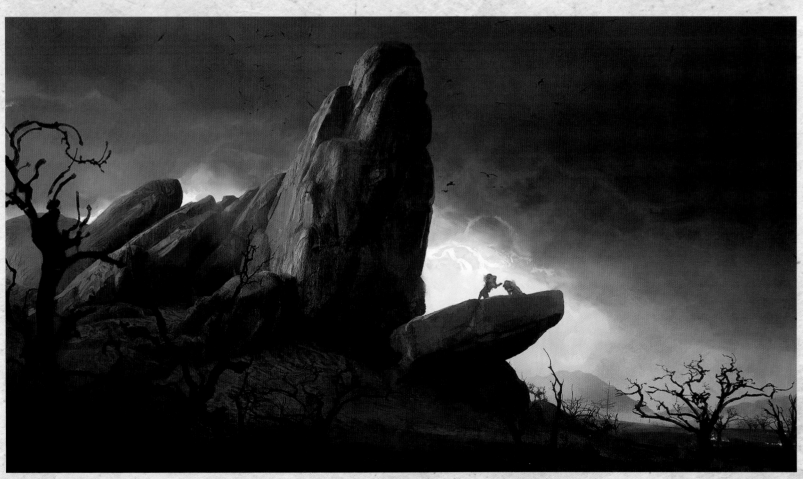

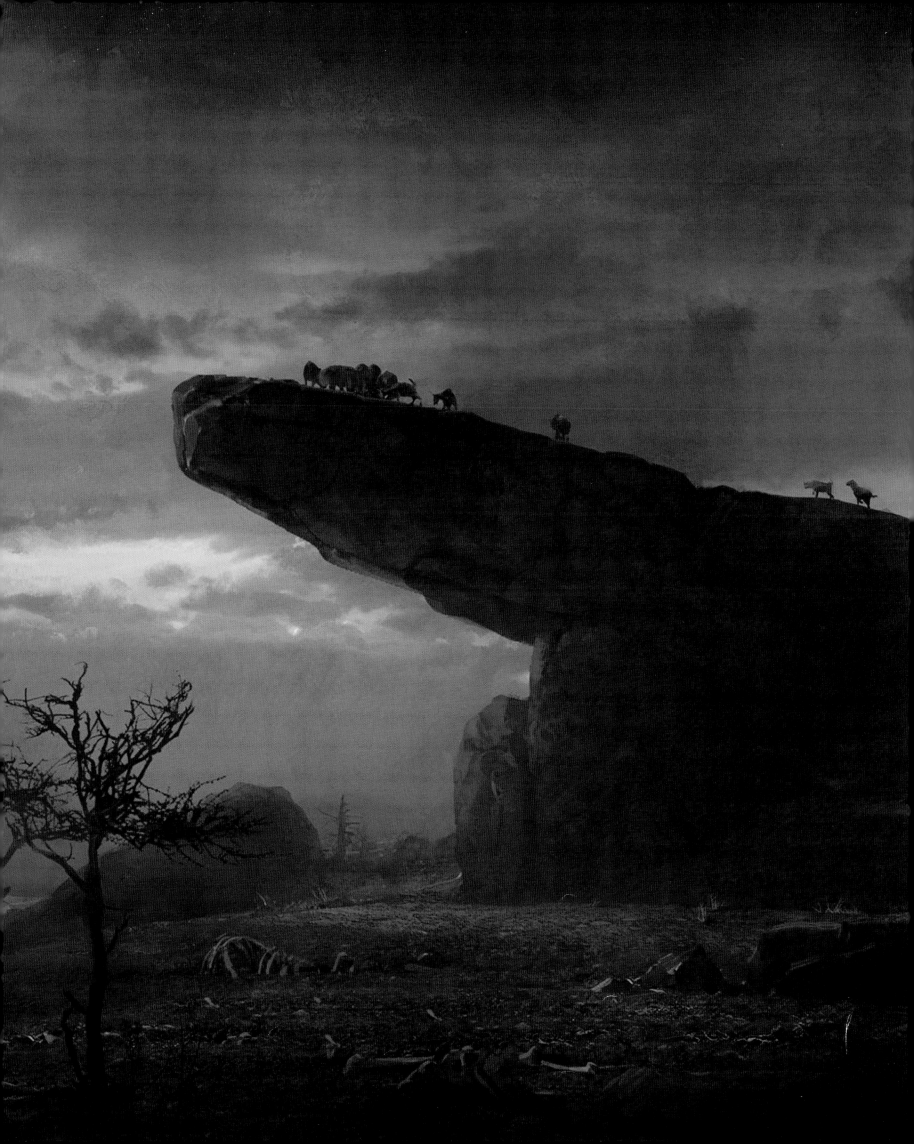

CLOUD
FOREST

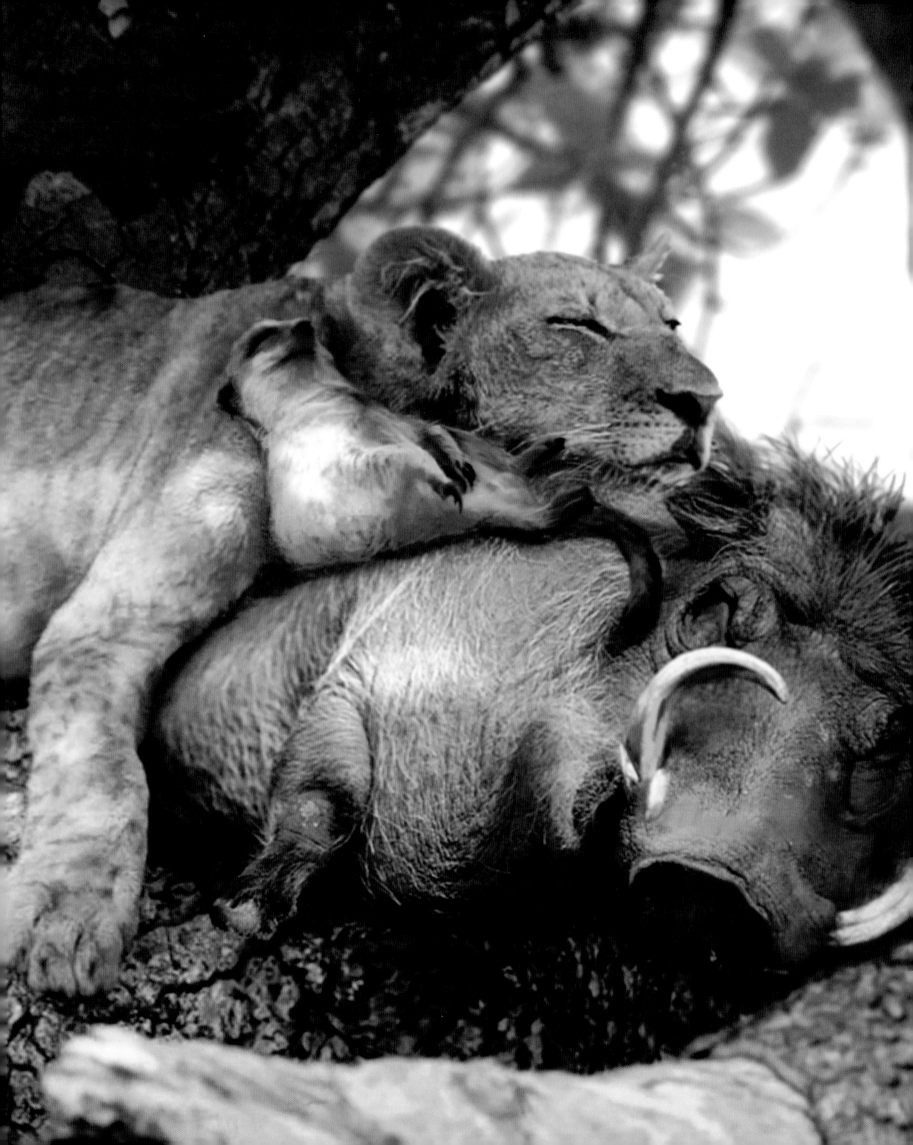

# CHAPTER EIGHT

### The Home of "Hakuna Matata"

The Cloud Forest was "an incredibly important set" to design and build as far as production designer James Chinlund was concerned. The reason for that, according to Chinlund, is that for the first time in the long, proud history of *The Lion King* franchise, filmmakers were able to make the jungle setting specific and realistic to a particular region of Africa. Thus, Chinlund elaborates, the place where the exiled Simba grows into manhood, with help from his new friends Timon and Pumbaa, is both believable and emotionally compelling.

"We felt that since this is the place Simba ends up after walking out of the Pride Lands, we should make it believable," Chinlund says. "During our trip to Kenya, we had the privilege to explore areas in and around Mount Kenya [the largest mountain in Kenya and the second largest in Africa after Mount Kilimanjaro], and what we found was an incredibly unique ecosystem. It was that region that we based the Cloud Forest on."

In that area, filmmakers discovered "trees I had never experienced before and all this plant life," Chinlund adds. "It's a really magical place, with a lot of plants that survive by capturing moisture from the clouds that wrap around the mountain, so there is this inherent sort of mysticism and romance to the place, and that's real. We pushed it by creating a hidden valley that does not really exist. But much of it is really verbatim from our location scout in Kenya."

In *The Lion King* (2019), adolescent Simba slumbers in the
Cloud Forest with his new best friends, Timon the meerkat and
Pumbaa the warthog in this piece of concept artwork.

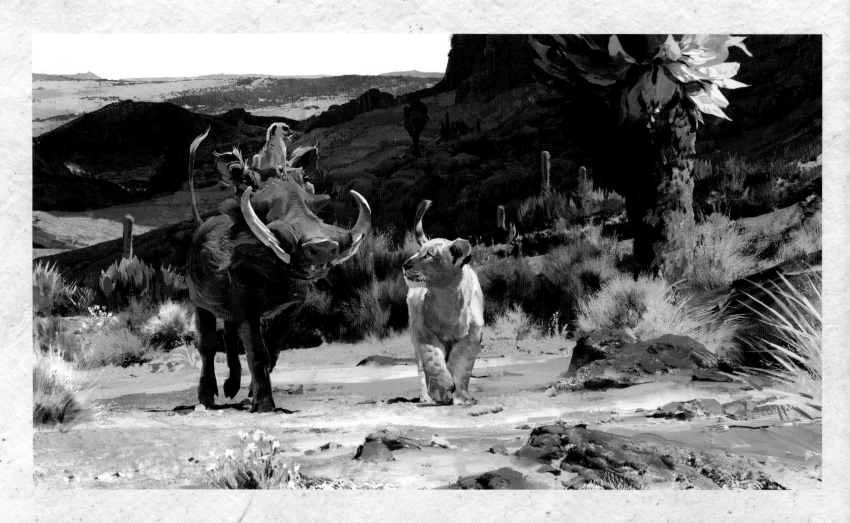

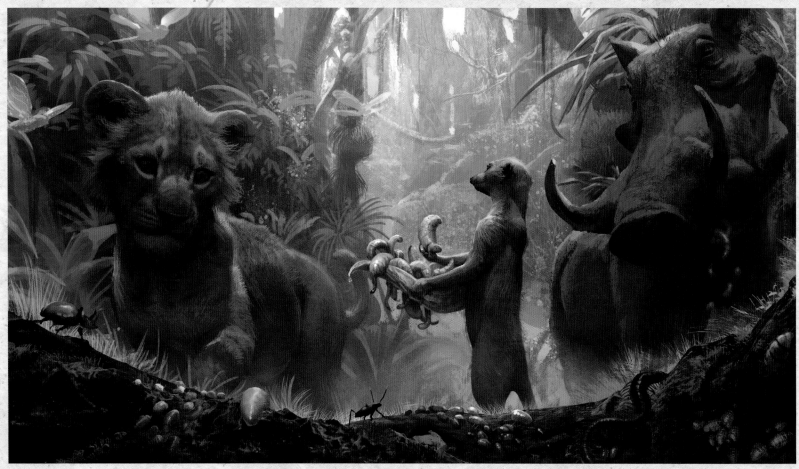

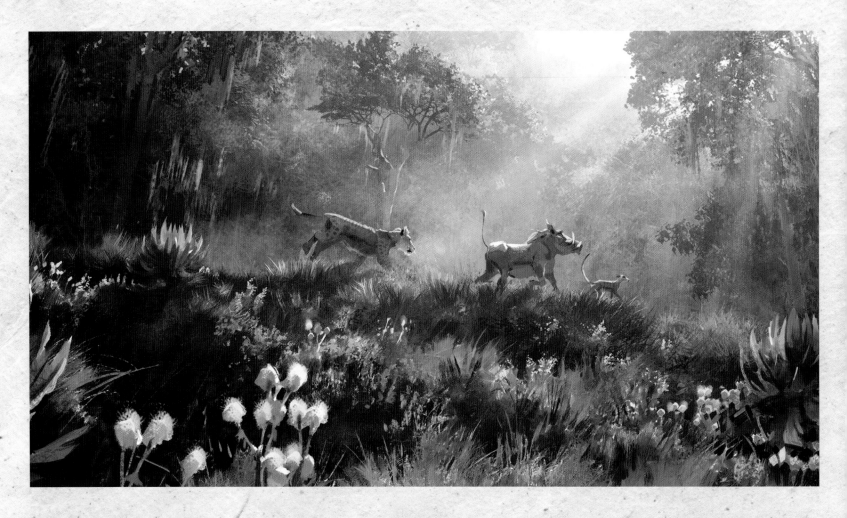

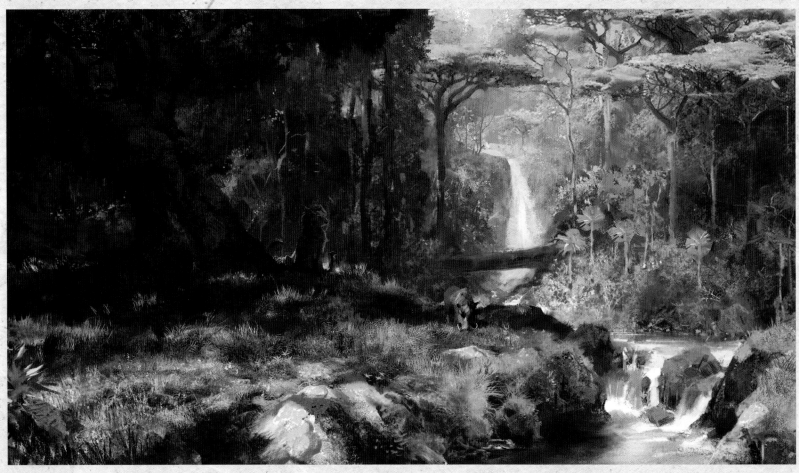

## Designing a Magical Forest

Cinematographer Caleb Deschanel adds that the realism of how the Cloud Forest was designed and built inside computers was so intense that the tree canopy on the virtual set grew just as thick as it is on parts of Mount Kenya, so much so that his team suddenly realized they would have to figure out ways to insert realistic rays of sunlight and shadows on the forest floor.

"We put up so many trees that almost no light was getting through," Deschanel says. "So we often had the people building the sets in the computer—the people actually building the trees—take the tops off them. That didn't alter what you saw on the bottom of the forest at all. But by taking the tops off, we could put our own giant digital cucoloris [a device for casting and directing shadows for motion picture lighting], get what light we wanted, and create the same realistic feeling of the tree casting a shadow. It was a similar feeling to experiences I've had shooting on real forest sets. There, you end up having [huge motion picture lighting rigs] coming through to give the feeling of the sun. Here, we did the same thing in the computer."

**Pages 158-161:** Simba's physical and emotional maturation in the Cloud Forest alongside his friends and mentors, Timon and Pumbaa, is illustrated in this series of visual development images. In many ways, the sequence is the emotional heart of the film, and their impact is enchased through an exceptional level of photorealistic detail. Note the subtle use of sunlight streaming into the jungle, and the distinct use of shadows, color, and accurate textures throughout as Simba evolves from a cub to an adolescent to a grown young adult male lion of regal stature.

**Above and opposite page:** Using visual development art like this collection, filmmakers then designed the Cloud Forest with state-of-the-art techniques to beam sunlight and cast shadows across the forest floor, and to simulate water, moonlight, and many more natural elements.

**Pages 164-165:** The aptly named the Cloud Forest was based on reference imagery from a region around Mt. Kenya, where clouds kiss the forest, waterfalls flow, and vegetation abounds. This visual development art illustrates such natural phenomenon, translated from the filmmakers' personal experiences in Kenya to the big screen.

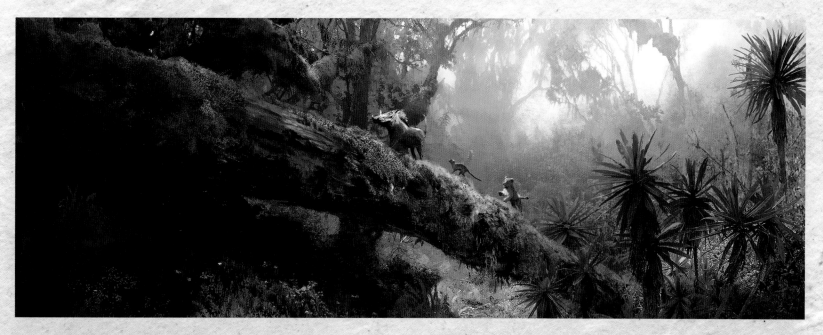

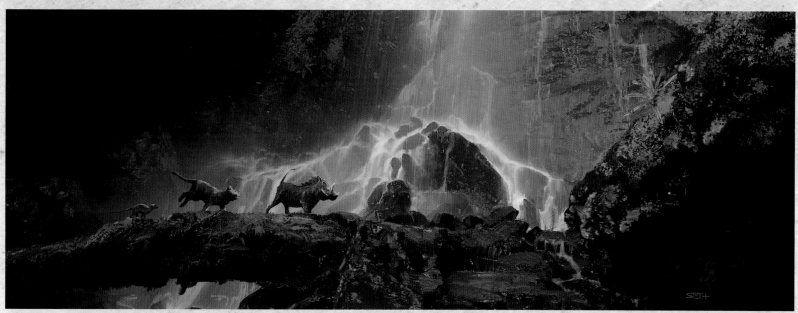

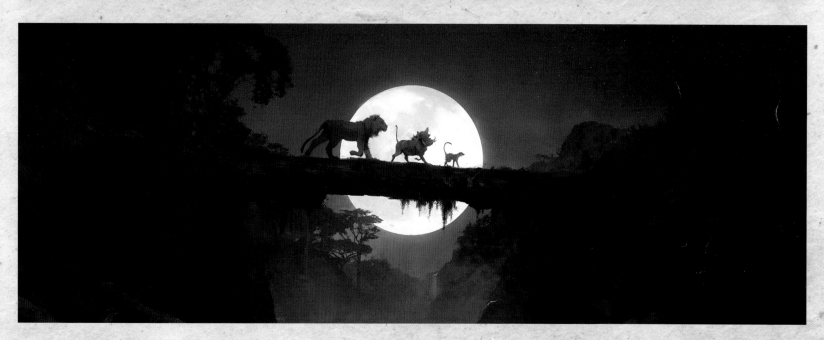

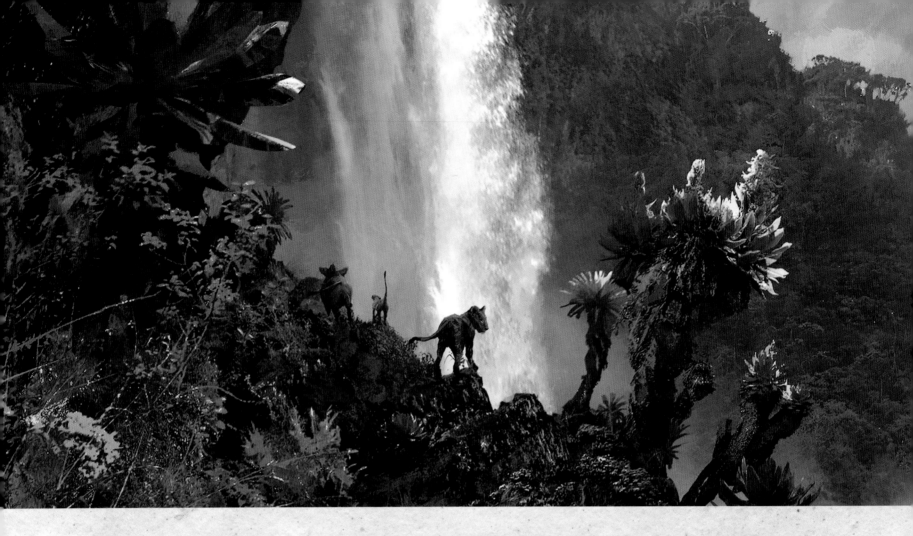

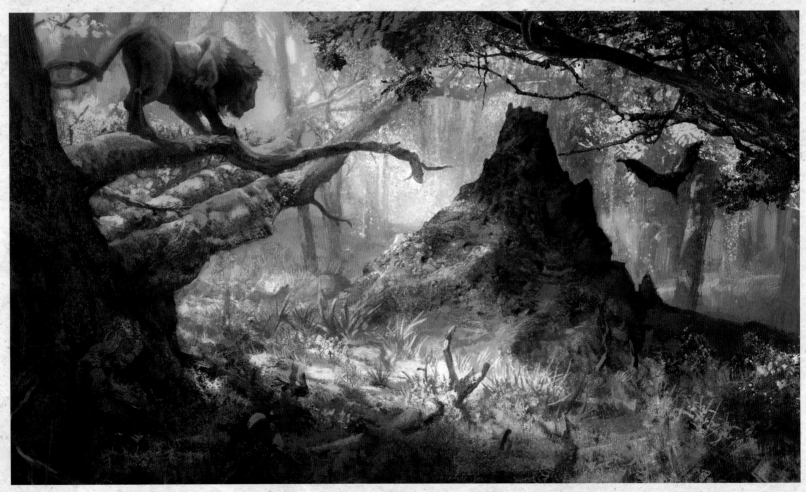

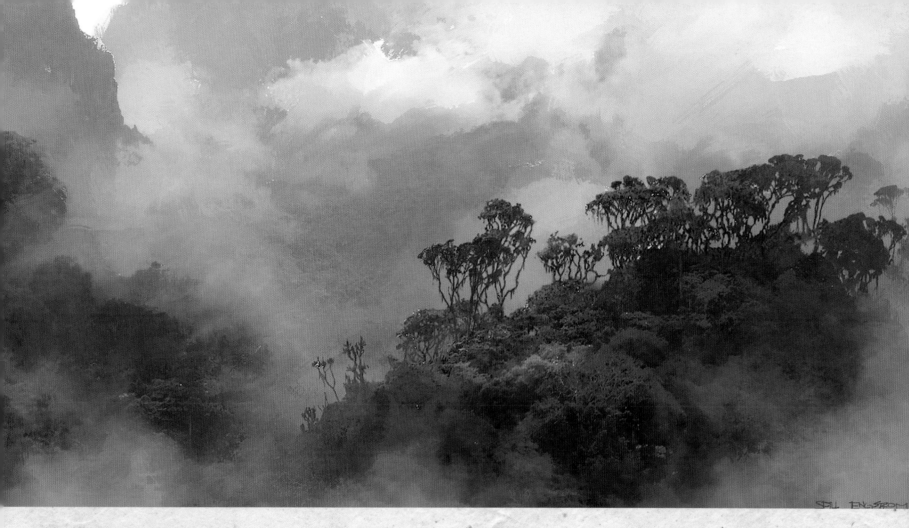

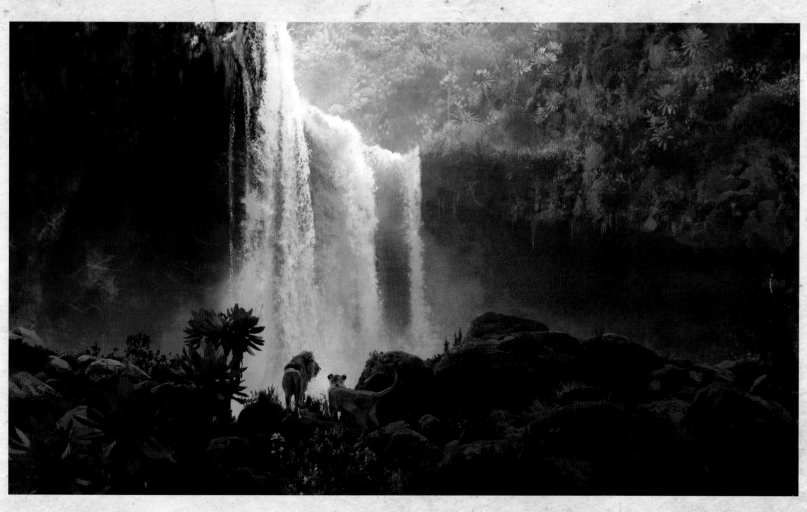

# TIMON

### Meet Timon

Timon is a spunky little meerkat with a hundred-mile-an-hour mouth. Partnered with his best pal, the warthog Pumbaa (Timon sees himself, naturally, as the brains of the team), he helps nurture and raise Simba into adulthood.

"I'm old," says comedian, actor, writer, and television personality Billy Eichner. "I saw [The Lion King] in the movie theater. The whole thing was really beautiful, and it's kind of simple in a way, a simple classic story, told with a great score. I love Elton John. And then I saw it on Broadway, too, and loved it again for other reasons. And I'm a huge Disney fan."

Eichner provides the mouthy meerkat with his vocal personality, a talent he has previously used in the animated TV shows *Bob's Burgers*, *The Simpsons*, and *Family Guy*; and the feature films *Penguins of Madagascar* and *The Angry Birds Movie*.

Eichner first gained fame in a critically-acclaimed itinerant stage variety show in New York, *Creation Nation: A Live Talk Show*, and was a regular performer at Upright Citizens Brigade. Becoming a go-to guy for comedy, he was a talk/personality show favorite, in original video shorts, and as himself, in segments of *Conan*, *Watch What Happens: Live with Andy Cohen*, *Last Call with Carson Daly*, *The Wendy Williams Show*, and *Fashion Police with Joan Rivers*, among others.

He has been nominated three times for the Emmy Award for Funny or Die's comedy game show *Billy on the Street*, on which he serves as star, executive producer, and creator. As an actor he has had recurring roles on the TV series *American Horror Story*, *Friends from College*, *Difficult People*, and *Parks and Recreation*.

"I really like doing voices," Eichner says. "It's a liberating way to perform . . . you're not worrying about what the rest of your body is doing. You can really hone in on what your *voice* is doing and on the jokes and the dialogue and the singing."

Asked if the idea of performing a now-beloved standard such as "Hakuna Matata" was intimidating, Eichner replied, "Some people don't know this, but I actually have a musical theatre background. I was a musical theatre performer in college, and growing up I sang a lot; and I loved Broadway—it was my first love. It still is the thing I love most, a Broadway musical.

"There's a lot of emotion in it . . . a lot of levels to it," Eichner says of *The Lion King*. "Along with Seth [Rogen], I get to be a sort of comic presence, the boldest comic presence in the movie, and that's something that I enjoy doing, obviously. And Timon and Pumbaa are such iconic characters, so it really is an honor to get to deliver my spin on it."

## Designing Timon

Timon is a small, light-colored meerkat with a fairly typical-for-his-species striped pattern on his back. He also has distinctive fur patches surrounding his eyes and flowing fur sweeping over his arms and legs. Once again, filmmakers faced the challenge of how to make one of nature's more unusual animals seem realistic, while still emoting his quirky personal traits.

"The meerkat has this amazing telescoping ability—the way they stand up and their bodies can stretch super long," says James Chinlund. "Then, they can compress down into a kind of ball of fur. So there is a physicality to Timon that the animators could use to click into comic performances, while still being believable movement."

That accomplishment took some work given the unique nature of what meerkats can do. After all, as Dave Lowery puts it, "we couldn't have his hands splaying out left and right. A meerkat's shoulders don't work that way, even though Timon was comic relief with jazz hands and big cartoon takes in the original movie."

Indeed, "Timon was probably the most anthropomorphic character in the original film, and Jon Favreau had no problem letting us try to breathe a little of that into our version," Andy Jones adds. "However, when we did a few tests using his front legs as arms and gesturing something like a human—it broke the realism of what a real meerkat can do. So we quickly retreated to a subset of real movement mixed with the type of gestures a meerkat could do with their front legs, timed well with dialogue and acting choices. Also, the sarcasm, wit, and speed of Billy Eichner's speech lent itself well to how real meerkats move with snappy head moves and body adjustments."

Some of Timon's comic eccentricities were enhanced with realistic camera movement, according to Caleb Deschanel. "We have a scene where Timon rides on top of Pumbaa, who, of course, is a warthog." Deschanel then adds, "He is kind of being dragged along, actually, and then is able to pull back a little bit and get closer to the camera. It took us a while, but we came up with the idea of moving our virtual Steadicam across a twenty-foot section of floor [via the virtual cinematography process (SEE PAGE 54]. That allowed the audience to move through the set with Timon to see and understand his unique capabilities."

**Opposite page:** Various visual developmental images of Timon, starting with early sketches, focus on the idea of utilizing a real-life meerkat's unique physical abilities to enhance his comedic performance.

meerkat

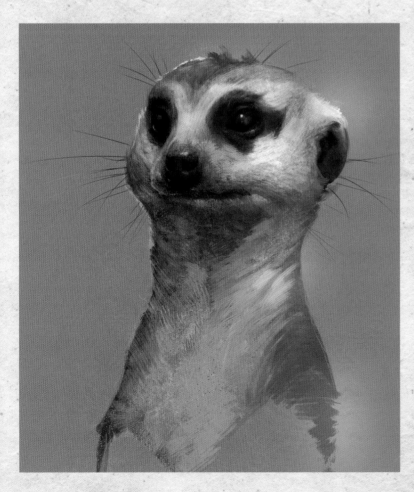

# PUMBAA

### Meet Pumbaa

Pumbaa, an African warthog, is Timon's partner in adventure—and frequently misadventure. He provides some of the biggest comic relief in *The Lion King* through what animation director Andy Jones calls "a combination of innocence and charm."

Seth Rogen embarked on a remarkable career path doing stand-up comedy during his teenage years in Vancouver, British Columbia, Canada—at age sixteen, he placed second in the 1998 Vancouver Amateur Comedy Contest.

The actor, comedian, writer, producer, and director initially rose to prominence in his twenties on Judd Apatow's highly-regarded TV series *Freaks and Geeks*. Rogen was then cast in the sitcom *Undeclared*, on which also worked as a writer, which led to a writing gig on *Da Ali G Show*, along with his childhood friend and writing partner Evan Goldberg.

He continued with Apatow on the director's debut feature film *The 40 Year Old Virgin*, and in Apatow's *Knocked Up*, *Superbad*, *Pineapple Express*, and *Funny People*. He also played Steve Wozniak in *Steve Jobs*.

Rogen and Goldberg co-wrote the films *Superbad*, *Pineapple Express*, *The Green Hornet*, and *This Is the End*. The partners also co-directed *This Is the End* and *The Interview*.

A talented voice artist, Rogen performed for the animated films *Horton Hears a Who!*, the *Kung Fu Panda* series of films, *The Spiderwick Chronicles*, *Monsters vs. Aliens*, *Paul*, and *Sausage Party*; and for the TV series *The Simpsons* and *American Dad*.

Securing Rogen for a vital role did not involve complex negotiations. "I think Jon Favreau just e-mailed me," the actor recalls, "and said, 'Would you like to be Pumbaa?' I just said, 'Absolutely.' I was happy because I was secretly hoping that I would get the part."

"Seth Rogen was a dead match for our Pumbaa, because he brings a perfect mix of comedy," Andy Jones says. "We studied real warthogs, and there is a lot of personality to how they move individually. That individuality really lent itself to this character."

Rogen says of his role, "As someone who really loves *The Lion King*, the idea of getting to relive that story in a new way is really exciting. It's exciting that I even get to *watch* another version of the movie, and that it'll deliver on all the stuff I love—and even elevate it in some ways. It's so gratifying and amazing."

## Designing Pumbaa

Production designer James Chinlund emphasizes the surface dichotomy between the comedic aspect of the Pumbaa character and the realism that was built into his design and movement. He suggests that the character's appealing personal qualities might, upon first glance, contrast with the stereotype of what you would expect from the intimidating real-world look of a meat-eating wild creature with a disproportionately large head, curved tusks, and bizarre fleshy padding on its head. But upon a second glance—it's a different story.

"Actually, the more time we spent observing warthogs in the wild, [the more] we realized they are incredibly charming, comical figures," Chinlund says. "Yes, they are ferocious and have great power, and you certainly wouldn't want to be on the wrong side of them in a fight, but when you see them interacting with each other, there is tremendous personality that comes through. So in that sense, making him realistic and yet [a good match for Rogen's performance] was easier than you might think. He's not exactly cuddly, but he's definitely a really appealing guy."

Continuing on that theme, head of story Dave Lowery elaborates that the comedic ad-libbing of both Rogen and Billy Eichner during audio recording sessions of their performances as Pumbaa and Timon caused the filmmakers to re-evaluate their original reference approach to animating both characters.

"They were really ad-libbing and being funny," Lowery says. "So ultimately, when the animatic was still being drawn and referenced, we had to redraw their performances based on dialogue, on their riffing together. We did that a couple times. But that said, we didn't break any boundaries in terms of what warthogs and meerkats can actually do in the real world."

**Above and opposite page:** The approach to designing the physical abilities of Pumbaa was to be both realistic to how actual warthogs act and subtly comedic, as evidenced in these visual development and character sketches.

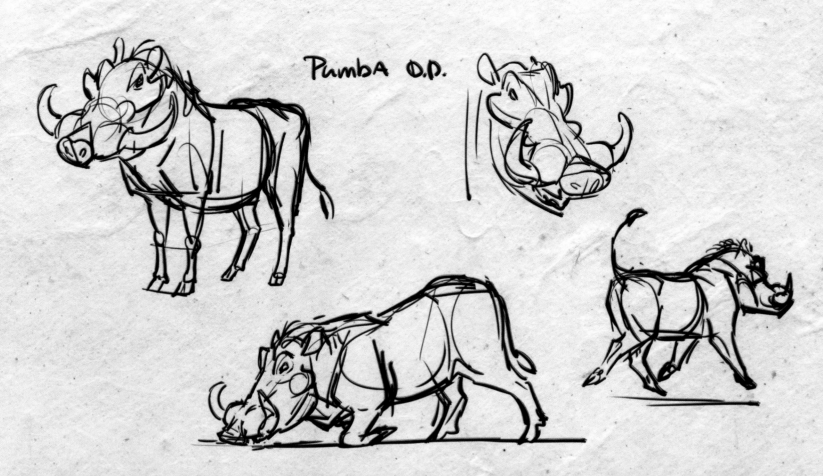

Pumba O.D.

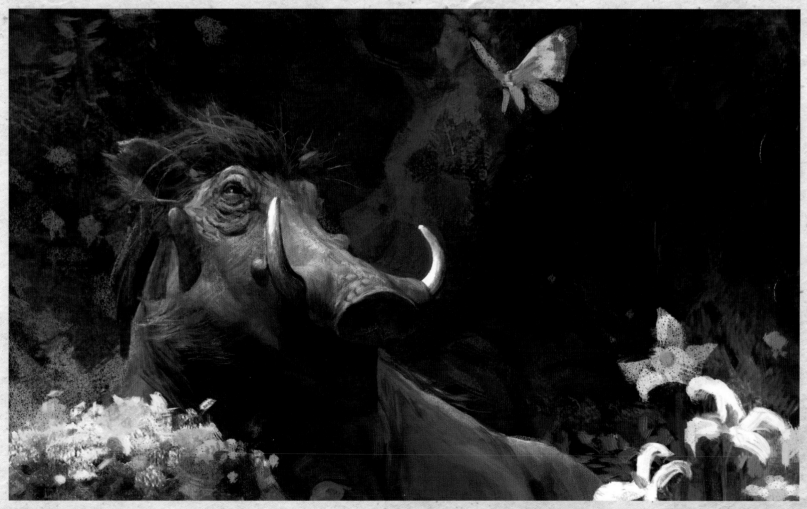

# SIMBA

### Meet Simba

"I feel very connected to Simba's journey," says Donald Glover, who voices the adult Simba. "I feel like a kid most of the time, and the world is a very scary place to me. I grew up on things like *Sesame Street* and Disney, where people are nice because that's what you're supposed to do. But the world's not really like that. You have to balance yourself, and hopefully you pass on the good things to your children and the people around you."

Donald Glover is an actor, comedian, writer, director, singer, rapper, and DJ. He sings and raps under the stage name Childish Gambino and performs as a DJ under the name mcDJ

His initial reaction to being cast as Simba was . . . shock. "I actually didn't feel the joy of it immediately," the actor admits. "I felt all of the responsibility because I just know how much it meant to me. And now it'll be out there forever."

"Donald Glover is a rapper, a singer, a producer, an actor, a sketch comedian, a stand-up comedian, a screenwriter, a director, a TV star, a movie star, and a prestige showrunner. That's in no particular order, in terms of either chronology or quality," says culture writer Rob Harvilla.

Glover's work as an actor includes *Mystery Team*, *The Lazarus Effect*, *Magic Mike XXL*, *The Martian*, *Spider-Man: Homecoming*, and *Solo: A Star Wars Story* (in which he plays young Lando Calrissian).

He created, stars in, and occasionally directs the TV series *Atlanta*, for which he has been honored with Primetime Emmy Awards for both Outstanding Lead Actor in a Comedy Series and Outstanding Directing for a Comedy Series. He also won Golden Globe Awards for Best Television Series, Musical or Comedy and Best Actor, Television Series Musical or Comedy.

Glover's music has ranged from self-released albums and mixtapes, to studio albums such as *Camp*, *Because the Internet*, and *Awaken, My Love!* The song and video "This Is America" debuted at number one on the *Billboard* Hot 100—and won Grammy Awards for both song of the year and record of the year.

In 2017, Glover was included on the annual *Time 100* list of the most influential people in the world. Ryan Coogler, writer/director of *Black Panther*, said "He can push the envelope in all these different areas, and it's not that difficult for him."

In feeling out his character, Glover thought deeply about the meanings contained in the story. "It's a very human and honest story of what everyone goes through. Nothing is permanent. I think this is a beautiful way of showing, and even talking to children about how permanence is not the point. 'More' is not the point. The point is to be present, and responsible for each other, and love each other. There's always going to be change, but there's always going to be each other, so why not help each other?"

## Designing Simba

The fully adult version of Simba, who eventually takes his rightful spot as the new lion king, appears only late in the movie, the "final realization of what was, until then, an unrealized power," suggests James Chinlund. However, along the way, we see the character transition from the Simba cub who begins the character's journey into full-blown adolescence on his way to adulthood. "At that point, he has a slightly sheepish physicality," Chinlund elaborates. "So, for some of that, we played with his mane, which he shares with his younger self— this sort of shock of hair that kind of flops down in his eyes a bit. We played with this idea of some kind of beach hair in his mane. This kind of relaxed vibe masks some of his insecurities."

Therefore, filmmakers set things up, Chinlund suggests, so that "when Simba finally does realize his potential at the end, when we see him standing majestically on the rock as king—it's not a shock as much as a development of an exciting transition that has been ongoing. Some of that came in character design, and obviously the work of the animators achieved it fully in terms of his body language and positioning."

The adult Simba retains his rich, warm orange-and-brown fur coat with strong lighter areas on the belly and inner legs. His mane is overall smaller and lighter in color than Scar's or Mufasa's, and he has the same color pattern near his face as his younger self, with a lighter portion of fur framing his face in a specific diamond shape. The older Simba's large muzzle and chin are reminiscent of his father Mufasa's features, even if slightly smaller. He also has a particularly athletic build, even though he is not remarkably larger than his uncle Scar.

**Opposite page:** Early sketches and visual development art of the fully-grown Simba show the character designed to resemble both his younger self and his father, Mufasa, in subtle ways.

**Pages 178-183:** Visual developmental images of Simba and Nala, all grown (plus a photorealistic rendering on the bottom of page 178) set the tone for their physique, their presence with the film's environment, and their evolving relationship. Simba, with Rafiki and alone on pages 180 and 181, has a moment to reflect on his father and his responsibilities in life.

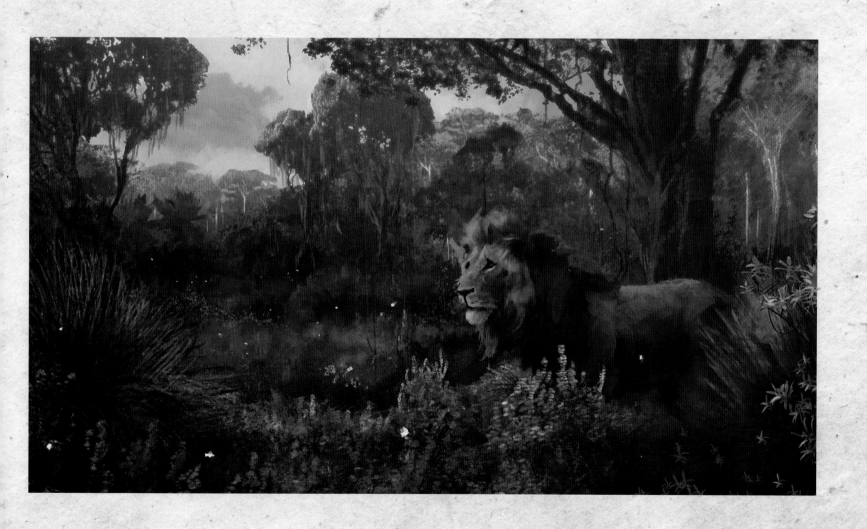

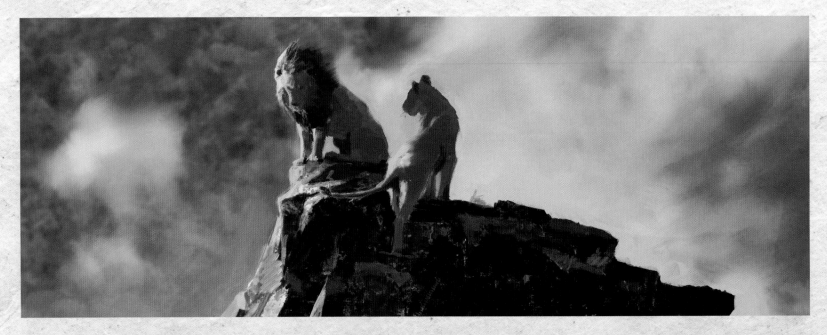

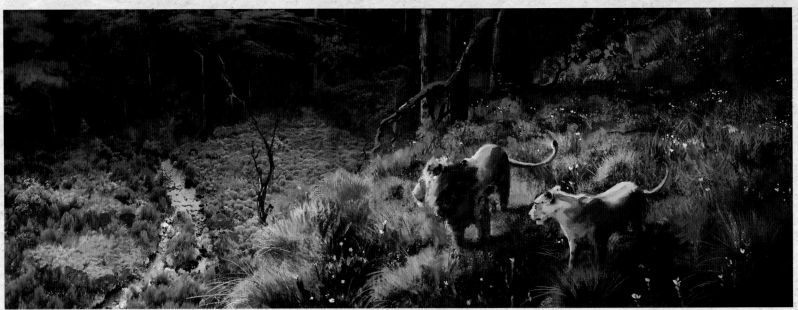

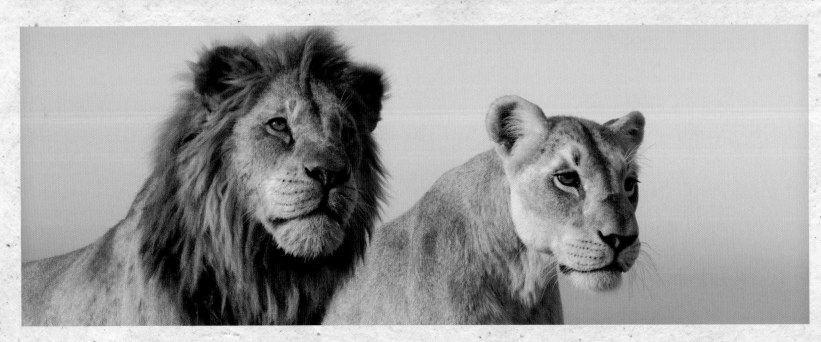

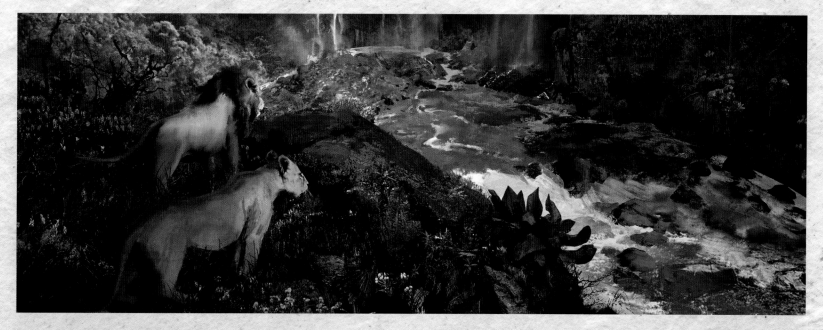

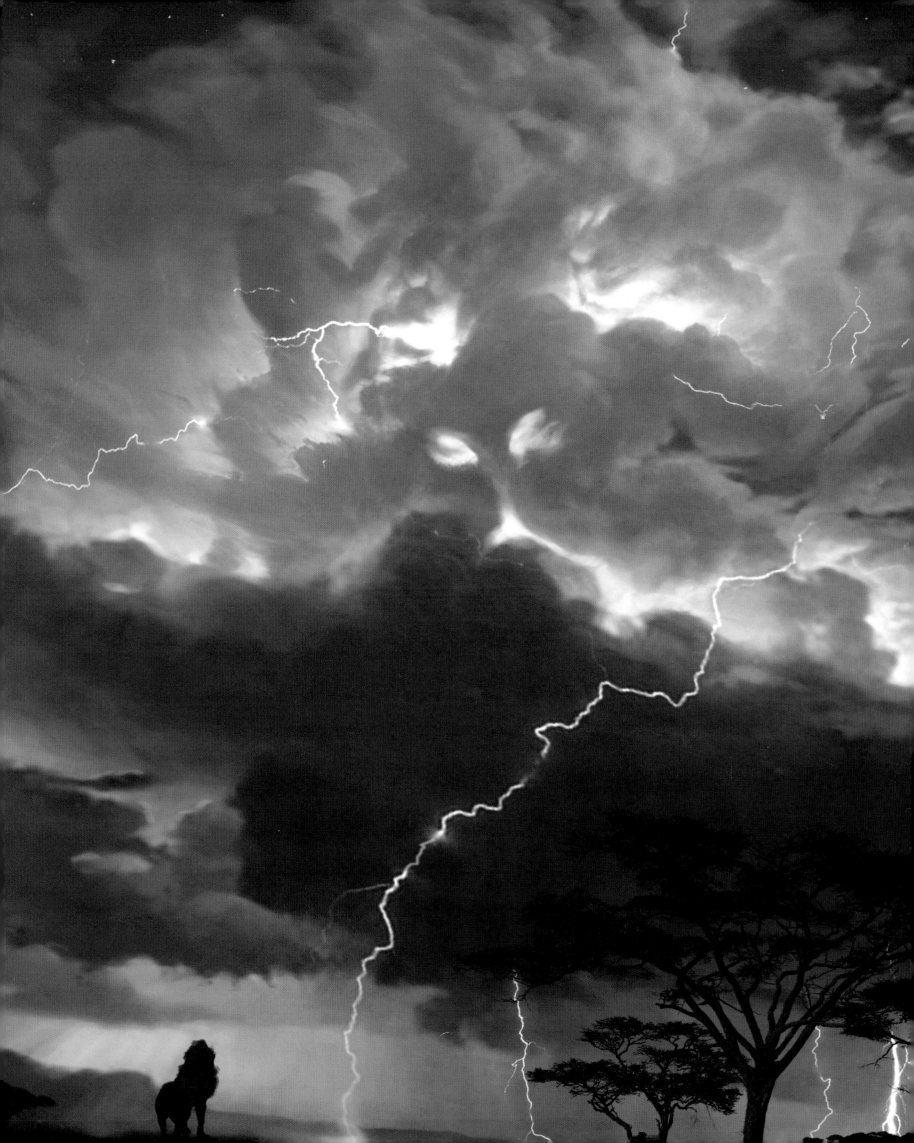

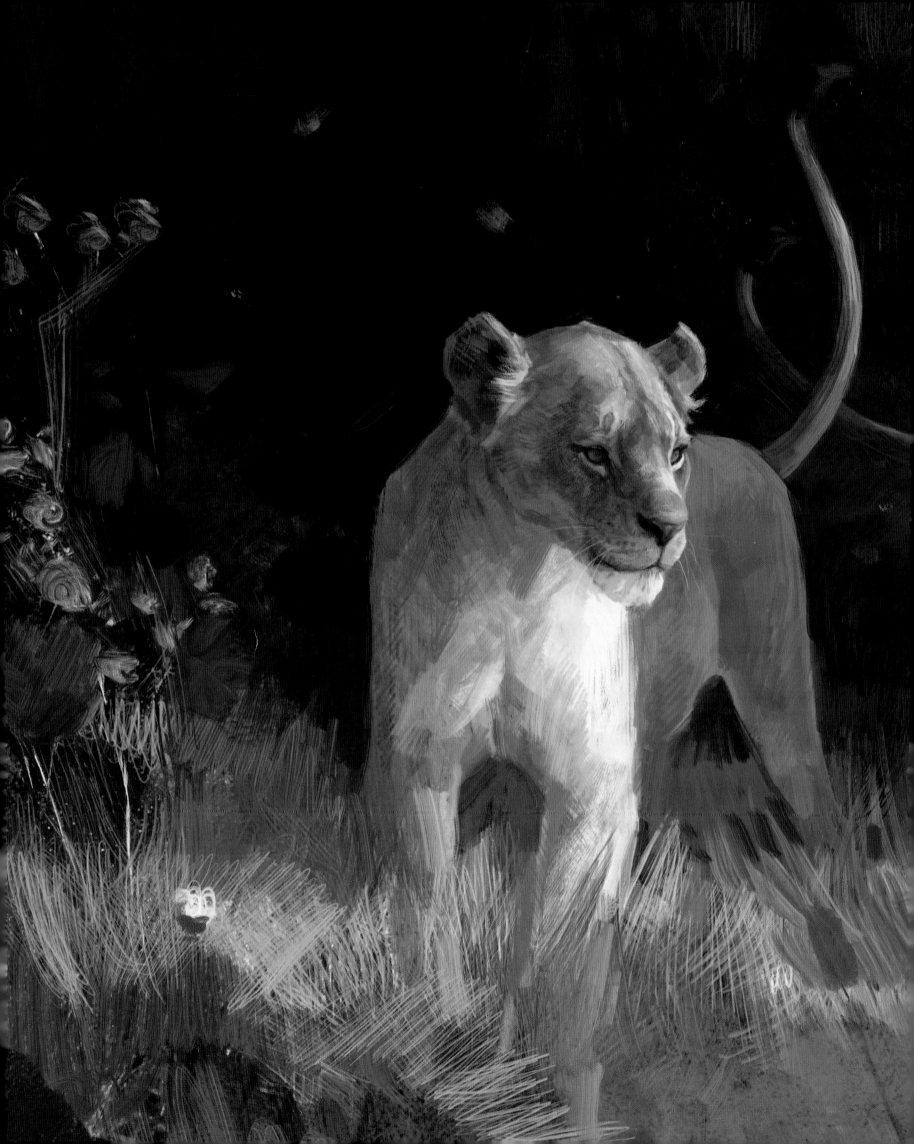

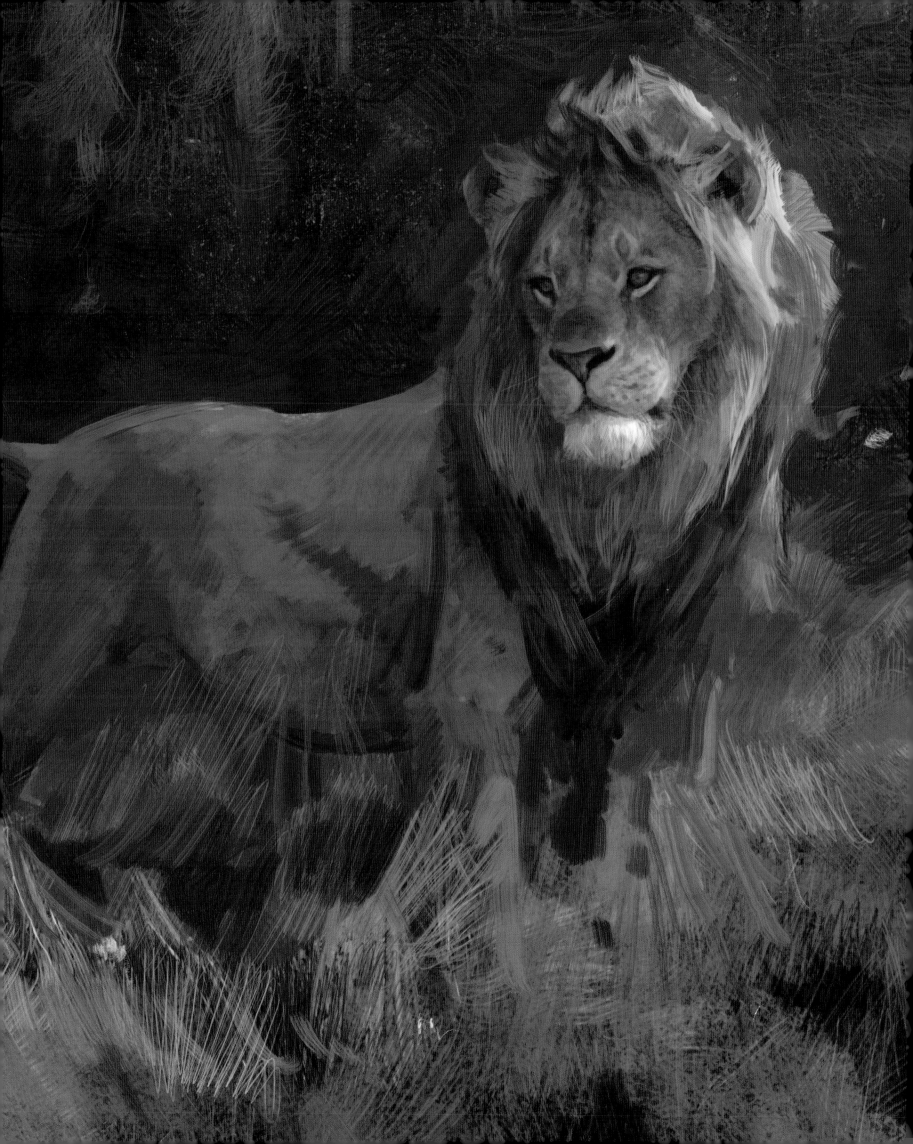

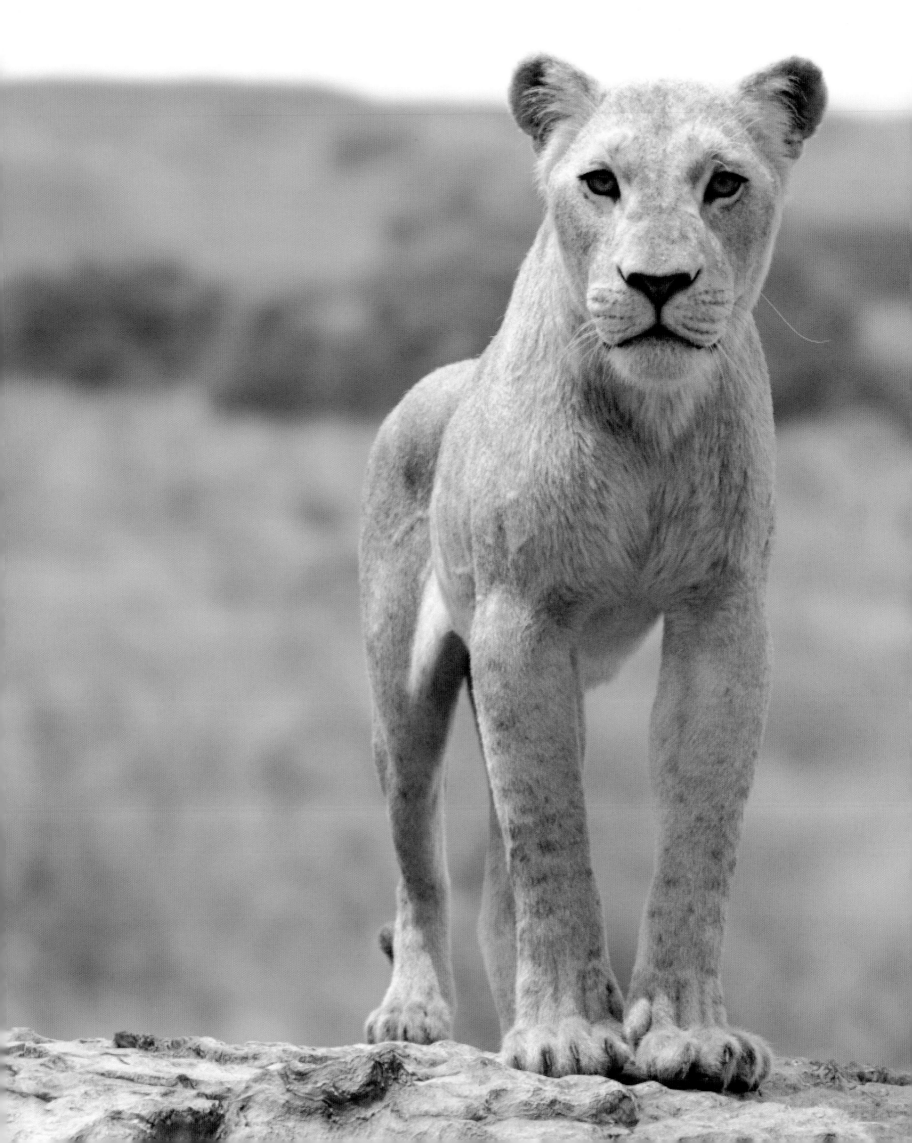

# NALA

·•·•·•·•·•·•·•·•·•·

### Meet Nala

Nala, the rambunctious cub and childhood friend of Simba, grows into a thoughtful, poised, and ultimately courageous adult lioness who rejoins her friend for the greatest challenges of their lives. She is played by the singer, songwriter, performer, and actress Beyoncé.

Born and raised in Houston, Beyoncé Giselle Knowles-Carter began performing as a child in various singing and dancing competitions. Beyoncé is one of the most widely-recognized and highly-respected women in the world of popular entertainment. She began performing in various singing and dancing competitions when she was a child, and in 1997 was a founding member of Destiny's Child, one of the best-selling female groups of all time.

In addition to fronting the group, Beyoncé co-wrote and co-produced many of their hit recordings—which have sold more than 50 million albums and singles worldwide, and earned 23 gold, platinum, and multi-platinum RIAA certifications since the group's debut. The group disbanded as each member pursued individual projects, but reunited in 2004 for *Destiny Fulfilled*, with Beyoncé is a principal songwriter and producer, as well as performer.

*Dangerously in Love*, her debut album after leaving the group, featuring the singles "Crazy in Love" and "Baby Boy," released at number one on the U.S. *Billboard* 200 chart, and earned five Grammy Awards. Her follow-up album, *B'Day*, contained three top-ten singles, "Déjà Vu," "Beautiful Liar," and "Irreplaceable"—her fourth number one single. This was followed by the album *I Am . . . Sasha Fierce*, which was recognized with the Grammy for Song of the Year for "Single Ladies (Put a Ring on It)" and five other Grammys.

With her fourth album, simply titled *4*, Beyoncé explored the styles of 1970s funk, 1980s pop, and 1990s soul. Her self-titled album, *Beyoncé*, was a change from its mellow predecessor, exploring a darker thematic in an experimental production style. The acclaimed *Lemonade*, her sixth album, was the best-selling album of 2016, and made Beyoncé the first and only musical act in *Billboard* history to debut at number one with her first six solo studio albums. A collaboration with husband Jay-Z as the Carters, *Everything Is Love*, was released two years later.

Beyoncé has sold more than one hundred million records worldwide, and this prolific body of work has earned the artist enormous recognition. She is the most-nominated woman in Grammy history, having won twenty-three of the prizes. She is the most-awarded artist at the MTV Video Music Awards, with twenty-four wins, including the Video Vanguard Award. The Billboard Millennium Award recognized her as Top Female Artist of the 2000s and the Top Radio Songs Artist of the Decade. She was ranked he as the most powerful female in entertainment on the Forbes magazine list in 2015 and 2017; and for two years was listed in the *Time 100*, and in 2016 she reached sixth place on the *Time* "Person of the Year" list. Other accolades for her work have included American Music Awards, World Music Awards, and the prestigious NAACP Image Award. In addition, she was the first African-American woman (and only the second woman) ever to receive the ASCAP Pop Songwriter of the Year Award.

In the midst of her success as a recording artist, Beyoncé began a successful acting career. She made her debut in the title role of Robert Townsend's *Carmen: A Hip Hopera*, followed by the comedy hit *Austin Powers in Goldmember*, *The Fighting Temptations*, *The Pink Panther*, *Dreamgirls* (as Deena Jones), *Cadillac Records* (in which she played Etta James), and *Obsessed*. Each of these efforts also came with awards and recognition from the public, critics, and her industry peers.

Even with all that success, the artist remains aware of the example she sets, and how her identity and the body of her work—including an iconic character such as Nala—resonates through the culture. "Imagine if someone hadn't given a chance to the brilliant women who came before me: Josephine Baker, Nina Simone, Eartha Kitt, Aretha Franklin, Tina Turner, Diana Ross, Whitney Houston, and the list goes on," Beyoncé says. "They opened the doors for me, and I pray that I'm doing all I can to open doors for the next generation of talents."

## Designing Nala

The adult version of Nala is a lithe, athletic lioness with short, glossy fur. "We also tried to keep a specific sort of angular face that may be somewhat reminiscent of the animated Nala from the original film," says James Chinlund. The adult Nala's color scheme echoes her color palette as a cub and the palette of her mother, Sarafina—an overall light white-yellow color tone.

"She does inherit some features from the Nala cub, such as spots on her forehead and intense dark patterning framing her eyes, as well as a similar yellow-green eye color to her eye color as a cub," Chinlund says. "She is slightly smaller than both Sarabi and Sarafina, but incredibly athletic."

**Opposite page:** Fully-grown Nala was designed to show off her athletic form and to subtly reference the character's younger self, as seen in this visual development piece.

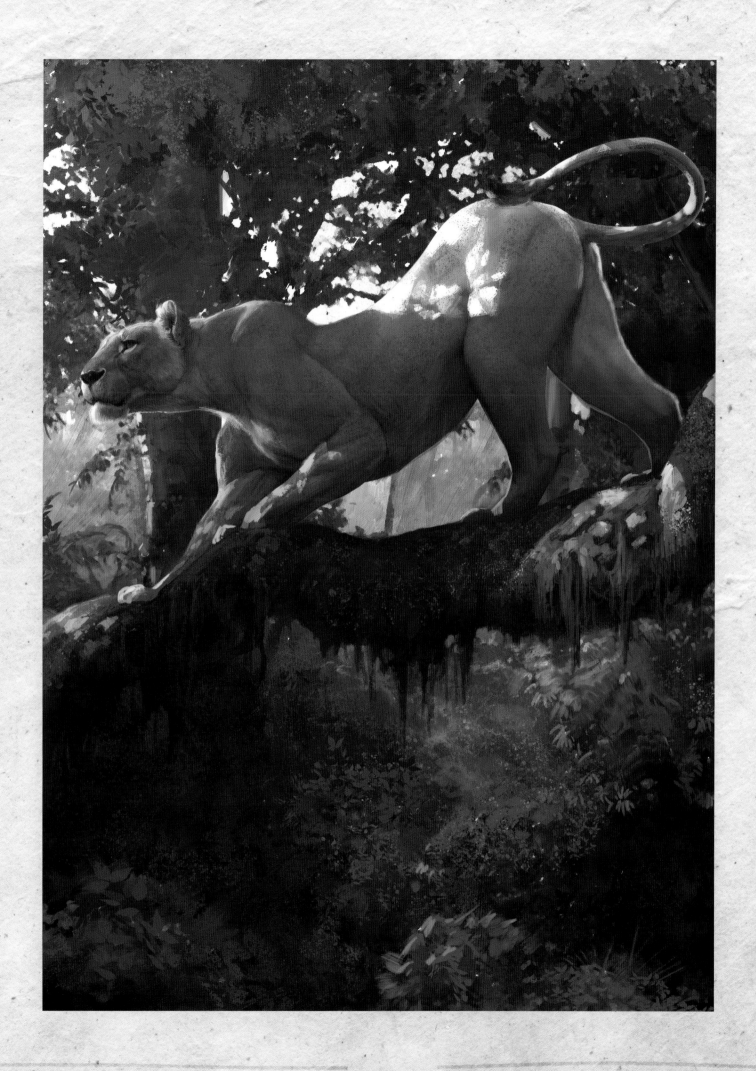

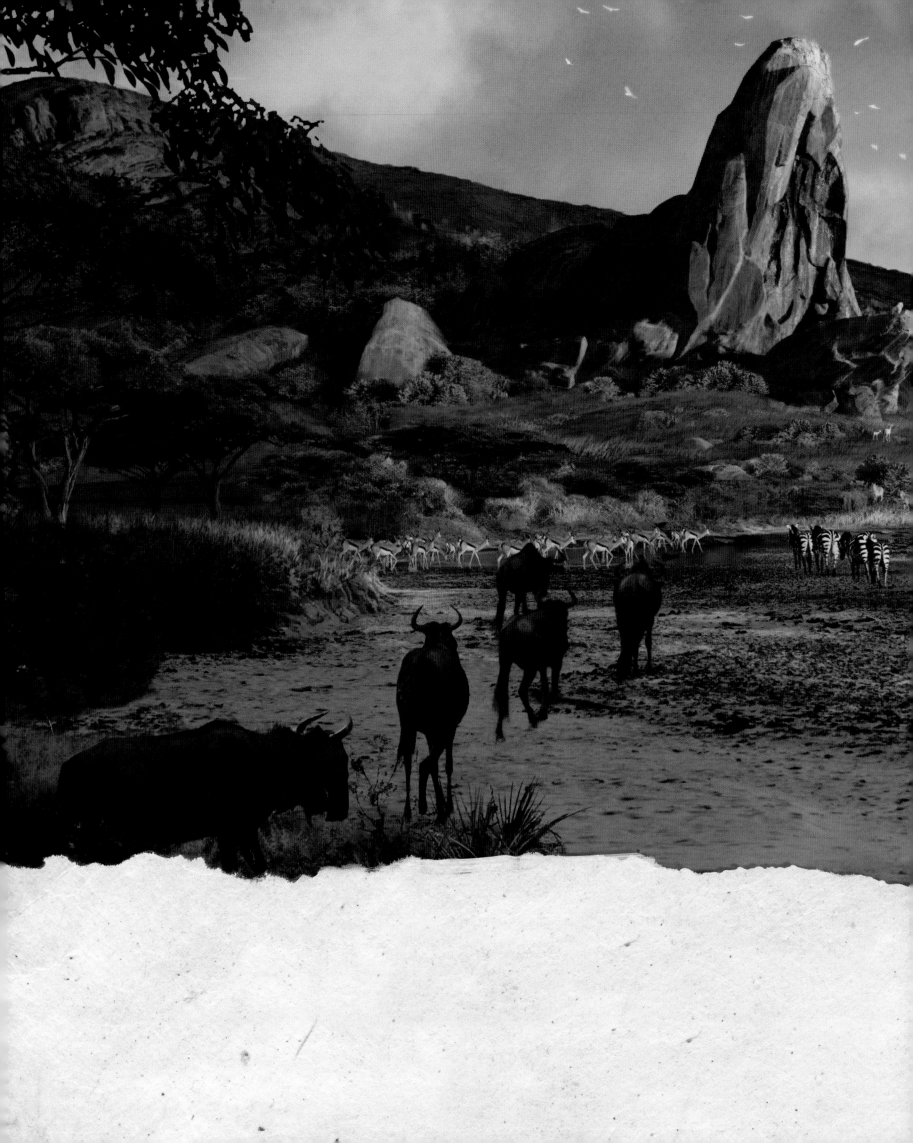

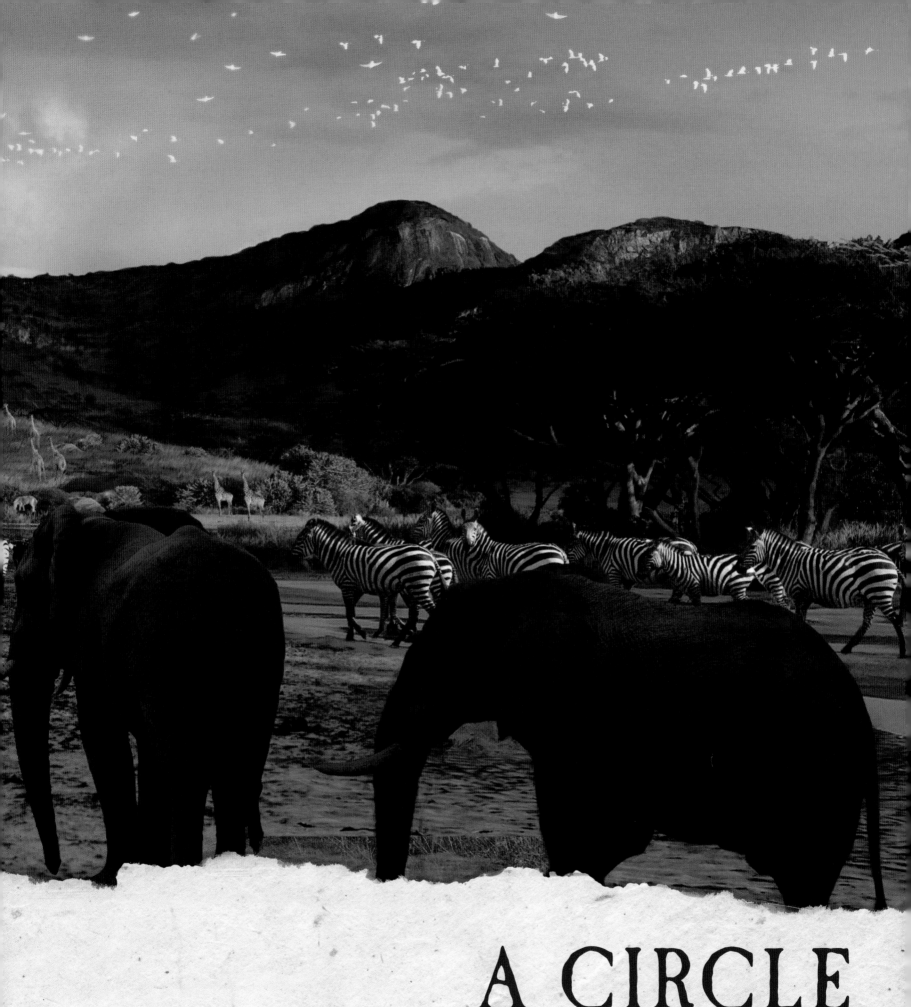

# A CIRCLE
# OF LIFE

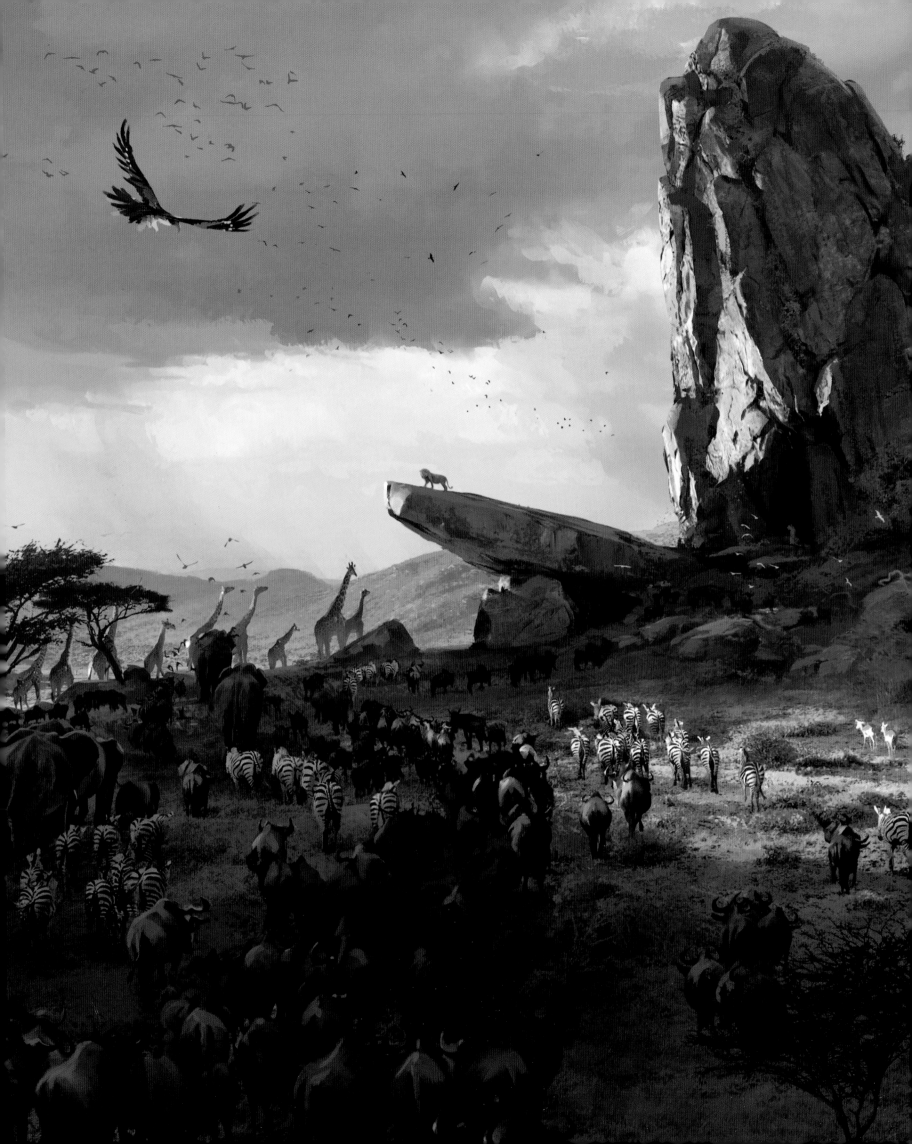

# CHAPTER NINE

### Hans Zimmer—Under *The Lion King*'s Spell

Resonant storytelling and unforgettable characters are obviously fundamental to the enduring appeal of *The Lion King*. But the gutsy decision to return to the legendary story set in concrete the requirement that the retelling would have to embody the spiritual and cultural majesty of the original work. To achieve that, *The Lion King*'s immortal music, ingrained eternally in the story's mythos, had to once again stand as a foundational pillar for the movie overall. From its origins in animation through audio recordings, a stage adaptation, and now again as a cinematic reimagining, *The Lion King* has always been inseparable from its sound.

"I still wonder at the idea that we originally did not think of the story as a musical," executive producer Thomas Schumacher relates. "It is now so much of the emotional core of what the story says."

Thus, at the end of the day, it shouldn't be surprising that to build that musical core with the same artistic and emotional success as the first time around, filmmakers would have no other choice than to turn to the coalescing presence of the legendary Hans Zimmer.

The budding light of sunrise captures the celebratory mood of the animals gathering at Pride Rock in this visual development art from *The Lion King* (2019), a moment inseparable from its signature song "Circle of Life".

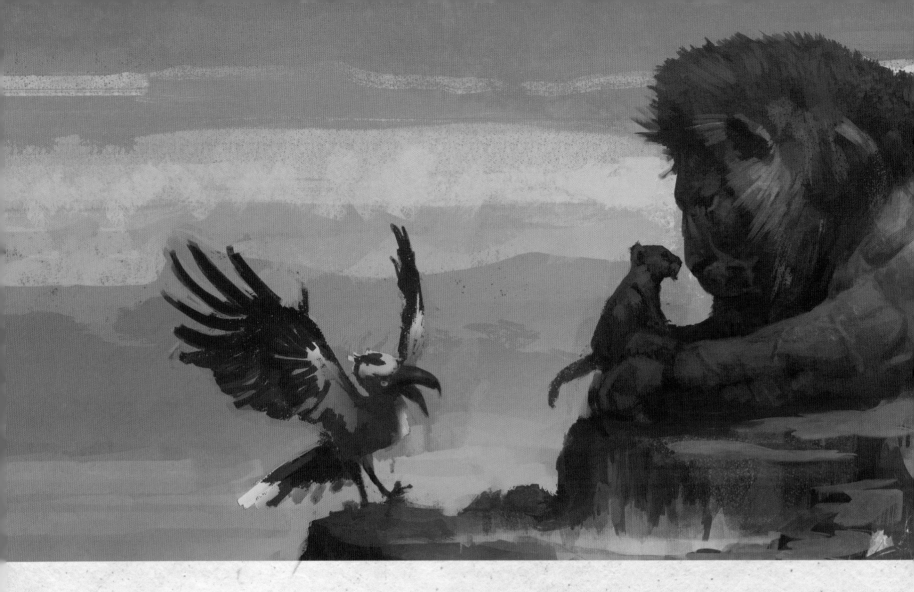

Indeed, the famed German composer, producer, and performer influenced the new movie even before he had any inkling he would be working on it. Director Jon Favreau distinctly remembers being shown, during the earliest days of preproduction on *The Lion King*, online video footage of Zimmer and his band performing Zimmer's unique brand of cinematic instrumental music at the Coachella Valley Music and Arts Festival in Indio, California, in 2017.

"Coachella is where you have rappers and DJs and Electronic music and pop music—all this relevant cutting-edge stuff, a snapshot of a moment in time in the culture," Favreau explains. "And there I saw all these kids quieting down and listening while the band plays 'Circle of Life.' In the footage, you see everybody's face—they were completely enthralled, just from the power of the performance of the music. Zimmer himself confirms the power of that experience. "We have photographic evidence of grown men crying at Coachella while we were playing music from *The Lion King* soundtrack," he says.

"But I had to be talked into even doing it. I didn't [originally] think it was appropriate to play *The Lion King* to that audience. I

didn't think they would get it. But [British musician and son of longtime Zimmer collaborator Johnny Marr] Nile Marr—twenty-three years old at the time—who, up until that point, had been very quiet, turned on me in the best possible way, and said, 'Hans, get out of your own way. This is what everybody loves. Everybody has a connection to this music.' I love that I was completely wrong, that Nile spoke up, and that I listened to him."

## The Circle Begins

A discussion on the everlasting cycle of *The Lion King* music naturally begins with the animated feature. That Hans Zimmer joined the project at all continues to surprise him to this day. "It started off with [directors] Rob Minkoff, Roger Allers, and [producer] Don Hahn saying they wanted me to do *The Lion King*," Zimmer says. "I said, 'Absolutely no—I don't know anything about cartoons.' I said, as much as I like Disney musicals, I didn't want to do another one, and I'm not into fairy tale princess stuff, and I just didn't want to do it. They told me that is exactly why they wanted me to do it.

"In the meantime, I have a daughter, and she was six years old at the time. I always regretted that I had never taken my child to a premiere of any of the movies I had done until then, because you can't really take a six-year-old to those kind of movie premieres. So I thought about wanting to show off for her, and finally said, 'Okay, I'll do it—so I can take my own princess to a premiere.' So really, all my reasons for doing it were wrong. And then the inevitable thing happened—I sat in front of it and suddenly realized this wasn't a cartoon about funny animals at all. It was a profound and incredibly moving story about the death of a father and how you deal with it as a child.

"My father died when I was six, the same age my daughter was at the time. I firmly believe children don't know how to really deal with death. What they know is how to lock it away. So, suddenly, I was sitting in front of this movie—it wasn't even a movie then, it was still storyboards and sketches—and I realized I would have to dig deep, profoundly let go, and write about things and confront things I had never confronted before. That was the only way to be honest about it. So, in a peculiar way, my side of it turned into a requiem for my own father."

## Heart of a New Endeavor

Despite Zimmer's success as a performer, record producer, and film composer on such major movies as *Dunkirk*, various Transformers films, *Interstellar*, *Man of Steel*, *12 Years a Slave*, *Inception*, *Kung Fu Panda*, various Pirates of the Caribbean movies, *Batman Begins*, *Gladiator*, *Armageddon*, *Thelma & Louise*, *Driving Miss Daisy*, *Rain Man*, and a host of others—it's clear that *The Lion King* holds a far different and clearly more emotional place in his heart than any of the others.

**Above:** At its heart, The Lion King is a father-son story, as evidenced in this visual development art of Zazu visiting Mufasa and Simba. It was that theme that originally hooked composer Hans Zimmer as it resonated with his own life, brought him to the original movie, and helped him decide to return to the material once more for the new film.

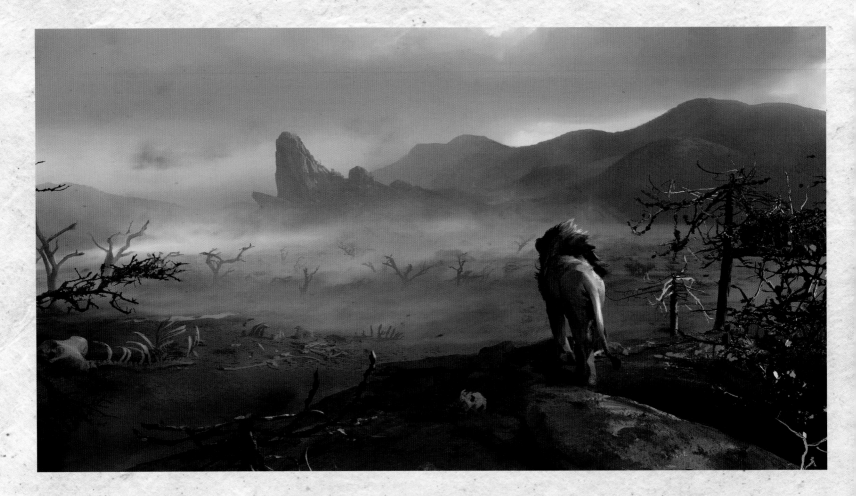

So when Zimmer was asked to return and participate in crafting a new soundtrack for the movie, he felt joy that, in a manner of speaking, his own personal "circle of life" was swinging back around. His responsibilities once again included taking charge of all composing duties; evolving five key songs from the original film into the new soundtrack and reimagining the underscore—the musical "glue" that binds story beats and sequences and emotional experiences together as filmmakers intended.

"I went down to see Jon Favreau, and I was my typical, 'Okay, whatever,' full-of-doubt self," Zimmer recalls. "And he said, 'Let me show you something.' And then he showed me [a previsualization] of the opening of the film. It made me cry—and he had me. I mean, it's not that easy to make me cry. But he showed me magic, and had a clear vision, which made it clear he was treating the material with the right amount of respect—and probably the right amount of trepidation and fear that comes with redoing something that has already been hugely successful. But the thing was, that convinced me he was going to treat it with enormous heart."

Maintaining that foundation—the golden nugget of heart from the original—without just doing the same thing over again, and hoping to have a similar impact on audiences, informed the filmmakers' philosophy for approaching the retelling, as well as Zimmer's thinking on a "new" soundtrack for this material.

## Masterpiece in a New Millennium

Even after so many years, and a generational technological change in how movie soundtracks are recorded, edited, and finalized, Zimmer was keenly aware that the quality and emotional resonance of the original songs would still hold up, particularly after his Coachella experience. And that reality gave him the strength to experiment with how to revise, edit, and add to or subtract from what came before to build an entirely new soundtrack.

"Well, the tunes are pretty solid," Zimmer says with a smile. "I was surprised, after all those years, going back to those tunes, because I think after doing so many movie scores, that usually, by the end of them, I tell myself, 'If I only had a little bit more time.' Time is always the problem, isn't it? Maybe I could have done this better or improved that.

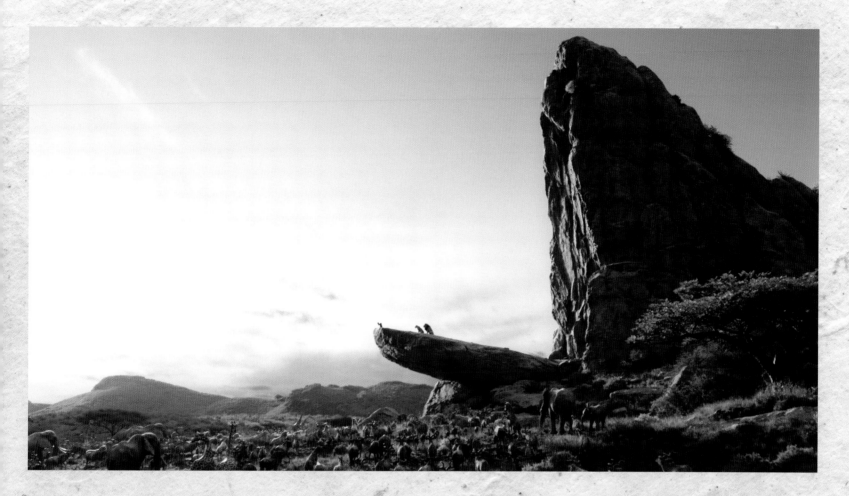

"And if we talk about technology for a moment, we did the original movie at the beginning of the digital sound recording era. Not all of those tapes even play back anymore. I mean, when I went to find original Elton John cassette demos, most people didn't even know what a cassette was! Then somebody found the cassettes, and it was like, we don't have a cassette player! So it's an interesting exercise to do it again but with much better technology.

"At the same time, here I was surprised, even though I'm my own harshest critic. I'm going, these aren't that bad! The tunes are solid, both Elton John's songs and the score. So that means I can go and experiment with them. It's like a good story—the music is a story, as well. So I'm putting new 'actors' into it, meaning new musicians. And I'm giving those musicians some freedom, exactly because the tunes are strong enough. I mean, 'Circle of Life' withstood the onslaught of Hans Zimmer originally and still kept the integrity of Elton's writing intact. So the same now seems to be happening with the tunes I wrote all those years ago. That means we can experiment, but we aren't throwing the baby out with the bathwater. We are keeping the emotional integrity, the emotional truth of everything intact."

## The "Last Actors" in the Movie

A parallel challenge was matching the music viscerally to the new kind of visuals—photo-real, grittier, and with a different character performance style. With the cutting-edge methodology being used by Jon Favreau and his filmmaking team, Zimmer similarly had to examine how his musical efforts would interact and intersect with a distinctly different cinematic technique and method.

Zimmer says, "I have a huge advantage there, because when we made [the original film], it wasn't a 'big Disney film' at the time. It was sort of a 'little' movie in terms of [resources]. Now, I actually have the best musicians playing parts I played originally myself on a cheap synthesizer, and they are really the last actors into a movie, and I suddenly have access to everyone. There is no one who does not want to come in and play on *The Lion King*, let's put it that way."

**Opposite page:** Iconic wide shot views of Pride Rock in paintover of the Wasteland following the cliff fight express the somber mood of the scene.

**Above:** A CG render of Pride Rock.

**Pages 196-197:** *The Lion King* teems with stunning visual development of all manner of African wildlife from the Stream to the African Plains.

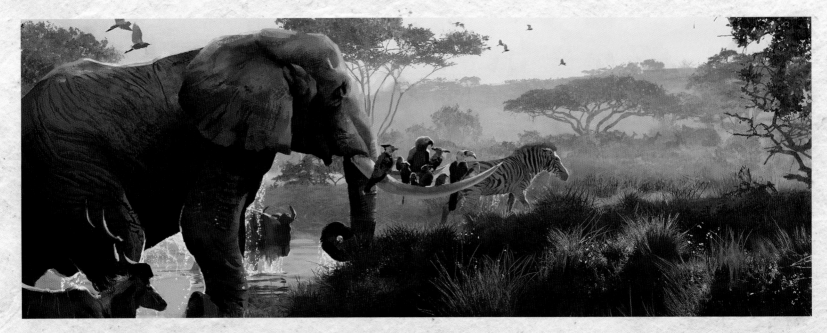

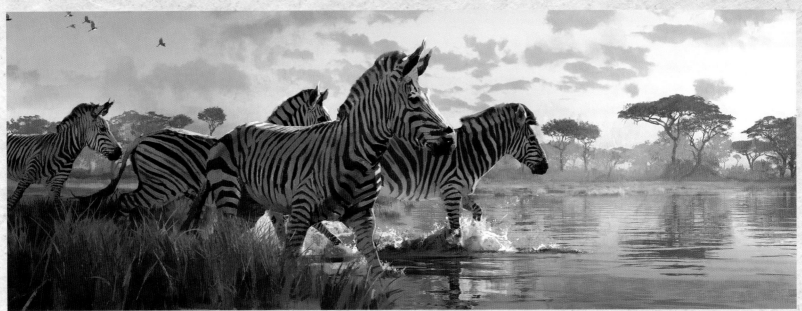

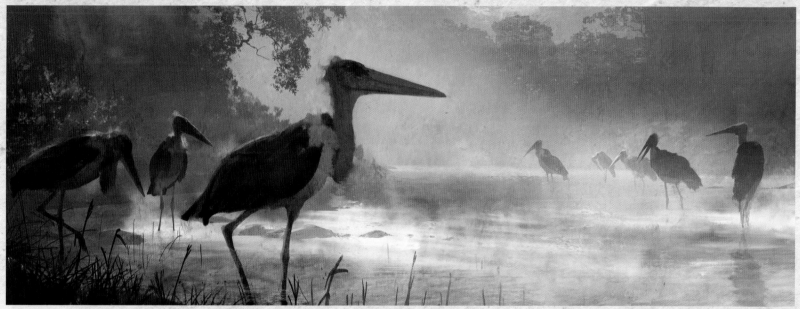

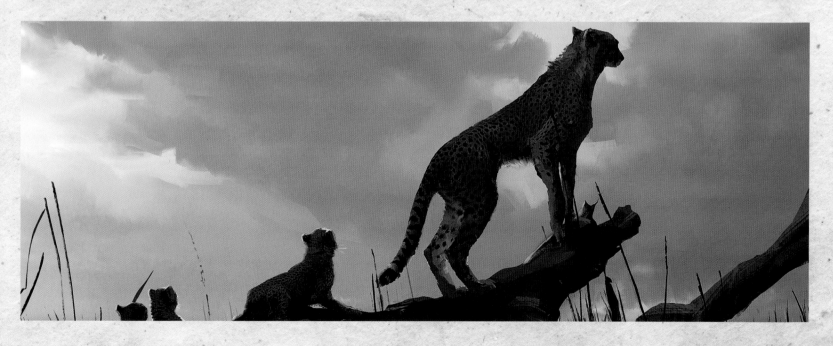

"So just by bringing in all these extraordinary musicians—I mean, that in itself broadens the emotional quality. These musicians, just like the actors, will add a level of humanity to it—if it is okay to use the word 'humanity' in a movie about animals. We are taking them and having a lot of the same adventure. We are going to Africa, we are recording choirs. In fact, I just sent Lebo [Morake, better known as Lebo M.] to South Africa and asked him to try and find out how many of the original choir's children are still singers. I think enough time has gone by that I would love to use the next generation. It's sort of like getting the family back together, but part of getting the family back together is that you want to go and get the sons and daughters of your original family to be part of it. So we are trying to broaden our horizons, our vision.".

## Legacy for a New Generation

Hans Zimmer was also keenly aware the historic, cultural, and political environment had changed since the original movie came out. And that meant, among other things, he had to craft a music track that could appeal to a whole new generation of fans.

"Within two weeks of us doing [the original The Lion King music recordings], the apartheid regime in South Africa fell," Zimmer recalls. "So it is a different world now. I think one of the things that Jon Favreau and others who heard our performance at Coachella responded to is the fact that we are so international. We have people from all over the world in the band and playing on these recordings. I think that is something great—that this story about lions in Africa is, at the same time, a story with universality to it, and that comes out with the playing of these incredible musicians.

"The thing is, I want to give this new generation [of filmgoers] an experience with this movie just like the last generation had. It will be a different experience in a sense, but at the same time, that's because we have all these wonderful toys and technology, and these fantastic young musicians. But that could also make us want to get really loud or overdo things, so we have been very careful to make sure that doesn't happen. We always keep the focus on the story."

## A Global and Eternal Rhythm

There is nothing within the culture of The Lion King that so deeply and succinctly symbolizes its cultural permanence, the depth of its visceral and emotional power, or the importance of its lessons than its music, and its reaffirmation of our shared world and shared future. Hans Zimmer, given his unique history on both The Lion King films, personifies all the filmmakers who have crafted this latest visit to the Pride Lands. They are aware of their responsibility, but take joy in their shared efforts to respect The Lion King.

"I am fully under the spell," Zimmer declares. "You have to become part of it, you have to throw yourself in and even let it take you to rocky places. That is the only way I know how to work. But you know, making good movies like this always feels to me like you are actually having a great dinner party with your best friend. Everybody working on the thing is completely committed and aesthetically in tune, speaking the same language to tell the same story. The audience deserves this respect. And so, we come at everything with our A game. We have the audience's back.

"The Lion King is a strange beast," Zimmer puns. "It constantly surprises you. It's not like other movies I've done, in that typically when you do a movie, it comes and it goes. Maybe it gets played on television or somebody plays it at a special screening. But The Lion King is constantly there, constantly alive. I remember I rebelled, at first, against [participating in] the Broadway musical. I said, 'I don't do Broadway musicals.' Well, it turned out, though I didn't know it at the time, I had already [begun working] on the Broadway musical when I worked on [the film score].

"That taught me this thing has a life of its own. Then, we went and played it at Coachella—we played a fair chunk of it that night. Having my dear friend Lebo with us, that voice sailing across the California desert in the heat of Coachella—that was an event. I realized I would always be completely passionate and involved in any way I could with The Lion King, that I would never get away from it."

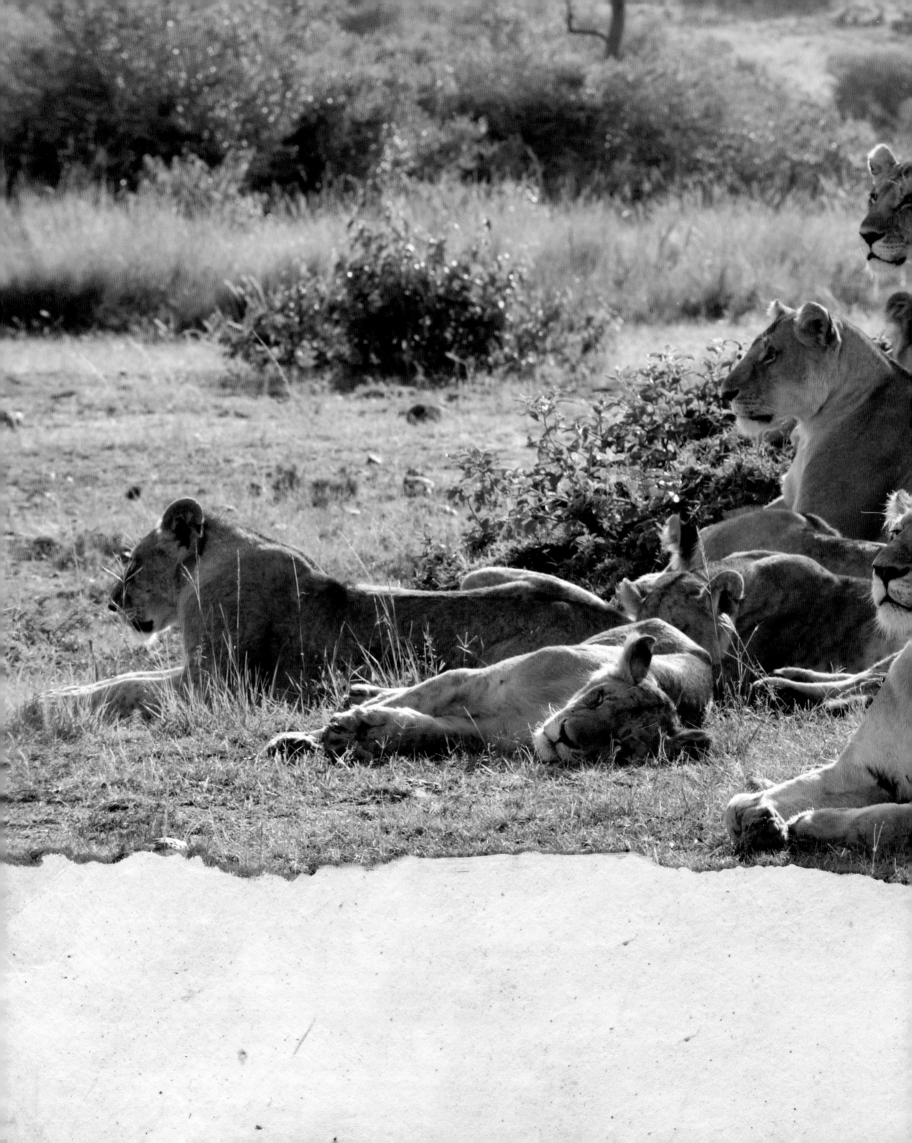

LONG LIVE
THE KING

# CHAPTER TEN

━━━━━━━━━━━━━━━━━━━━━━━━━━━━━━━━━━━━━━━━━━━━━━━

## Disney and the Natural World

*"Disney is committed to being more than just one of the world's leading entertainment companies; we are all citizens and caretakers of this planet, and we take seriously our responsibility to protect this incredible place that we call home."*

—Bob Iger, Chairman and CEO
of The Walt Disney Company

It is common knowledge that Walt Disney had a transformative and lasting impact on our culture through the pioneering and perfecting of animation, family entertainment, and theme parks. Among the less obvious Disney legacies, however, is Walt's support of nature conservation. For more than sixty years, animals—and overall nature themes—have been a part of Disney storytelling, and these tales continue today alongside efforts to protect wildlife and habitats around the world, providing immersive experiences that connect us all with the magic of nature.

In 2009, Disney launched an official corporate policy aimed at reducing the company's environmental footprint. Five years later, the Disney Conservation Fund was established and has since directed more than $75 million to save wildlife, protect the planet, and inspire millions of people to take action for nature in their communities. Today, the idea that nature should be both appreciated and protected has become fully integrated into the Disney culture.

Historians point to many key points in Walt Disney's life that fostered his true appreciation and respect for animals and the natural world. One was working on the animated classic *Bambi* (1942). Before and throughout the production of the film, Walt and his artists sat, sketched, and even fed young fawns as part of their visual development research exercises.

## Early Nature Filmmaking at Disney

From the earliest days of The Walt Disney Studios, which won its first Academy Award in 1932 for the Silly Symphony short *Flowers and Trees*, to the decades that followed, nature has provided the basis for all films the studio was developing. Starting in the late 1940s, Walt sent film crews to remote locations across America, and eventually around the world, to capture dramatic footage of wildlife. The result was the groundbreaking and immensely popular True-Life Adventure series, debuted with *Seal Island* and went on to win eight Academy Awards over its twelve-year life span (1948–1960) and created the template for the modern nature documentary.

By the 1950s, Disney was beginning to reach such a vast movie and television audience that the entertaining and informative depiction of animals and nature in True-Life Adventures kindled a spirit of conservation in millions of Americans. Films like the 1955 release *The African Lion* allowed audiences to travel from their local theater, and later their living rooms, to Africa and follow a family of lions as they experienced changing seasons, the thrill of a hunt, a blinding dust storm and an incredible locust invasion. The legacy of the True-Life Adventures series fueled a mainstream appreciation of wildlife conservation and set many modern-day conservation leaders on their career paths.

"You've probably heard people talk about conservation. Well, conservation isn't just the business of a few people. It's a matter that concerns all of us," Walt said. "It's a science whose principles are written in the oldest code in the world, the laws of nature. The natural resources of our vast continent are not inexhaustible. But if we will use our riches wisely, if we protect our wildlife and preserve our lakes and streams, these things will last us for generations to come."

## Enter Disneynature

Sixty years after the first True-Life Adventure film, The Walt Disney Studios announced a new production banner: Disneynature. Starting with its first film release, 2009's *Earth*, and through each subsequent film, Disneynature has showcased nature's most compelling creatures and environments and engaged moviegoers in conservation initiatives linked to their featured animals and habitats by working with globally recognized organizations that specialize in focused conservation programs. Disneynature ties donations to tickets sold during each film's first week in theaters, allowing audiences to feel more connected to the programs in the field, as their attendance drives the amount invested in these initiatives.

For *Earth*, Disneynature contributed to The Nature Conservancy to plant trees in Brazil's Atlantic Forest, resulting in more than three million new trees in one of the planet's most endangered rain forests. Disneynature and The Nature Conservancy teamed up again the following year with *Oceans*, ultimately establishing the first forty thousand acres of a new marine protected area off Andros Island in the Bahamas.

A unique 2011 conservation program effort connected to Disneynature's fourth feature documentary: *African Cats*. Using box office revenue from the film, "See African Cats, Save the Savanna" supported big cats with a multifaceted approach through the African Wildlife Foundation, which worked to conserve the lands between Kenya's Amboseli, Chyulu Hills, and Tsavo National Parks and to enable animals to roam freely between these protected habitats. The program ultimately helped protect sixty-five thousand acres of savanna, and the film—with Disneynature's signature storytelling style—connected moviegoers to these majestic cats in a way that inspires an ongoing commitment to the natural world.

The record-setting opening-day and opening-week ticket sales of *Chimpanzee* in 2012 supported the Jane Goodall Institute's efforts to conserve chimpanzee habitats, expand educational programs for schools in the Congo, and provide care for orphaned chimpanzees. The story of a mother grizzly and her cubs in *Bears* inspired a host of conservation programs in 2014 that benefited the National Park Foundation. In 2015, *Monkey Kingdom* paired Disneynature with Conservation International to protect monkeys and other endangered species across Indonesia, Cambodia, and Sri Lanka. Featuring iconic pandas, as well as snub-nosed monkeys and elusive snow leopards, *Born in China* aptly inspired a 2016 collaboration with the World Wildlife Fund in an effort to increase the wild panda population and establish new snow leopard conservation

programs. In 2019, with a new film, *Penguins*, Disneynature teamed up with the Wildlife Conservation Network, which invests in select on-the-ground conservationists (including the world's leading science-based penguin conservation organization, the Global Penguin Society) to help scientists track penguin migration and fund coastal cleanup efforts across the southern hemisphere.

**Opposite page, left and right:** In making the first True-Life Adventure featurette, *Seal Island*, Walt Disney reviewed film footage from Alaska and selected the seals as having the most promise for a documentary. Walt asked his filmmakers to emphasize the life cycle of seals in the film and not show any human presence. This is the approach that earned the film an Academy Award and became the signature style for the remainder of the True-Life Adventure films, including *The African Lion*.

**Above:** Disneynature films, including *African Cats*, offer their own signature storytelling about nature's most compelling creatures and environments as well as engage moviegoers in conservation initiatives linked to their featured animals and habitats.

## A Start to Something Special

As with Disney films through the years, so too has nature become a key foundational theme in the storytelling at Disney theme parks. Walt Disney himself had much input into attractions like the Jungle Cruise and Enchanted Tiki Room at Disneyland, and that tradition continued after Walt's passing, such as in the earliest days of the Walt Disney World Resort, which opened with the natural Floridian recreational sanctuary of Disney's Fort Wilderness Resort & Campground in 1971.

Building on this legacy, in 1990, a plan conceived by Disney Imagineer Joe Rohde and dubbed "Disney's Wild Animal Kingdom" was set into motion. This new theme park would use theater and storytelling to celebrate wildlife and the emotional connection between people and animals.

"When we Imagineers started the development of Disney's Animal Kingdom, we knew that we were entering a new territory of storytelling," Rohde says. "These stories were not fantasies, but real. They were not classic tales, but ongoing epics whose conclusions are still unknown. They were not ours alone, but shared with people all around the world, who lived with and cared about the lives of wild creatures. We could not tell such stories unless we ourselves participated in the reality we were describing, contributed to the epic struggle, and shared our skill and our commitment with people around the world. Thus, we concluded that an entity like the Disney Conservation Fund was essential to our story. Without it, our own words and actions would be empty."

Rohde and his handpicked Imagineering team engaged an advisory board of top zoo, animal welfare, and conservation professionals who offered guidance on the park's design and development. These experts also helped Disney expand its commitment to conservation by establishing a strategic approach to support threatened species in the wild.

It was this simple idea that eventually led to the creation of the Disney Conservation Fund, which began on Earth Day in 1995. When Disney's Animal Kingdom Theme Park opened three years later, the two were forever united on a mission to protect wildlife and wild places. From opening day, guests inspired by their experiences at Disney's Animal Kingdom could add a personal contribution to the Disney Conservation Fund through merchandise locations around the park.

Today the Disney Conservation Fund has evolved to become a respected leader in international conservation, supporting field research, conservation education, and community engagement in 120 countries spanning across six continents. Likewise, Guests

continue to play an important role in supporting Disney's conservation efforts by making contributions at select locations at the Walt Disney World Resort and aboard the Disney Cruise Line ships. One hundred percent of these contributions are matched by The Walt Disney Company and directed to nonprofit organizations working to protect the planet.

## Protecting the Magic of Nature

The Disney Conservation Fund (DCF) has paired philanthropic grants with the direct participation of more than 180 of Disney's Animals, Science, and Environment Cast Members who, along with other employees, work together to help protect more than four hundred species—including elephants, cranes, butterflies, and coral reefs. The DCF annually awards grants to leading nonprofit organizations implementing comprehensive conservation programs that inspire people to take action for wildlife and the planet.

Opposite page, top: Walt Disney and technician Louis Frahcuz examine a family of lions in the Jungle Cruise attraction at Disneyland Park in California. Walt originally wanted the Jungle Cruise experience to allow Guests to observe live animals, but the logistics of the time made it impractical.

Above and opposite page, bottom: At Walt Disney World in Florida, Disney's Animal Kingdom Theme Park, known for its iconic Tree of Life, beckons Guests to experience the Kilimanjaro Safaris attraction, an expedition through the 110-acre Harambe Wildlife Reserve, which is home to thirty-four species living across grassy plains, shady forests, and rocky wetlands.

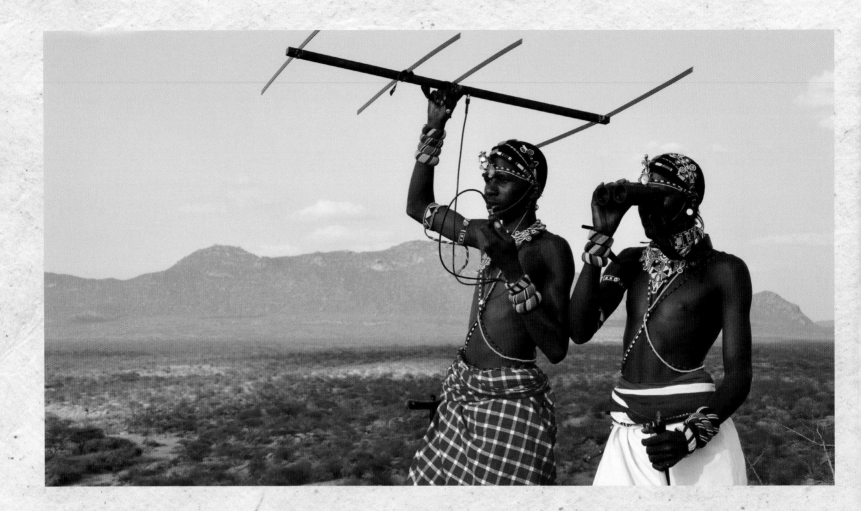

## Honoring the Protectors

The people and projects and organizations working in Africa alone are vast and varied. For example, with DCF support since 2010, African People & Wildlife has excelled at developing win-win solutions for big cat conservation in areas where rural people live alongside lions, leopards, and cheetahs. Also thanks to DCF, an organization called the Grevy's Zebra Trust expanded its conservation efforts into remote areas of northern Kenya where little is known about the wildlife species. Another organization supported by the DCF, Painted Dog Conservation, "[is] viewed with high esteem in the local community due to the engagement with the young minds and providing a better tomorrow," according to Wilton Nsimango, the program's manager of Education & Community Development Programs. These examples, while representing only a fraction of the many inspiring nonprofits and conservationists DCF has supported over the last two decades, capture the essence of why the fund was created and demonstrate the depth and breadth of its worldwide impact.

Recognizing that conservation endeavors would not be successful without the passionate, dedicated individuals who give their all to champion conservation in their communities, protect animals, and preserve ecosystems, the Disney Conservation Fund also began a program to honor Conservation Heroes. Jeneria Lekilelei of Ewaso Lions is one of more than 160 individuals who have been recognized with this award. A livestock herder and Samburu warrior in Kenya, Lekilelei realized at a young age that he needed the help of other warriors to protect threatened lion populations surrounding his community. He created a program called Warrior Watch to train others to monitor lion populations and advocate for peaceful coexistence between people and carnivores. In addition to supervising seventeen warriors who monitor an area of more than 2,500 square kilometers and spending countless hours monitoring lions in the field himself, Lekilelei also manages community programs to engage women and children in conservation efforts.

**Above:** Jeneria Lekilelei, shown on left next to his team member, is the Field Operations & Community Manager of the conservation group Ewaso Lions. In 2015, he won the Conservation Hero Award from The Walt Disney Company through the Disney Conservation Fund (DCF).

**Opposite page, clockwise from top left:** DCF supports multiple organizations worldwide: for example, Painted Dog Conservation which educates children—like this girl in Zimbabwe—about painted dogs in their environment. Other groups backed by DCF include the Kenya-based Grevy's Zebra Trust and African People & Wildlife, which focuses on big cat conservation.

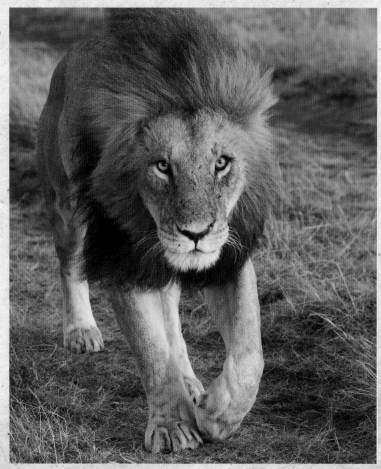

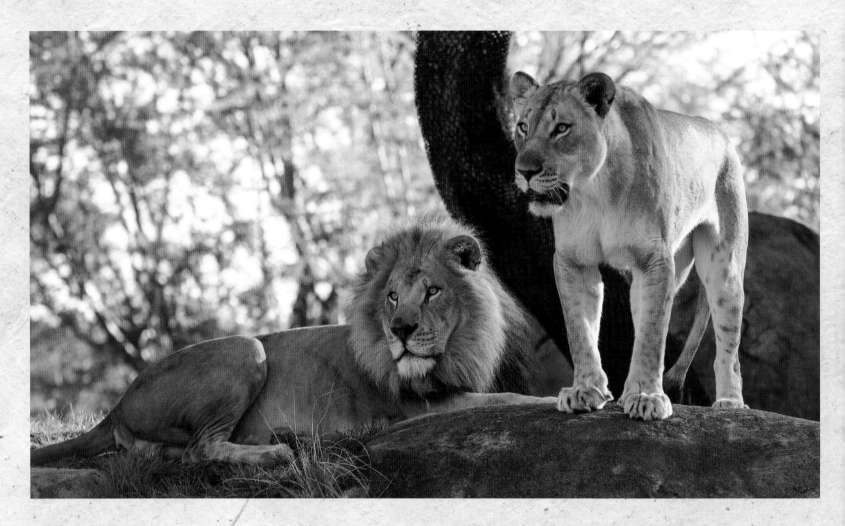

## Coming Full Circle

Whether in the Disney theme parks, on the big screen, or through experiences that bring people face to face with animals around the world, dedicated experts work hard to bring the magic of nature to life and become ambassadors for the many species they work with. Through company-wide partnerships, Disney ensures the representation of animals is accurate and respectful, which is why, more than two years before *The Lion King* was slated to hit theaters, the filmmaking team spent weeks observing the incredible African species residing at Disney's Animal Kingdom to expand their up-close, real-life character inspirations even before their eventual trip to Africa took place.

The team spent time with Disney's Animals, Science, and Environment's animal care experts to gain unique insight from the individuals responsible for the daily care of each animal and to experience the social dynamics, behaviors, and personalities of each species. As the filmmakers marveled at the beauty of these animals, they captured reference photography to make sure the natural behaviors of the individual species would be represented in the film. "We were honored to have our Animals in Film & TV team and Animal Care experts work closely with *The Lion King* production crew at Disney's Animal Kingdom to ensure the accuracy and authenticity of the way animals were being depicted," says Mark Penning, vice president of Disney's Animals, Science, and Environment. "Our company is dedicated to protecting all wildlife and celebrating the important role animals play in the world. The steps The Walt Disney Studios took to bring to life animals in this film as realistically as possible is just one example of that."

## Bringing Back the King

Filmmakers also wanted *The Lion King* to contribute something more than reference photography to Disney's long-standing commitment to education and conservation. And the jarring truth is that the world has lost half of its lion population since 1994, for context, the same release year of the original *The Lion King*. As human population growth and development rise across Africa, lions increasingly face threats from the bushmeat trade, poaching, conflicts with humans, and loss of habitat as land is converted for agriculture and infrastructure. Today, while only about twenty thousand lions remain,

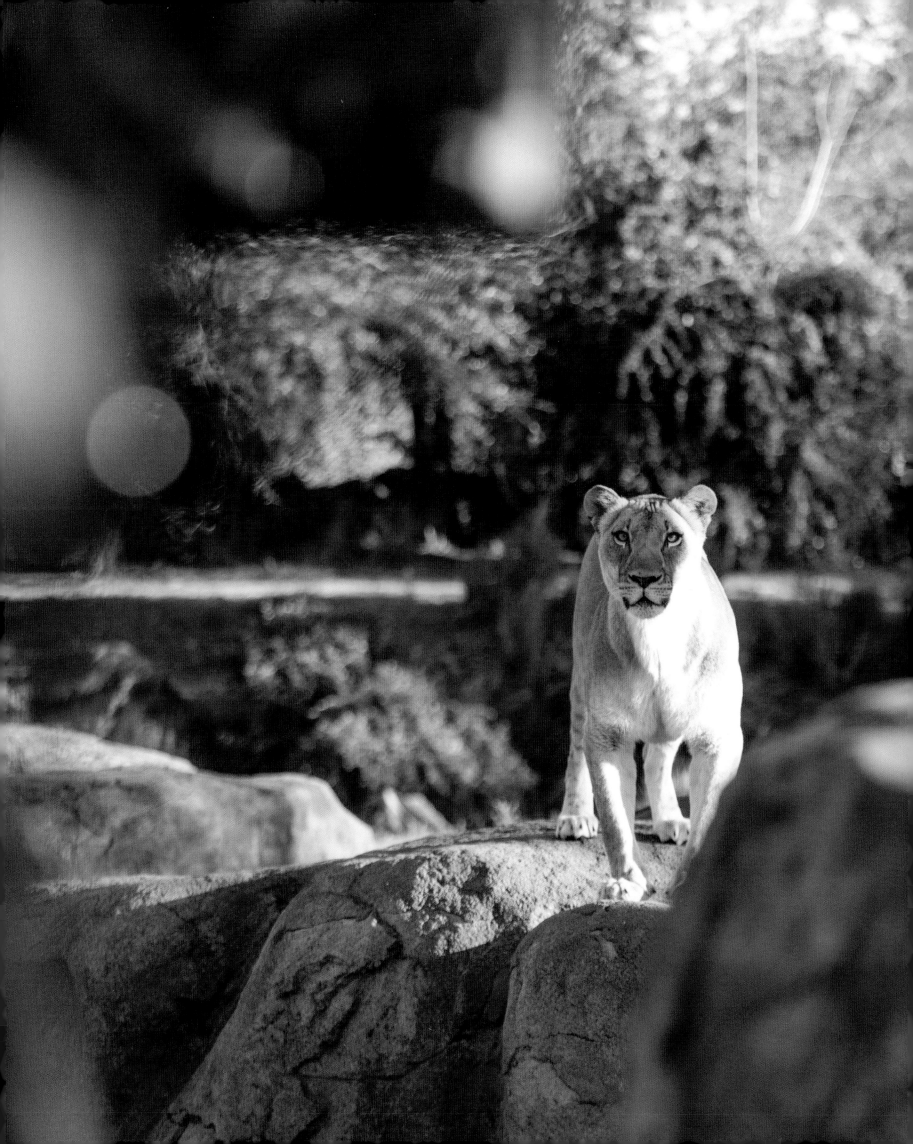

## The Lion Recovery Fund

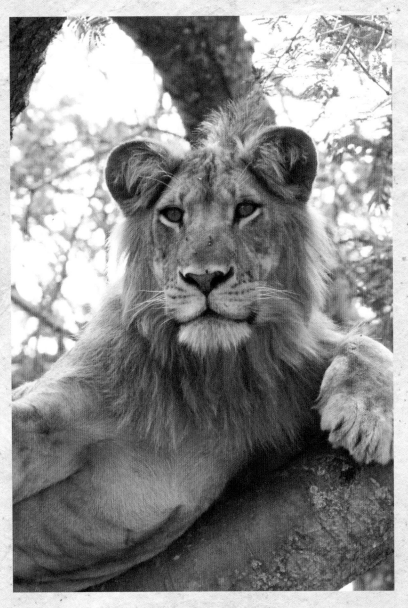

Wildlife Conservation Network's Lion Recovery Fund (LRF) drives investments to game-changing actions by funding the most effective, vetted partners who work collaboratively to bring lions back. It targets site-based results on the ground supporting protected area management and community-based conservation solutions throughout Africa and campaign strategies that build public, political, and philanthropic will for lion recovery. Disney has supported various conservation efforts with Wildlife Conservation Network for nearly fifteen years, together protecting nineteen species in fifteen countries around the world.

The practical plan to save lions involves connecting leading lion experts in a coordinated, long-term approach that aims to expand land for lions, connect their home ranges, and protect them through increased support of wildlife rangers and drive collaboration to ensure people sharing land with lions benefit from protecting them. For example, in Chad, the LRF is enabling a major survey of lions and prey species with the organization, African Parks, that will guide the future management and conservation efforts for the park and encourage decision makers to protect the areas of land with the largest remaining wildlife populations. In Zambia, the LRF supports the Zambian Carnivore Programme and Conservation South Luangwa to tackle the twin threats of snaring and human-wildlife conflict by leading anti-poaching patrols, outreach, and education to improve livestock management to prevent both human-lion and human-elephant conflict.

In celebration of this book and to lend support to the LRF, Disney Publishing Worldwide and the Disney Conservation Fund will collectively donate $25,000 to the Wildlife Conservation Network to help "Protect the Pride" through efforts that engage communities to ensure a future for African wildlife and their habitats.

there is still an opportunity to bring lions back and thus help safeguard the diversity of wildlife across the African savanna, preserving thriving habitats for both animals and people.

Disney and the filmmakers of *The Lion King* aim to inspire audiences to help double the population of lions by 2050. Building on $13 million Disney has invested to protect wildlife and habitats across Africa, the Disney Conservation Fund will collaborate with the Wildlife Conservation Network, founders of the Lion Recovery Fund, as well as with other key respected conservation organizations to help advance impactful and innovative efforts to ensure a future for lions and other wildlife across Africa. "The Lion Recovery Fund has a vision to restore lions across Africa, and Disney's powerful storytelling is a perfect way to further these efforts. Wildlife Conservation Network is proud to collaborate with Disney on *The Lion King* to inspire people around the world to bring lions roaring back," says Charlie Knowles, founder of the Wildlife Conservation Network.

**Pages 210–211:** As evidenced by these reference photos, filmmakers of *The Lion King* (2019) traveled to Disney's Animal Kingdom Theme Park at the Walt Disney World Resort as part of their research efforts to better understand the movements of animals.

**Above and opposite page:** Observing wild lions of Africa also served as a creative inspiration for filmmakers of *The Lion King*. Now the majestic animals are also the focus of the Wildlife Conservation Network's Lion Recovery Fund (LRF).

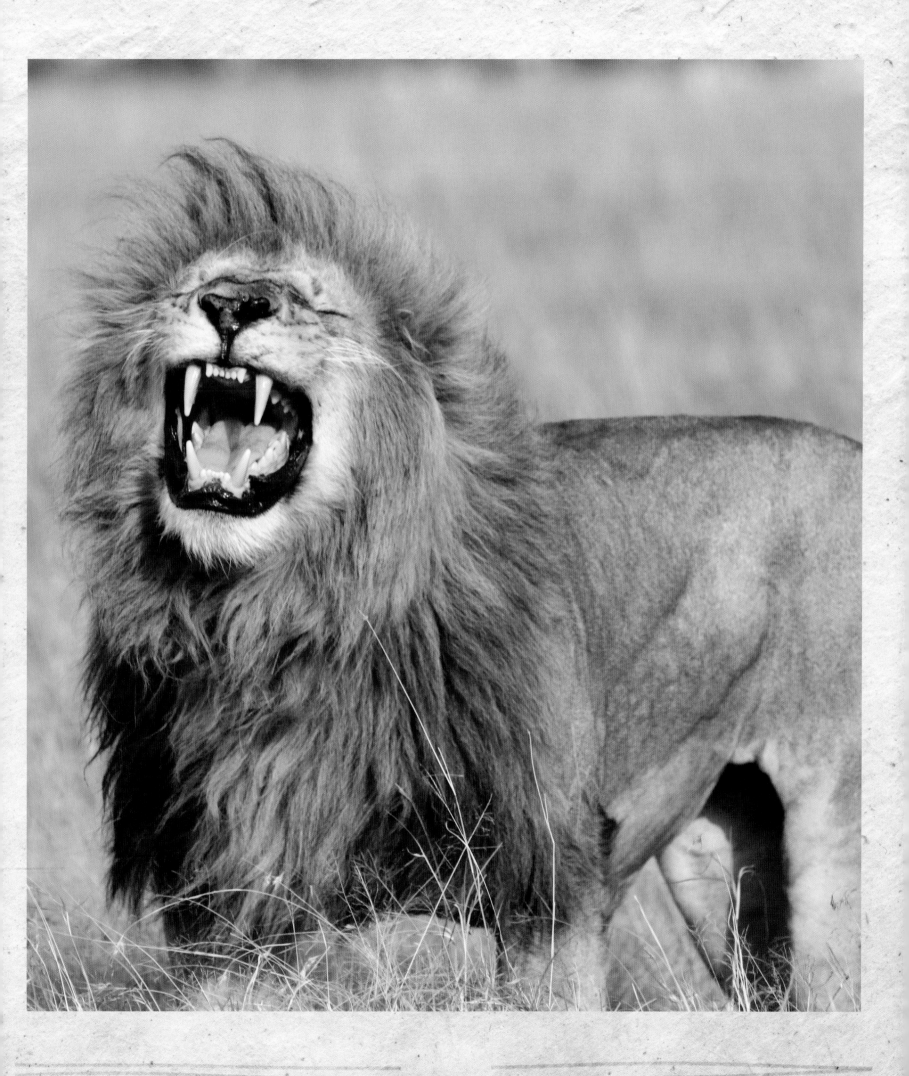

# GLOSSARY

- **3-D model:** A three-dimensional representation of any object surface created in a computer using mathematical processing

- **3-D printer:** A device that analyzes three-dimensional computer models and constructs them as physical three-dimensional objects made of thin layers of materials, like plastic or metal, piled on top of each other

- **animatic:** A rough, preliminary version of a movie created by filming storyboards, adding temporary sound, and editing those elements together to give filmmakers a visual roadmap to follow

- **ARRI ALEXA 65:** A high-resolution, large-format digital cinema camera system

- **camera dolly:** A camera platform on wheels that rolls across a track for moving shots

- **CGI:** Computer-generated imagery

- **computer numerical control (CNC):** A method for automating control of certain precision machines using software and computer chips built into those machines

- **cucoloris:** A device used for casting shadows or silhouettes to create certain patterns with motion picture lighting

- **design stills:** Rendered frames exemplifying particular locations, which filmmakers use to approve visual details of various environments

- **digital sculpting:** The use of computer software to manipulate a digital object in various ways until it is "formed" into the desired image, emulating the way clay can be molded into a specific object

- **drone:** A small unmanned aerial vehicles used for a wide range of applications, including filmmaking, to capture unique points of view

- **HTC Vive virtual reality system:** A well-known hardware system used to provide virtual reality experiences

- **mood board:** Key conceptual images arranged to illustrate filmmaker preferences, used as reference

- **MPC:** Moving Picture Company, a well-known British visual effects company

- **OptiTrack Active Tracking motion capture system:** A hardware system used for capturing three-dimensional data related to camera movement for videogame and filmmaking applications

- **rendering:** Automated process of transforming computer image data into clear, recognizable images using high-powered computer systems

- **Skin Model:** In the technique of skeletal animation, a skin model is a version of a CG character that includes a representation of its skin (or mesh) surface on top of the computer model's connected bone system so the skin can be animated to move in a believable way

- **Steadicam:** Stabilized camera mount worn by an operator for filmmaking

- **Unity rendering engine:** State-of-the-art video game hardware system for rapidly rendering animated images into recognizable pictures, created by Unity Technologies and recently applied to some virtual production pipelines for filmmaking

- **VAD:** Virtual Art Department

- **virtual production:** A new and advanced filmmaking technique involving the use of specialized hardware and cameras that captures motion of objects or people in combination with real-time rendering techniques so that viewers see motion applied to digital images in real time during production

- **virtual reality:** Artificial computer-generated three-dimensional environment designed to be experienced in a realistic way by viewers who wear specialized goggles and other hardware that allows them to "interact" with the environment

- **virtual world:** A computer-generated simulated environment

# INDEX

# SOURCES AND CREDITS

## Interviews

Allers, Roger. Unpublished interview with Jeff Kurtti, 2002. Also quoted from: Finch, Christopher. The Art of The Lion King. New York; Hyperion, 1994. Print.

Bartnicki, John. Interview with Michael Goldman on Playa del Rey set in Los Angeles, January 12, 2018.

Barton, Craig D. Quoted from: Kurtti, Jeff. Practically Poppins in Every Way. Los Angeles • New York: Disney Editions, 2018. Print.

Chinlund, James. Phone interview with Michael Goldman, March 22, 2018.

Deschanel, Caleb. Interviews with Michael Goldman on Playa del Rey set in Los Angeles, January 12, 2018, and March 7, 2018.

Favreau, Jon. Interviews with Michael Goldman on Playa del Rey set in Los Angeles, January 12, 2018, and March 8, 2018.

Gilchrist, Karen. Interview with Michael Goldman on Playa del Rey set in Los Angeles, January 12, 2018.

Grossman, Ben. Interview with Michael Goldman on Playa del Rey set in Los Angeles, January 12, 2018, and e-mail exchange with Michael Goldman.

Hahn, Don. Unpublished interview with Jeff Kurtti, 2002.

Hudson, Richard. Quoted from: Royston, Peter. The Lion King Study Guide. New York: Disney Theatrical Productions Education Department, 2007. Print.

John, Elton. Interview with Jeff Kurtti, November 30, 2002.

Jones, Andy. Phone interview with Michael Goldman, March 28, 2018, and e-mail exchange with Michael Goldman.

Kupershmidt, Alex. Quoted from: https://50most-influentialdisneyanimators.wordpress.com/2011/05/13/43-alex-kupershmidt/. Accessed 10 Sept. 2018. Web.

Legato, Robert. Interviews with Michael Goldman on Playa del Rey set in Los Angeles, January 12, 2018, and March 7, 2018.

Lowery, Dave. Interview with Michael Goldman on Playa del Rey set in Los Angeles, March 8, 2018.

Mancina, Mark. Unpublished interview with Jeff Kurtti, December 16, 2002.

Mecchi, Irene. Unpublished interview with Jeff Kurtti, December 4, 2002.

Minkoff, Rob. Unpublished interview with Jeff Kurtti, 2002.

Montan, Chris. Interview with Jeff Kurtti, November 21, 2002.

Peitzman, Tom. Interview with Michael Goldman on Playa del Rey set in Los Angeles, January 12, 2018.

Rice, Tim. Unpublished interview with Jeff Kurtti, November 30, 2002.

Rubin, Matt. E-mail exchange with Michael Goldman.

Schumacher, Thomas. Unpublished interview with Jeff Kurtti, January 6, 2003.

Sciutto, A. J. E-mail exchange with Michael Goldman.

Silver, Jeffrey. Interview with Michael Goldman on Playa del Rey set in Los Angeles, January 12, 2018.

Valdez, Adam. Phone interview with Michael Goldman, March 27, 2018.Other Media

Zimmer, Hans. Phone interview with Michael Goldman, October 14, 2018.

## Other Media Sources

Bierman, Elizabeth. "The 100 Most Influential People: John Oliver." TIME 100: April 16, 2015. http://time.com/collec-tion-post/3822865/john-oliver-2015-time-100/. Accessed 10 Sept. 2018. Web.

de Waal, Shaun. "Analysis: 20 bizarre apartheid moments." Mail & Guardian. April 26, 2014. https://mg.co.za/article/2014-04-26-20-bizarre-apartheid-moments/. Accessed 10 Sept. 2018. Web.

dvdizzy.com. "Interview: Roger Allers and Rob Minkoff, The Directors of The Lion King." www.dvdizzy.com/lionking-di-rectors-interview.html. Accessed 08 Oct. 2018. Web.

Fey, Tina. "The 100 Most Influential People: Donald Glover." TIME 100: April 20, 2017. http://time.com/collec-tion/2017-time-100/4736210/donald-glover/. Accessed 10 Sept. 2018. Web.

Finch, Christopher. The Art of The Lion King. New York: Hyperion, 1994. Print.

_____. The Art of Walt Disney: From Mickey Mouse to the Magic Kingdoms (First Edition). New York: Abrams, 1973. Print.

Hornaday, Ann. "James Earl Jones: A voice for the ages, aging gracefully." Washington Post. September 25, 2014. washingtonpost.com. Accessed 10 Sept. 2018. Web.

Jefferson, J'na. "Interview: JD McCrary Talks 'The Lion King,' Working with Donald Glover." vibe.com. November 28, 2017. Accessed 10 Sept. 2018. Web.

Kurtti, Jeff. *Practically Poppins in Every Way*. Los Angeles • New York: Disney Editions, 2018. Print.

Lassell, Michael. *The Lion King: Twenty Years on Broadway and Around the World*. Los Angeles • New York: Disney Editions, 2017. Print.

Marx, Rebecca Flint. "James Earl Jones Biography." allmovie.com. Accessed 10 Sept. 2018. Web.

McDonnell, Brandy. "Tulsa native Alfre Woodard continues long career with Marvel role in 'Luke Cage.'" newsok.com. June 22, 2018. Accessed 10 Sept. 2018. Web.

Rogo, Paula. "Tony Awards Honor James Earl Jones with Lifetime Achievement Award." essence.com (ESSENCE Communications, Inc.). June 12, 2017. Accessed 10 Sept. 2018. Web.

Royston, Peter. *The Lion King Study Guide*. New York: Disney Theatrical Productions Education Department, 2007. Print.

Salinas, Tara. "Makers of The Lion King Don Hahn and Rob Minkoff." August 22, 2017. http://www.trippinwithtara.com/makers-of-the-lion-king-don-hahn-androb-minkoff/. Accessed 08 Oct. 2018. Web.

Sandberg, Sheryl. "The 100 Most Influential People: Beyoncé." TIME 100: April 23, 2014. http://time.com/collection-post/70716/beyonce-2014-time-100/. Accessed 10 Sept. 2018. Web.

Sperling, Nicole, and Susan King. "Oprah shines, Ratner controversy fades at honorary Oscars gala." November 12, 2011. latimes.com. Accessed 10 Sept. 2018. Web.

Stidhum, Tonja Renée. "Keegan-Michael Key, On 'Hotel Transylvania 3' and How Looney Tunes Taught Him the 'Anatomy of a Joke.'" July 19, 2018. shadowandact.com. Accessed 10 Sept. 2018. Web.

Taymor, Julie (with Alexis Greene). *The Lion King: Pride Rock on Broadway* (Updated Edition). Los Angeles • New York: Disney Editions, 2017. Print.

Thomas, Frank, and Johnston, Ollie. *Disney Animation: The Illusion of Life* (First Edition). New York: Abbeville Press, 1981. Print.

Wakeman, Gregory. "'Hotel Transylvania 3: Summer Vacation' allowed Keegan-Michael Key to really uncensor himself." July 11, 2018. metro.com (Metro Media US). Accessed 10 Sept. 2018. Web.

Walt Disney Home Entertainment. *The Lion King: Platinum Edition*. Burbank, CA. 2003. DVD video.

## Image Credits

# ACKNOWLEDGMENTS

Telling a story about cinematic storytellers can be complicated. In the case of *The Lion King*, crafting this narrative about how talented filmmakers were able to tell a legendary story in a revolutionary new fashion only happened thanks to huge contributions from tremendous allies and collaborators. Along those lines, Michael Goldman would like to offer thanks and a big hakuna matata to the following people:

Wendy Lefkon, Disney Editions editorial director, for kindly inviting me to participate in this project to begin with, appreciating and wanting to include my expertise.

Jennifer Eastwood, senior editor for this book—probably the most "chill" book editor I have ever worked with. I really appreciate the support and guidance.

Project editor Jeff Kurtti, the original godfather of this book in terms of envisioning and helping execute its depth and scope. Jeff's voice is an important part of this narrative, yet he encouraged me to take a leading role on the project, which I really appreciate.

Tamara Khalaf for her graphic design excellence on this beautiful book, and the rest of the Disney Publishing team.

Gregg Brilliant, unit publicist on this film, an old friend, and an expert in helping journalists and filmmakers get together so that compelling behind-the-scenes stories like this one can be told. Gregg opened more doors along the way than I can possibly remember.

Jonny Vale, Global Head of Marketing and Communications for MPC Film, for tracking down and putting me in touch with the film's visual effects team on extremely tight deadlines.

Robert Legato, the award-winning visual effects supervisor on this movie and a good pal, who encouraged me to pitch myself to the Disney team as the right guy to translate for public consumption how this incredibly complex project came together. Rob then contributed his time and insight into explaining how the movie was made, and why the effort was so significant.

Jon Favreau, the director/mastermind of this movie and a Hollywood leader in terms of dancing on the cutting edge to find new ways to tell emotionally compelling stories. Jon contributed time and support to this project, and emphasized the importance of explaining how exactly this new kind of filmmaking works.

The movie's producers and crew, virtually all of whom made themselves available to me, squired me around the *Lion King* set, and helped me understand what they were doing with those wacky virtual reality goggles, strange computers, and camera-less camera rigs. In particular, legendary cinematographer Caleb Deschanel offered me far more time and input than his duties permitted.

Special thanks to my mom, Lynn, and my stepdad, Lionel, who have always backed me up no matter what. Shortly before press time, Lionel passed away after a brave battle, so I want to dedicate my hard work on this book to him. Lionel worked hard every single day of his life and repeatedly told me that hard work was the only path to success. Hopefully, on this project and others, I have applied that lesson, so I want to thank Lionel for emphasizing it. I'll miss him.

And finally, special thanks to my gorgeous wife, Bari, for tolerating the crazy schedule and strange moods of a frenzied author, supporting me every step of the way; and my two boys and best friends, Jake and Nathan. My sons told me it was "really cool" that I had the opportunity to explain the new *Lion King* to the world through this book. In turn, I think it's pretty cool being their dad.

—Michael Goldman
Los Angeles, California, 2019

# AFTERWORD

Remaking a classic like *The Lion King* posed a unique set of challenges. We set out to tell a story beloved by so many in a medium in which a wonderful version still exists. The animated classic still holds up to viewing by modern audiences. How should we set about making our version? What was the case for making it at all? The key for me was the musical stage production.

The stage production has been a success since it first opened. Fans of the 1994 animated feature did not find the show redundant. In fact, they saw it as another way to experience this timeless story and inspiring music in a whole new medium. Most importantly, it was seen as complementary and not in competition with the 1994 film. Perhaps audiences would be open to a version that appeared "live action."

Technological breakthroughs in visual effects and CGI would allow me to mount a version that would appear to be a documentary or live-action narrative feature, even though every shot was animated using key frame techniques. This approach confined us to a photo-real style of rendering and animation. Exhaustive reference of real-world environments and animal behavior were rigorously studied to create this illusion. Virtual reality hardware was utilized as we created what was essentially a "multi-player VR filmmaking video game." We used this platform to set up shots that "photographed" the handmade animated performances with a human crew driving the camera moves. All of this was designed to take full advantage of the artistic talents of the illustrators, animators, key frame artists, cast, and production crew—and created as analog a look as was possible in a completely digitally animated world.

The results of this experiment in filmmaking were quite unique, and we were able to offer an immersive retelling of *The Lion King* that will hopefully stand alongside the classic 2-D animated and musical stage productions. The hundreds of artists and filmmakers involved in every stage of research, planning, and execution of this vision must be thanked for the realization of this ambitious endeavor. We also owe a debt of gratitude to the original storytellers who presented the story in the first place and inspired this latest production. Our efforts will hopefully point the next generation to discover the previous iterations of this timeless story.

—Jon Favreau
Director
Los Angeles, California, 2019

Editorial Director: Wendy Lefkon
Senior Editor: Jennifer Eastwood
Project Editor: Jeff Kurtti

This book's producers would like to thank Albert Park, Alex Ferrari, Alicia Chinatomby, Alison Giordano, Andrew Sansone, Alyson Melling, Charleen Chung, Christina Novak, Claire Martin, Dale Kennedy, David Jefferson, Elke Villa, Fanny Shefield, Fox Carney, Hunter Chancellor, Jeffrey Epstein, Jennifer Black, Jennifer Chan, John Breckow, Kate Milford, Ken Shue, Kevin Kern, Mariel Pinciotti, Marybeth Tregarthen, Max Calne, Megan Granger, Michael Legato, Michael Serrian, Miki Carter, Monica Vasquez, Monique Diman, Muriel Tebid, Nicole Carroll, Paige Olson, Pat Van Note, Rachel Rivera, Rebecca Cline, Robert Johnson, Rudy Zamora, Sarah Huck, Scott Petrower, Scott Piehl, Seale Ballenger, Terry Downes, Tyra Harris, Therese Ellis, Tim Retzlaff, Warren Meislin, Winnie Ho, and Zan Schneider.

ISBN 978-1-368-02343-6
FAC-034274-19158
Printed in the United States of America
First Hardcover Edition, July 2019
10 9 8 7 6 5 4 3 2 1
Visit www.disneybooks.com

D23
The Official Disney Fan Club
D23.com